AUTOBIOGRAPHY *of a* DELICATESSEN

AUTOBIOGRAPHY
of a DELICATESSEN

KATZ'S

Photographs by Baldomero Fernandez

Text by Jake Dell

Foreword by Adam Richman

Edited by Beth Daugherty

BAUER AND DEAN PUBLISHERS, NEW YORK
IN ASSOCIATION WITH GLENN HOROWITZ BOOKSELLER

Contents

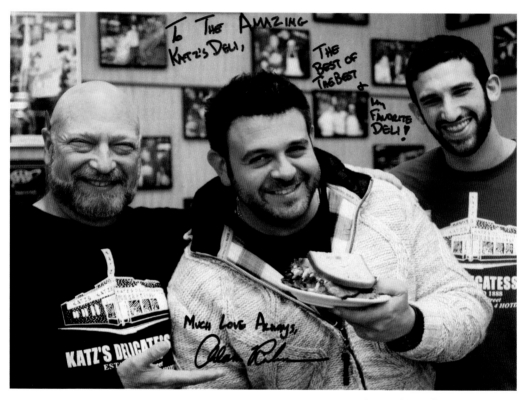

Adam Richman flanked
by Alan Dell on the left and
Jake Dell on the right.

Foreword

Katz's Delicatessen made me who I am today. Literally.

Now, I'm not talking about being a big guy as a result of eating copious amounts of arguably the greatest pastrami on planet Earth. I'm a native New Yorker, so Katz's Delicatessen has been a touchstone in my life since birth. My grandfather grew up just blocks away on the Lower East Side and on weekends we would all gather at Katz's for knoblewurst. While a young man, when the Lower East Side was experiencing its renaissance as a major nightlife destination, Katz's became a key destination for late-night eats and delicious treats. And as a TV personality, I owe a great deal of gratitude to Katz's Deli: my final screen test for *Man v. Food* occurred in the hallowed halls of Katz's. I said to my friends, "This is unfair, I have total home-field advantage!" and luckily for me, my appreciation and knowledge of my favorite delicatessen paid off.

To most in the know, calling Katz's Delicatessen anything other than just Katz's is unheard of. Its legendary stature and ridiculously delicious food have elevated it to superstar status, where only one name is necessary to identify the high priests of pastrami on Houston. To walk into that establishment is, in itself, a history lesson. You get your ticket, you hold on to it for dear life, you glance around at the thousands of pictures of notables who have dined at this meaty oasis—and then the smell hits you. Dear lord, the smell!

An absolute perfume, an ambrosia of cured and cooked meats prepared with an expert touch. Garlic and pepper, fried potatoes and years of tradition. You literally want to eat the air. You head to the cutting stations where men carve the best

corned beef and pastrami with laser-like precision, before gifting you with a small plate to taste the deliciousness that awaits you betwixt two slices of fresh rye bread.

You grab a table, perhaps near a photo of your favorite actor (or basic cable-television host), maybe even the table where Harry and Sally had their orgasmic meal. Then you sink your teeth into traditions and flavors that reach back to generations past. Those gorgeous sandwiches, massive in their size and taste, are the objects of affection and adoration of fans from across the world. They have remained excellent, consistent, and sought after for decades. These are the things that lifelong New Yorkers like me cling to when we think of home, family, and what deli should be. Absolute perfection—preferably with homemade Russian dressing and coleslaw.

Katz's Delicatessen is the type of restaurant that they just don't make anymore. A place that has the quality of the finest Michelin-starred restaurant with a decidedly "come as you are," no-pretense attitude. A place where family works, and treats you like family. A place where New York history, of those who settled in the city that never sleeps and the traditions they brought with them, and great homemade dill pickles sit side by side. If you've never been to Katz's, may this book be your tasty introduction. And if you have, may the pages that follow remind you of the greatest name in New York deli . . .

Like the sign says, "Katz's—That's all."

ADAM RICHMAN

Host of NBC's "Food Fighters"

Host of Travel Channel's "Man v. Food"

Executive Producer and Host of Travel Channel's "Man v. Food Nation" and "Best Sandwich in America"

Author of *America the Edible: A Hungry History from Sea to Dining Sea* and the forthcoming cookbook *Straight Up Tasty*

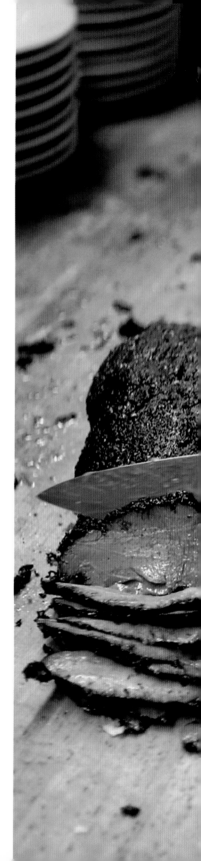

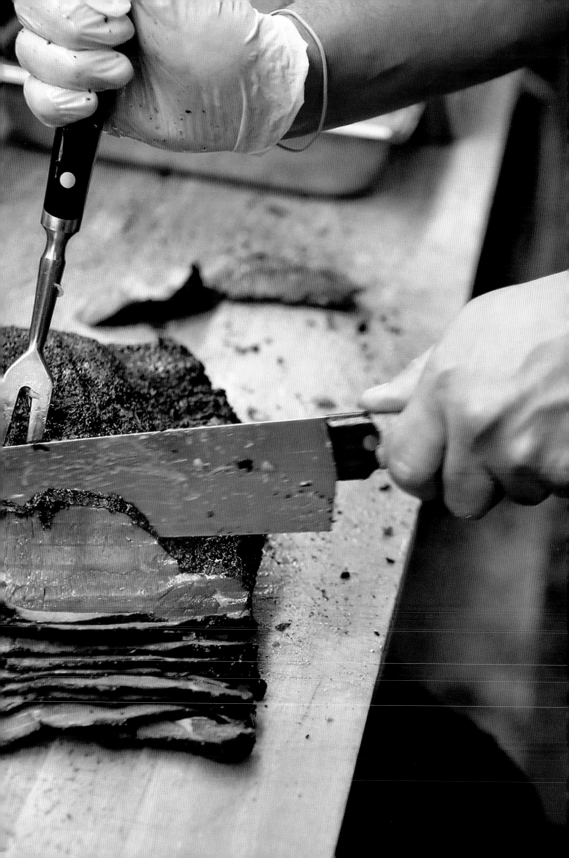

Katz's: A Brief History

Katz's Delicatessen has a long and rich history that ties together over 125 years of tradition, multiple generations of family management, and an exceptional culinary culture found only in the heart of the world's greatest city. As the fifth-generation owner, I invite you to take a journey as I explain the unique history of Katz's Deli, a staple of New York City and my second home.

THE TRADITION OF DELI: JUST A TASTE

New York City truly is the birthplace of the delicatessen.

The first deli owners sought to answer a simple question: How do you take an inexpensive cut of meat, give it an excellent taste, and make it last? For the deli men of the Lower East Side in New York City more than a century ago, the answer was simple: cure the meats as it was done in the *shtetls* (small towns) of the old country.

The recipes, handed down from generation to generation, came directly from the villages and towns in Eastern Europe where the deli owners grew up. While cooking was traditionally viewed as the wife's duty at home, shop owners were primarily men, who were compelled to learn, among other things, proper curing techniques. These unique salt-brining and smoking methods offered a solution to the lack of refrigeration available at the time. Moreover, the seasonings enhanced what would otherwise be an average cut of meat, giving it a wonderfully rich flavor. The long shelf life, however, was what made the meats truly valuable, allowing poor immigrant families to feast for days.

This, combined with affordable prices and the familiar tastes of home, enabled delicatessens to thrive.

From the late nineteenth century into the early twentieth century, barrels of meat and pickles lined the streets of the Lower East Side. Delicatessens were on every corner, each with a slightly different menu and a distinct and loyal set of customers. This food tradition held strong for the first- and second-generation immigrants comforted by the tastes they recognized from home.

Slowly, but surely, delicatessens made their way across the country. By the time they reached the West Coast, there were creative new sandwiches such as the Reuben, tuna melt, and cheesesteak. Delis thrived throughout the early part of the twentieth century; however, as the years went by, the number of delicatessens both on the Lower East Side and across the country began to dwindle, dropping to only the handful we see today. Katz's has stood the test of time, making it the oldest deli in the country.

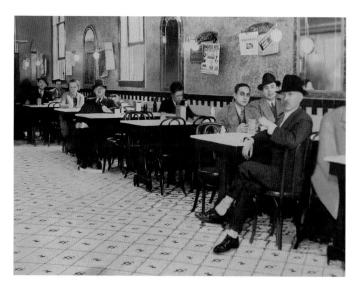

Katz's Delicatessen, colorized photograph from the 1930s.

THE FIRST AND SECOND GENERATIONS: 1888–1940

The story of our restaurant dates back to 1888, when Morris Iceland and his brother Hyman opened Iceland Brothers, an unassuming delicatessen on Manhattan's Lower East Side. As did most deli owners at the time, the Iceland family traced their roots to an unknown location in the *shtetls* of Eastern Europe. Before 1900, another immigrant, by the name of Willy Katz, joined the partnership and the store became Iceland & Katz. Soon after, Willy bought out the Iceland brothers, invited his younger cousin Benny to the partnership, and gave the restaurant its current and universally recognized name—Katz's Delicatessen. They carried

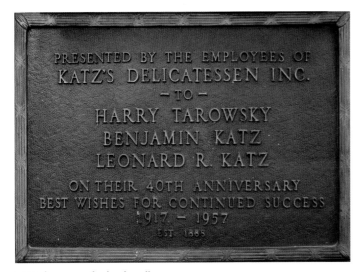

1957 plaque on the back wall of the deli.

on the food traditions of the previous generations, curing navels and briskets the old-fashioned way.

By 1917, *landsman* (fellow countryman) Harry Tarowsky had officially become a partner, establishing an ownership trio that would last for decades. Originally located on the east side of Ludlow Street, Katz's moved across to the west side in 1923. The entrance remained on Ludlow Street; the north side of the deli then faced an empty lot on East Houston Street. This space became home to dozens of barrels filled with pickles, along with the legendary Katz's meats in various stages of the brining (corning) process.

Katz's Feeds the Yiddish Theater Katz's early days coincided with the heyday of the Yiddish theater. The famous National Theater thrived on Houston Street and numerous stages and theater groups lined Second Avenue. With their religious themes and "old country" inspirations, the performances sought to connect Jewish culture with the modern world. The vibrant population of Eastern European Jewish immigrants living on the Lower East Side facilitated the growth of this unique art form. This same group came to eat at our restaurant before and after performances, becoming an important

Katz's new facade on the west side of Ludlow Street, ca. 1932.

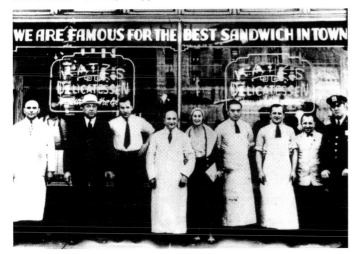

part of our history. Also during this time, Katz's experienced its first celebrity visits—from well-known actors, singers, and comedians of the Yiddish theater—establishing a reputation that continues to grow.

THE SECOND AND THIRD GENERATIONS: 1941–1987

Over the years, we've heard all types of heroic tales involving our meats. Ingrained in my memory is the one about how we helped end the Second World War. It is said that when soldiers ran out of ammunition, they loaded their bazookas with our dry-aged, hard salamis. The German forces had no choice but to surrender when they found themselves bombarded with the best of the *wurst*. The smaller, one-pound salamis are now known as bullets and the larger, two-pounders as torpedoes.

My favorite tale is the one about the soldier who was saved by a well-hidden salami. He was carrying a two-pounder inside his coat when he found himself under heavy artillery fire. His life was spared when the bullet that penetrated his outer coat was stopped by the salami. That one made the papers!

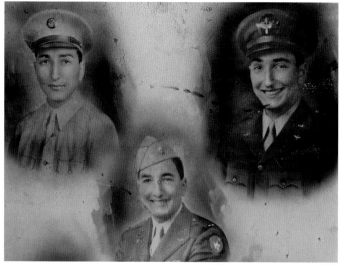

Izzy Tarowsky, Harry's son, in various military uniforms for an advertising campaign, no date.

Send A Salami! During World War II, the partners' three sons served in the armed forces. Inspired by the courage demonstrated by the young Katzes, Tarowskys, and their peers, the owners wanted to show their support to the young men, and began a family tradition of sending food overseas. Thousands of troops were soon enjoying Katz's familiar taste, thanks to the new (and now trademarked) SEND A SALAMI TO YOUR BOY IN THE ARMY campaign.

The Rise of the Deli Back at home, the city was teeming with delicatessens; there were more than a dozen in the blocks surrounding Katz's. To beat out the competition, we served heaping, high-quality portions at relatively low prices. Furthermore, because we were not kosher, we were able to feed the Lower East Side community on Saturdays, when kosher restaurants closed in observance of the Sabbath. Though Katz's didn't cater to a strictly religious clientele, it was important for us to maintain our status as "kosher-style." This meant that while there were no milk products in the restaurant, we didn't have a *mashgiach* (a supervisor of Jewish dietary laws in a kitchen) involved in the slaughter or curing processes.

Word spread quickly about our unbeatable sandwiches, necessitating expansion onto the empty lot facing Houston Street, next to the existing storefront. Construction began on the new space in the late 1940s and was completed in 1949. Since that time, patrons have found their way into our deli through the famous entrance on the southwest corner of East Houston and Ludlow.

Katz's after its expansion, ca. 1950.

The next generation of customers viewed the delicatessen slightly differently. It wasn't the food from their home countries, but rather a weekly family tradition that drew them to Katz's. Today, many of our older customers remember Sundays bargain shopping on Orchard and Delancey streets and topping off the day with a Katz's feast. Generation after generation return to the neighborhood to experience the wonderfully nostalgic moments they remember from their childhood or to introduce their children to this great culinary tradition.

Above: Dave Tarowsky in
"The Delicatessen" painted
by Max Ferguson, 1993.

Below: Kevin Albinder,
Dave's grandson, behind the
counter at Katz's, 2012.

A Family Affair Beginning with the Iceland brothers and continuing with the Katz and Tarowsky families, Katz's Delicatessen has always been a family-run business. When Willy Katz died in 1942, his son, Lenny, took his place in the partnership. Likewise, when Benny and Harry passed away, in 1979 and 1980 respectively, their children took over: Benny's son-in-law, Artie Maxstein, and Harry's son, Isadore "Izzy" Tarowsky, joined Lenny as the third generation of owners. Izzy's cousins, Robert and Kevin Albinder, are now our highest-ranking managers. They have been an integral part of Katz's legacy for almost forty years; their grandfather Dave Tarowsky, was

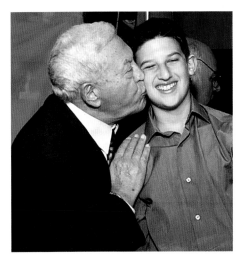

Jake Dell with his grandfather, Martin Dell, 2000.

Harry's brother and, for fifty-seven years, our store manager. Dave's image is immortalized in an oil painting on the back wall of the restaurant.

An Old Friend and New Partner At this point I would like to introduce Martin Dell, my grandfather and personal hero. In this city of larger-than-life characters, Marty wore the crown; he was as tough as the nails holding the deli's walls together. Even at the age of eighty, Marty challenged muscular clientele to punch him in the gut as hard as they could. They always did as he asked, and he never flinched.

Marty grew up on the Lower East Side; he came from nothing. His father died shortly after his birth and, as the youngest of six, he was often left to fend for himself. His mother suffered from tuberculosis for many years, and Marty and his siblings had to be placed into foster care. The scattered children were brought back home one by one as their mother regained her health. Marty was the last to return—his mother reasoned that though he was the youngest, he was the strongest and could survive on his own longer than his brothers and sisters.

During his early teens, Marty became the leader of the Third Street Gang, a notorious crew sworn to protect the neighborhood. When he was fifteen, Marty lied about his age

so he could work at the Civilian Conservation Corps (CCC) camp in Priest River, Idaho, where he earned $30 a month, selflessly keeping only $2 and sending the remainder home. As the only Jew serving in the camps (and quite possibly the only one in Idaho or its six neighboring states), my grandfather was singled out by his bosses to enter the boxing ring against much older and larger fighters. Marty's tenacity and relentlessness carried him through countless victories.

Once Marty returned to New York, he worked a series of odd jobs that spanned an array of industries from *shmata* (the rags trade) to glazes, flashlights to banana chips, hospitality to the shipyard. Marty did it all. He once owned a club on Cornelia Street that, at the time, was the only spot in the neighborhood where the gay community felt safe to party. Although Marty didn't drink, he wanted to provide a haven where all were welcome to enjoy a few cocktails and have fun. He was a generous and open-minded host.

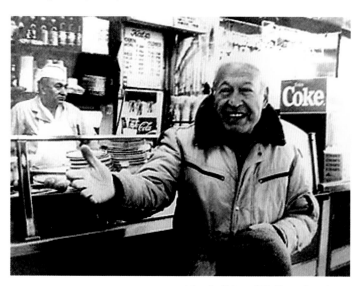

Martin "Marty" Dell, undated photograph.

Despite his rich tapestry of professions, Marty found his true calling in the deli business. In the late 1950s, his children, Alan and Juli, were old enough to join Marty on his weekly excursion to Katz's, his favorite New York deli. After devouring a family-sized portion of the famous corned beef, Marty would schmooze with the owners. It was my grandfather's dream to eventually take over the restaurant and incorporate the family business into his own lineage. For years, Marty asked co-owner Izzy, "Ready to sell? Ready to sell?" If Izzy had only known how serious my grandfather was!

By the mid-1980s Artie, Izzy, and Lenny realized the business was not fated to continue within their own families. Their children had no interest in running the deli and although Izzy's cousins worked there, they were unable to buy it. So, after three decades of Marty's persistent prodding, the partners finally agreed to sell Katz's to him, and the tradition of family ownership carries on with the Dells.

THE FOURTH GENERATION: 1988–2008

Like his father, my father, Alan, had held an impressive range of jobs—including math and music teacher at Seward Park High School, where he met my mother, Diana—but he learned the world of deli from his time as manager at Wolf's Deli located nearby.

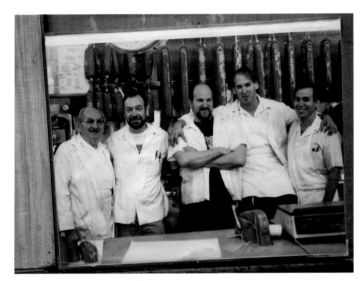

1988 photograph, from left to right: Dave Tarowsky, Alan Dell, Fred Austin, and Kevin and Rob Albinder.

In April 1988, the restaurant officially transferred to my family's hands. My father and grandfather took shifts on the sidewalk, diligently calculating the number of people who went inside Katz's, and pledging to triple it within the year. Alan left Wolf's, and my mother, still dean of Special Ed at Seward Park, spent free hours helping out at Katz's. My aunt Juli and my uncle Fred Austin moved back to New York City after twenty-one years in San Francisco to join my parents and grandfather in the world of traditional Jewish cuisine.

To ensure that the deli would remain a family business, Marty signed his share of the ownership over to his partners—his children and their spouses. The four of them bravely emptied their life savings into the deli and squeezed every penny as far as it could stretch, confident of Katz's continued success.

Due to a loyal fan base, business was booming when the Dells and Austins started in 1988. A year later, however, the Williamsburg Bridge was closed for emergency repairs, inadvertently causing a massive upheaval in the calm and steady world of Katz's Delicatessen. In the past, customers could stop by the deli during their commutes out of lower Manhattan. Now they were forced to take other routes home, leaving them hungry and throwing Katz's into a tenuous financial situation. As my dad eloquently states, "*Tough* is putting it mildly." We lost a large number of our regular customers, unsure of when, if at all, they would return. To make matters worse, the economy was struggling in the early 1990s, decreasing the amount customers were willing to spend on quality meats. To keep afloat, each of the four owners took out a personal loan, and my grandfather contributed all the retirement money he could find underneath his mattress.

Together, my family weathered the storm. My mother, always as sharp as a butcher's cleaver, came up with an innovative solution: have tour guides and bus drivers bring their groups to the Lower East Side for an authentic New York Jewish deli experience at Katz's Deli in exchange for a free plate of irresistibly tantalizing food. Before the age of social media, there was the flyer. My parents dropped off promotional sheets wherever they could: toy shows, garment centers, subway stops—you name it! New York City was ringing with the Katz's name.

***That* Scene** Then came Hollywood. While location scouts had been interested in using our restaurant in their television shows and movies as early as 1977 (*Contract on Cherry Street* starring Frank Sinatra), the most memorable appearance was in the 1989 cinematic classic *When Harry Met Sally*, thanks to Meg Ryan's infamous "faking it" scene. The film's director, Rob Reiner, screenwriter, Nora Ephron, and leading man, Billy Crystal, were regular customers and wanted to include Katz's in the movie. Once fans made the association between Meg's climactic performance and the deli, they flocked to "have what she's

having." The added business helped carry us through the mid-1990s. To this day, customers come in to reenact the scene. Katz's has since been featured in countless films, including *Donnie Brasco*, *Across the Universe*, *Enchanted*, and *We Own the Night*.

Food Porn In the late 1990s, the development of the Food Network and the Travel Channel brought a growing trend known as "food porn" into the living rooms of people around the world. Hosts including Mario Batali, Samantha Brown, Guy Fieri, Bobby Flay, Emeril Lagasse, Wolfgang Puck, and Adam Richman increased Katz's exposure by highlighting our traditional cuisine on their food-centric shows.

I will never forget a lecture I went to while in college. A fellow student asked Anthony Bourdain, "If it was 3 a.m. and you could eat anything in the world, what would you have?" His answer was simply, "Katz's Deli." What better endorsement could we ask for?

Around this time my father and uncle expanded our nationwide shipping. It gave Food Network and Travel Channel viewers a chance to sample the wonderful Jewish delicacies they had just learned about. Furthermore, we were bombarded with calls from displaced New Yorkers craving the meats they couldn't find in their restaurants or supermarkets. The combination of shipping and increased movie and television exposure helped boost business, carrying Katz's into the new millennium.

THE FIFTH GENERATION: 2009-PRESENT

Traditionally, the owners of Katz's have been very involved with the deli. While I can't speak to the habits of Morris, Hyman, or Willy, I know that both Benny and Harry were cutters, Arty was a utility guy, Lenny an office dweller, and Izzy an inventory manager. My grandfather Marty was very social and would make it a point to talk to every customer. As owners, my father, Alan, and my uncle Fred have very different temperaments. While my dad is always on the floor talking to people, as his father did, my uncle stands by the cake counter, keeping an eye on the store. I am a calculated blend of the two.

A Fresh Face So how did I come to join this fine establishment? I was born for the job, unintentionally training for it my entire life. I celebrated countless birthday parties, and my bar mitzvah, right in the deli. As an adolescent, I listened to my dad's stories when he'd come home from work full of news of the day's events. After he was finished, he always asked how I would have handled a given situation. It is an honor that I am now in charge.

Jake Dell in the hotdog costume he wore for every Halloween between 1991 and 1997.

Jake and Alan Dell at Jake's bar mitzvah, 2000.

Many Jewish families that own businesses push their children to become doctors or lawyers and then find themselves without anyone to carry on their legacy. Alan and Diana aren't your typical Jewish parents. Although my father supported my decision to apply to medical school, he was thrilled when I asked if I could shadow him at Katz's. After one year working

with my father, I knew I was destined to become my grandfather. I served traditional Jewish food, schmoozed with regulars, lived in my grandfather's apartment (where my father grew up) and drove his old tank of a car, a gold Mercury Grand Marquis, Black Tie Edition. All it took was one year of being a young Jewish deli man to decide I wanted to grow into an old Jewish deli man.

I was in college when my grandfather was hospitalized. I'll never forget when he pulled me close and whispered, "Why the hell do you want to be a doctor? Come to the business." Marty was right. In late 2009, I withdrew my med school applications and officially joined the team.

Jake's sister, Beckylee Dell, 1997.

At this point in the story I am usually asked whether my sister, Beckylee, will also follow in our father's footsteps. While we would be an amazing team, I honestly don't believe she would work here for one simple reason: Beckylee is a better person than I am. She wants to save the world! Beckylee's dreams reach beyond the Lower East Side and I want nothing more than for her to follow those dreams.

Our Well-Known Friends The first celebrity picture was nailed to the wall in 1988 after Soupy Sales visited Katz's. My father absolutely loves the classic comedian. He was at the deli, on the phone with my mother, and in his excitement to greet Soupy abruptly hung up (later apologizing to his dear wife). Luckily, our manager Kevin had a camera and captured that special moment. Hanging photos on the wall has been a tradition ever since.

Over the years, Katz's has been visited by some of the biggest names in the entertainment industry. One unforgettable moment involves Johnny Depp during the filming of *Donnie Brasco*. It was raining heavily. Depp was busy signing autographs in the front of the store when he was approached by a small, elderly lady who said she was his biggest fan. While Depp thanked her, he noticed she was soaking wet, with no umbrella or raincoat to shield her

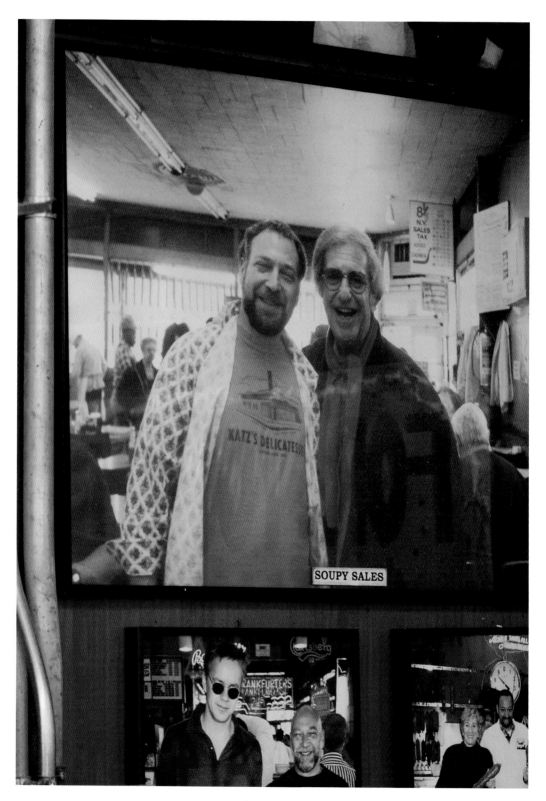

SOUPY SALES

from the downpour. Without hesitation, Depp walked her to her apartment, holding his own umbrella above her head during the eight-block trip.

Another of my favorite stories involves Jon Voight, who also showed extreme kindness to his fans. Recognized by our other patrons, he indulged them by signing autographs for a little more than an hour before he had to leave for an appointment uptown. After his appointment, Voight returned to the Lower East Side, this time with a stack of photos. Picking up where he had left off, Voight stayed until every customer in the store received a photograph signed with a personal message.

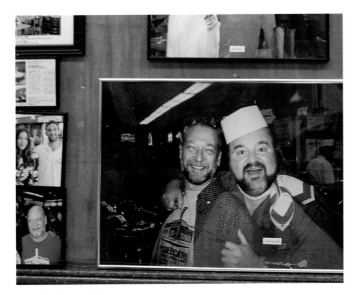

Dom DeLuise with Alan Dell, mid-1990s.

We are always honored when the elites of the culinary world eat at our restaurant. One of our best memories involves the great chef-owner Daniel Boulud, who is a regular at Katz's. When his New York flagship restaurant *Daniel* received three stars from Michelin, Boulud celebrated at Katz's with his entire staff. For one of his restaurants he even created a bone-marrow dish featuring our pastrami!

Katz's has also seen its fair share of distinguished politicians. No candidate's campaign is complete without a stop in Katz's Deli. When the United Nations is in session, various heads of state visit, including presidents, prime ministers, and even royalty. Four United States presidents have been to Katz's, and more have had our food shipped to them.

Katz's has been honored to have President Bill Clinton visit twice; we like to believe that he modified the presidential-motorcade route to pass by our restaurant. On one visit he ate

Left: First photo on the wall, Soupy Sales and Alan Dell, 1988.

a pastrami sandwich, two hot dogs, and a knish, and still took the time to shake hands with every employee. My uncle loves to reminisce about a legendary third visit when an unmarked SUV double-parked in front and a Secret Service agent jumped out and came in to order. He raced back to the street, bag in hand. The tinted backseat window slowly rolled down and an outstretched hand took the bag from his grasp.

As my uncle Fred says, "Every day is a day of possibilities."

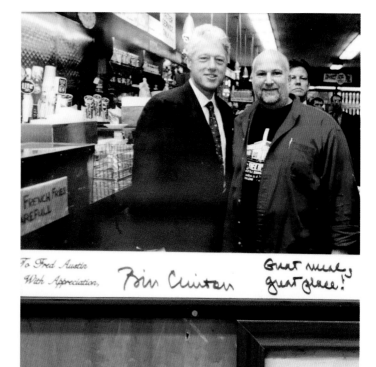

To Fred Austin With Appreciation, Bill Clinton *Great meal, great place!*

President Bill Clinton with Fred Austin, 1998.

Our Customers While it's always an honor to be visited by one of these celebrities, our regular customers are truly what make the store run. No matter their age, race, or background, each has a story about their love of Katz's Deli. I often hear people confess to taking a "momentary hiatus" from being kosher, vegetarian, or vegan. Worried that I will somehow expose their indiscretion, they swear me to secrecy!

We have regulars who live in the neighborhood, the outer boroughs, and the tri-state area. Some take the train in from Boston, D.C., or Philly, or fly in from Chicago, Los Angeles, or Miami. We have fans from small towns like Sheridan, Wyoming, or Canton, Mississippi, and international regulars from London to Johannesburg, Buenos Aires to Singapore. They all make the pilgrimage to our quintessential New York delicatessen.

On weekends Katz's experiences two dynamic, twenty-four-hour cycles that start with breakfast on Friday. At lunchtime,

New Yorkers dine side by side with tourists from all over the world; by dinnertime, Katz's is mainly populated by locals, many partaking of a Friday night tradition of "specials and beans" (two knockwurst and a side of baked beans). Later, into the night, we are mobbed by the after-club crowd, a younger (and often rambunctious) clientele. Many New Yorkers under the age of thirty can say that they've only been to Katz's after 3 a.m.! As night turns back into day, we set up the stations and get ready to do it all again.

Our Version of Modernization In a city that constantly reinvents itself, I am often asked how we've survived so long. Our recipe for success is simple: serve top-quality food prepared the old-fashioned way, and try our best to make each and every customer happy. I run the deli with the same old-school mentality that has made Katz's Delicatessen great since 1888.

From the time my family took over, the recipes and food quality have not altered; we have, however, made minor changes, including our hours and the décor. Traditionally, the former owners of Katz's would close during the week of Passover and other Jewish holidays; now we stay open three hundred and sixty-five days a year, twenty-four hours a day on weekends, and we even offer a special Thanksgiving Day menu. Also, for years, the only decorations were the neon signs that lined the walls. Now the restaurant is bursting with photos of customers who have dined here.

That's it. Preserving Katz's legacy is important to us, so I guess you could say we're more than a little hesitant to change anything. I sincerely hope that 125 years from now, my great-grandkid will be exactly where I am today, writing an updated history of Katz's and explaining what tradition really means. Whether you're a seasoned Katz's pro or have never been into the deli, come on in and say hello.

We hope to see you soon!

STATISTICS

Legal name: Katz's Delicatessen of Houston Street, Inc.

Number of locations in 2013: 1

Telephone number in 1888: None

Telephone number in 1933: DRydock 4-7887

Telephone number in 1963: ALgonquin 4-2246

Telephone number in 2013: 212-254-2246

Number of customers a day: 400 to 4,000

Number of ticket colors: 18

Year of first shipping order: 1941

Number of shipments in December 1941: 3

Year of first website order: 1999

Number of shipments in December 2012: 900

Average number of bicycle deliveries per week: 200

Average number of car deliveries per week: 60

All curing done on-site in our main pickling room:
a 500-square-foot walk-in refrigerator

Each barrel holds approximately 400 lbs. of meat

Each tank holds up to 2,000 lbs.

Each week 25,000 to 40,000 lbs. of meat are
in different stages of pickling

Pounds of pastrami served per week: 6,000 to 16,000 lbs.

Pounds of corned beef served per week: 4,000 to 9,000 lbs.

Number of hot dogs served per week: 2,000 to 5,000

Number of pickles served per week: 8,000 to 15,000

Average number of salamis sold in a year: 4,000 to 8,000

Number of salamis sent "To Your Boy In The Army": 100,000

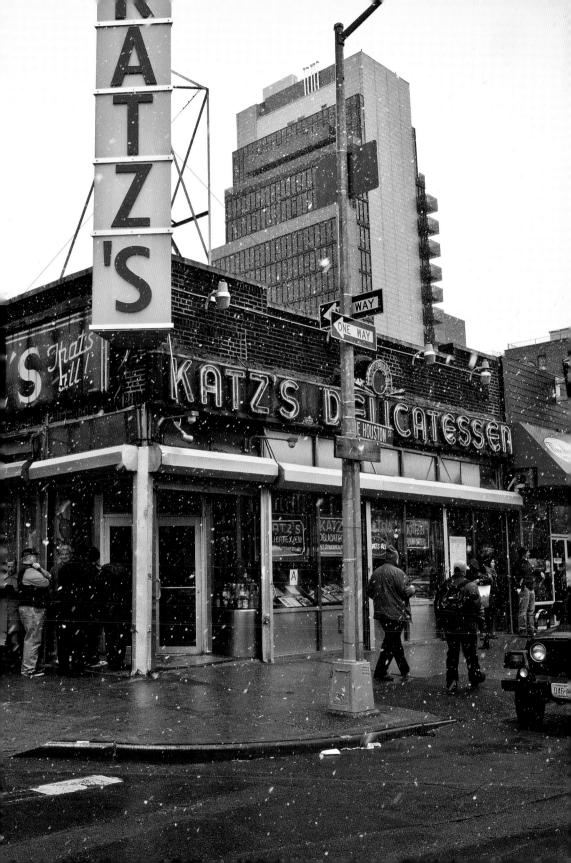

The Floor Plan

SELF-SERVICE

Walk up to one of the stations along the counter and place your order. On a busy night, the line moves fast, so we recommend knowing what you want before you get to the front of the line. Self-service seating is available anywhere in the middle or the back of the restaurant.

KITCHEN

MAIN PICKLING ROOM

BACK COUNTER

The last counter at the back of the store, before the cake case. Specialty items—bagels and lox, latkes or blintzes—are ordered here. Bring any uneaten food up to this counter to be wrapped to go. This is also our wholesale station where you can ship anything nationwide or "Send A Salami To Your Boy In The Army!"

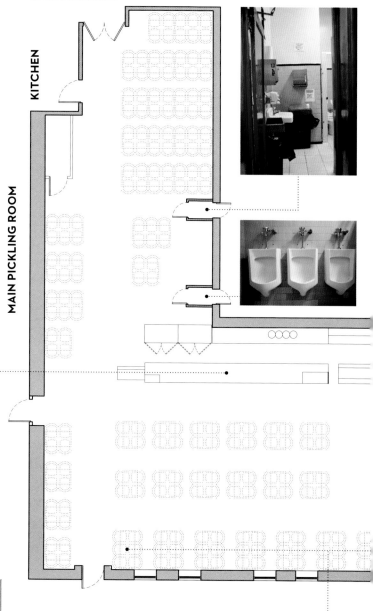

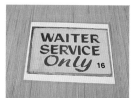

WAITER SERVICE *Only* 16

WAITER-SERVICE ONLY

A limited number of waiter-service tables are available. If this is your preference, grab any table along the eastern wall in the front part of the store and a waiter will be right with you.

SQUARE FOOTAGE

Kitchen = 762 sq ft
Main pickling room = 500 sq ft
Men's bathroom = 105 sq ft
Women's bathroom = 70 sq ft
Dining area = 3,330 sq ft

SEATING 300 chairs and 54 tables

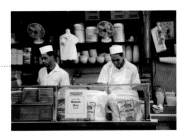

SANDWICH STATIONS

Four to nine cutting stations are open on any given shift, each cutter having his or her own line. Once you are here, you're one step away from a delicious pastrami, corned beef, brisket or turkey sandwich, or any of the other sandwiches or platters we have to offer.

SODAS AND SIDES

This is the next station along the counter, right before the stack of trays and flatware. Grab a Dr. Brown's Cel-Ray soda and a side of our famous steak fries, coleslaw, or potato salad.

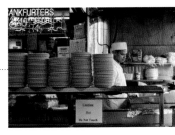

THE GRILL

The first station you encounter when you enter Katz's. Order cheesesteaks, burgers, hot dogs, knishes, soups, and egg creams here.

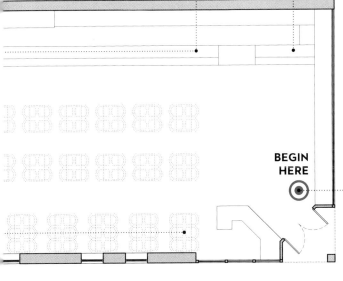

BEGIN HERE

THE TICKET

When you walk in the door you're given a ticket and when you leave you must return the ticket. If you go for self-service, present your ticket at each station after receiving your food or drink.

THE STORE

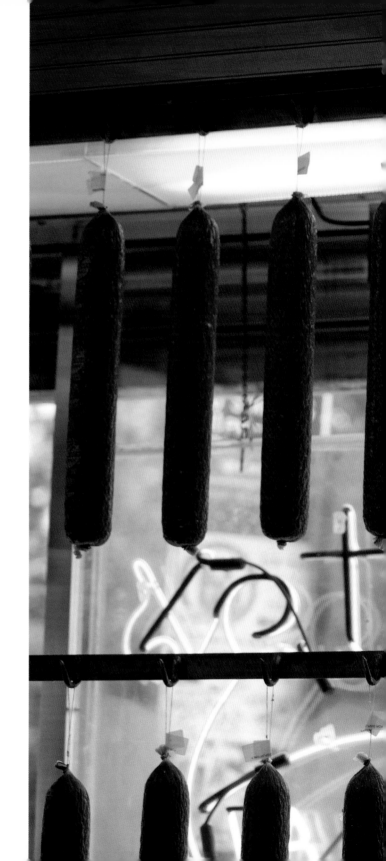

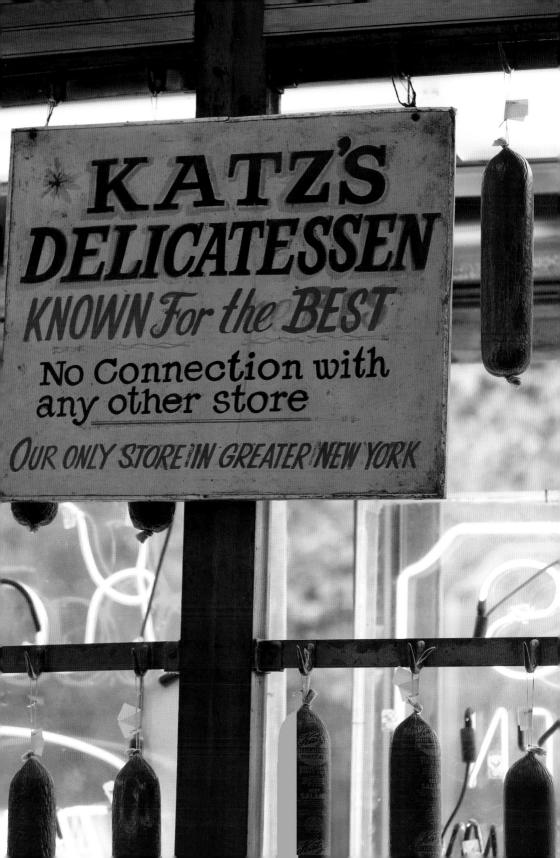

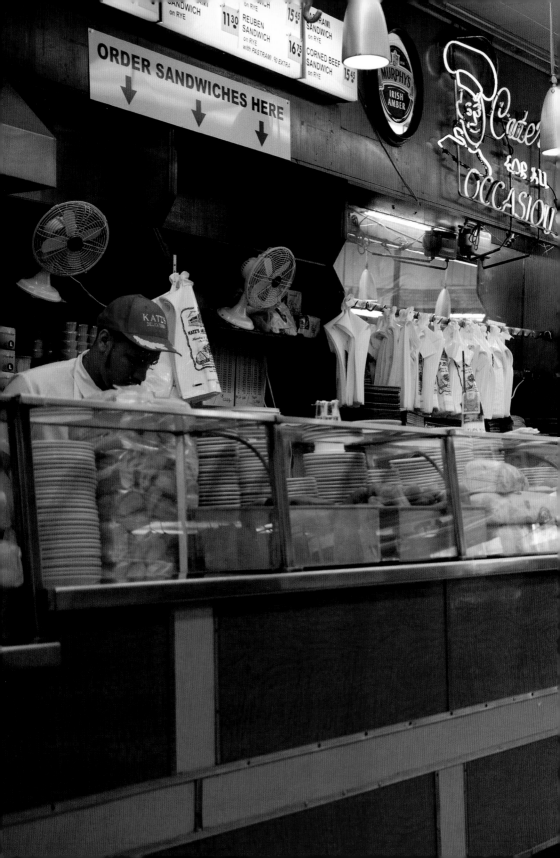

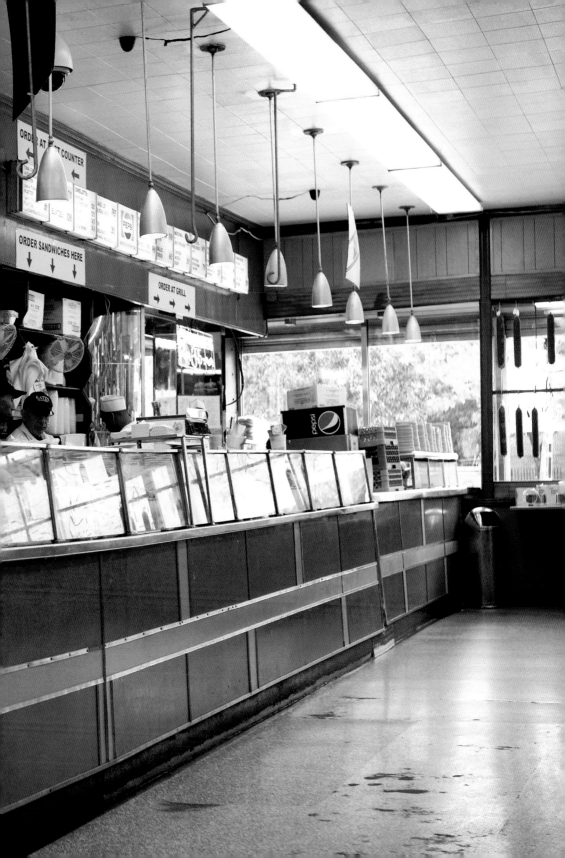

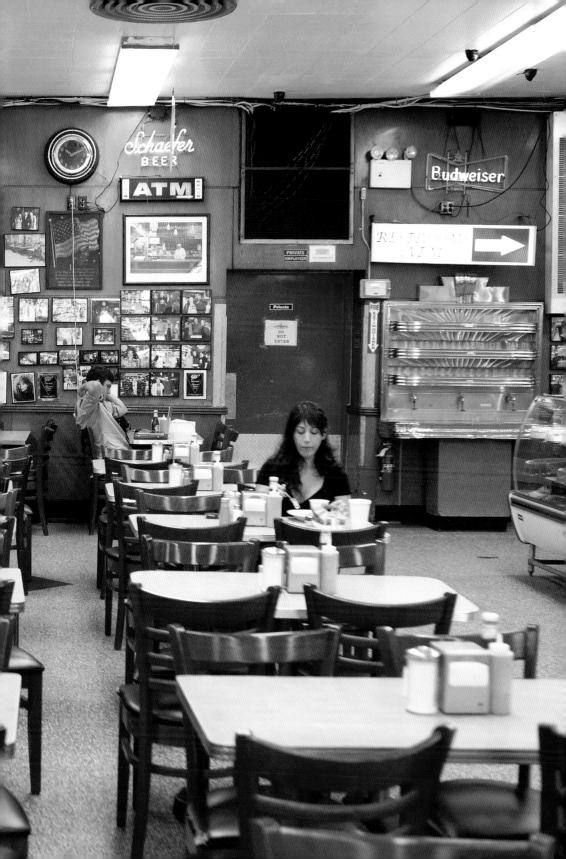

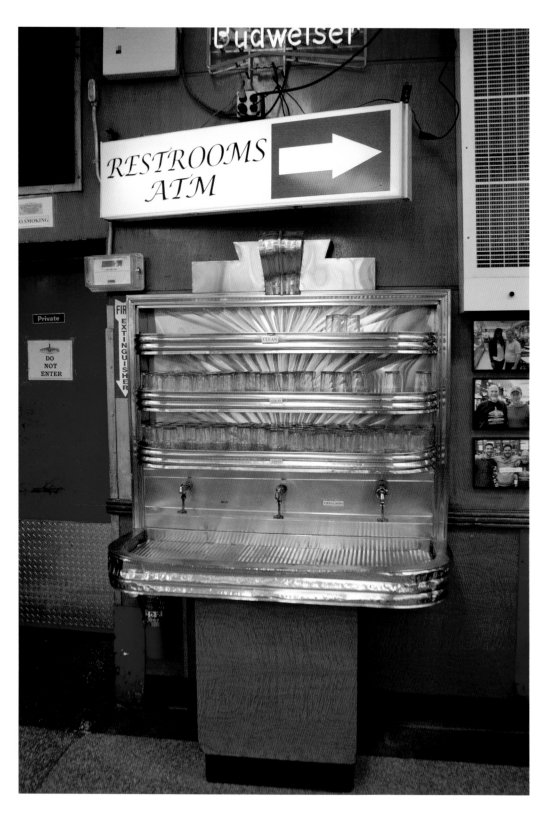

43

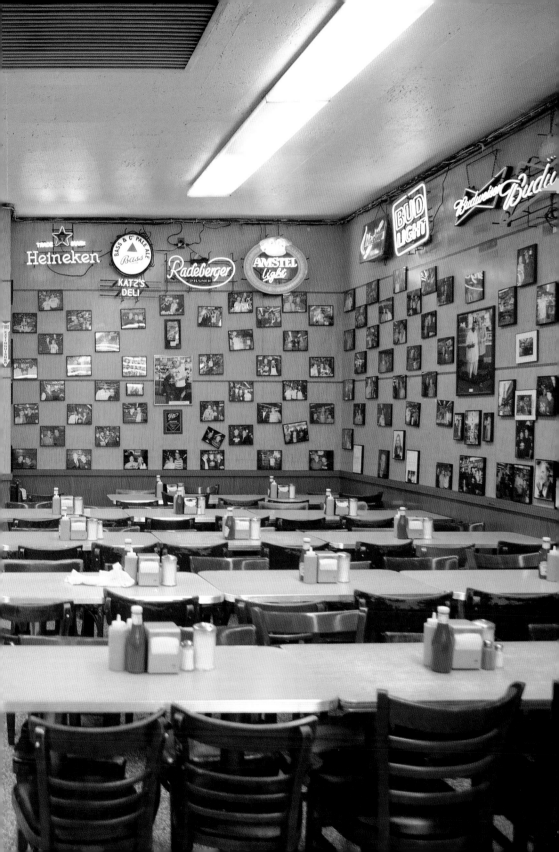

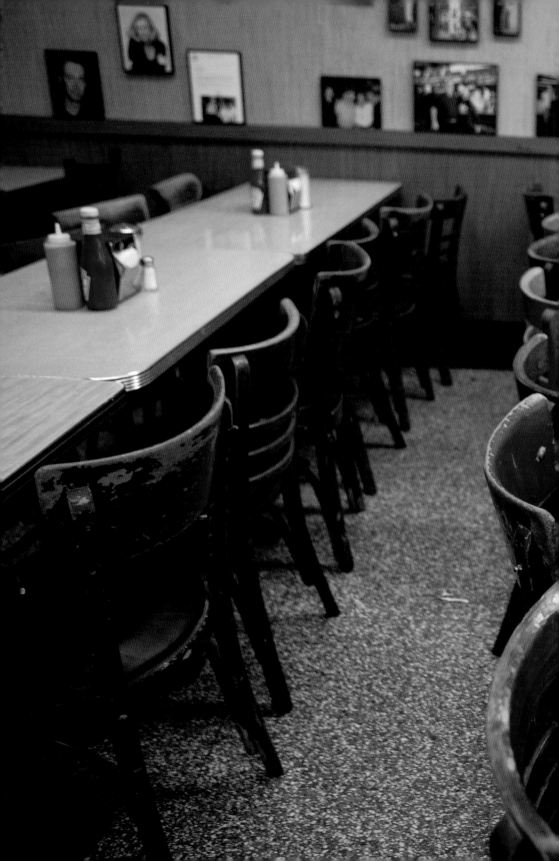

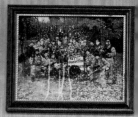

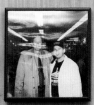

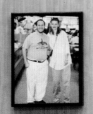

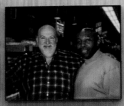

COOPER ST. JAMES

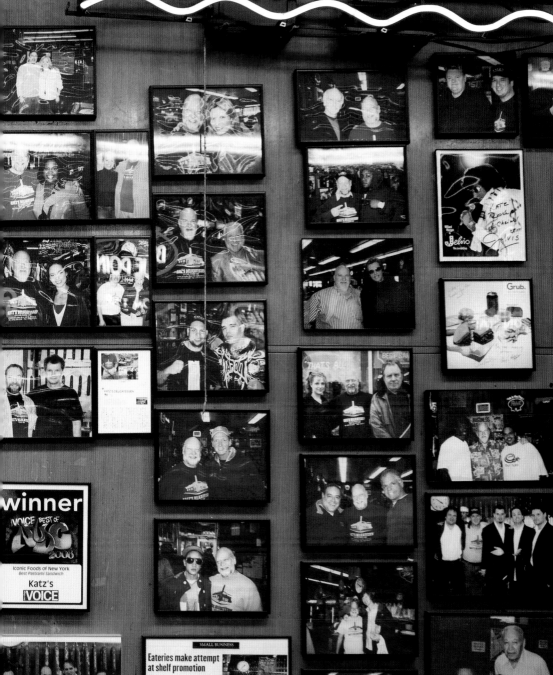

WAITER RULES

PLEASE PUNCH IN/OUT
FOR LUNCH IF YOU
DO NOT, YOU WILL BE
PENALIZED

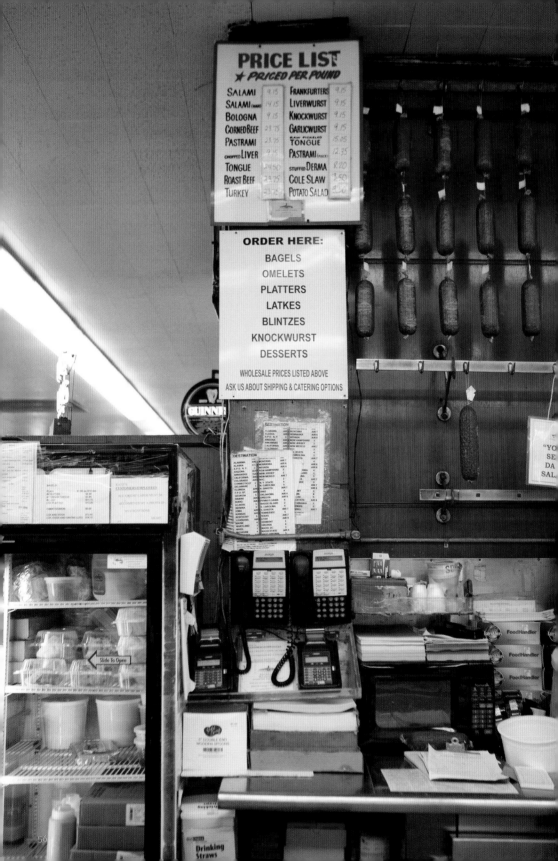

PRICE LIST
★ PRICED PER POUND

SALAMI	9.15	FRANKFURTERS	9.15
SALAMI (HARD)	14.15	LIVERWURST	9.15
BOLOGNA	9.15	KNOCKWURST	9.15
CORNED BEEF	23.75	GARLICWURST	9.15
PASTRAMI	23.75	RAW PICKLED TONGUE	15.05
CHOPPED LIVER	9.15	PASTRAMI (THICK)	12.35
TONGUE	24.50	STUFFED DERMA	8.20
ROAST BEEF	23.75	COLE SLAW	3.50
TURKEY	23.75	POTATO SALAD	3.00

ORDER HERE:

BAGELS
OMELETS
PLATTERS
LATKES
BLINTZES
KNOCKWURST
DESSERTS

WHOLESALE PRICES LISTED ABOVE
ASK US ABOUT SHIPPING & CATERING OPTIONS

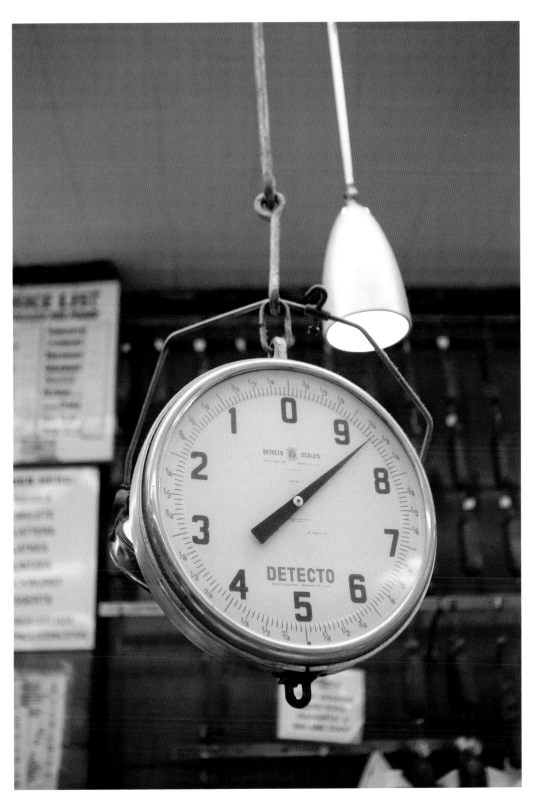

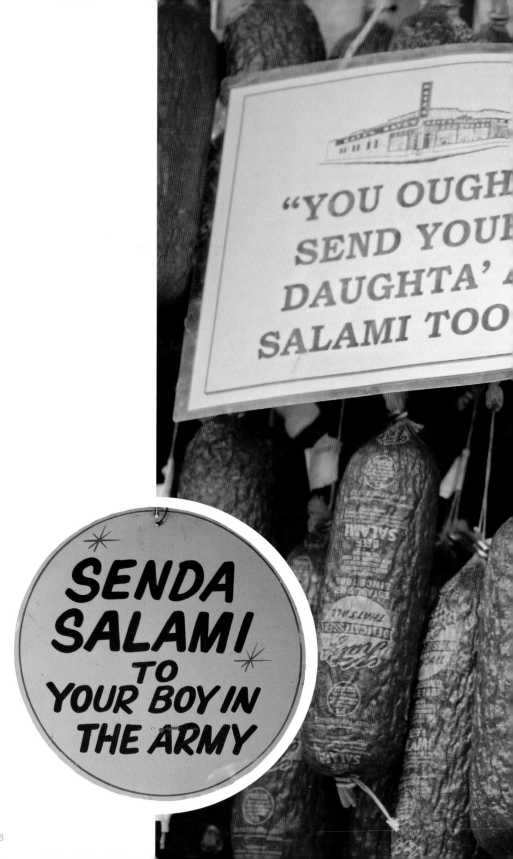

"YOU OUGH
SEND YOU
DAUGHTA'
SALAMI TOO

SENDA
SALAMI
TO
YOUR BOY IN
THE ARMY

MAIL ORDER DEPT.
SEND A SALAMI
That's all
THAT'S ALL
enas the best

DETECTO

"YOU OUGHTA'
SEND YOUR
DAUGHTA' A
SALAMI TOO!"

KATZ'S DELICATESSEN
ESTABLISHED 1888
205 East Houston St. at Ludlow St.
New York City 10002
TEL (212) 254-2246 1 800-4-HOTDOG
KatzDelicatessen.com

KATZ'S DELICATESSEN
205 East Houston St. at Ludlow St.
New York City 10002
TEL (212) 254-2246 1 800-4-HOTDOG
KatzDelicatessen.com

KATZ'S
Join our
Drop yo
Include a
name o
For
Win a f
For OUT
Win a f

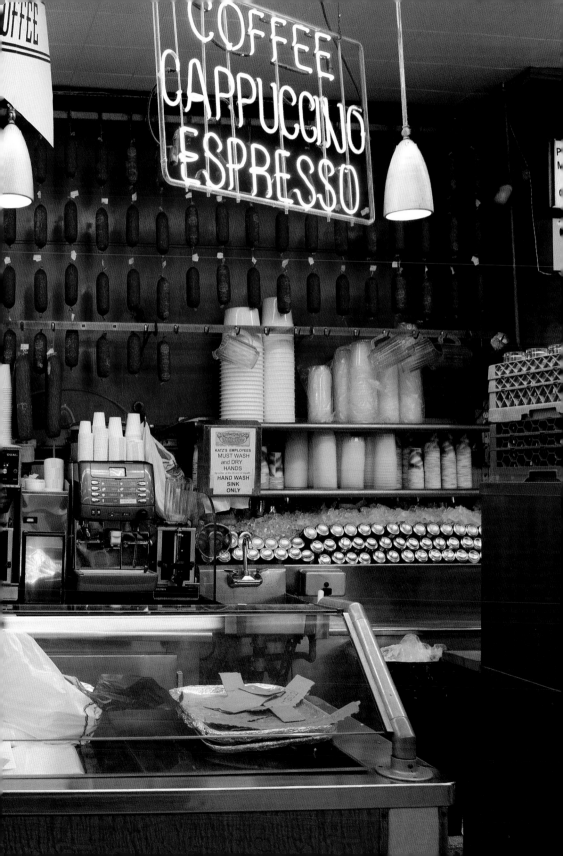

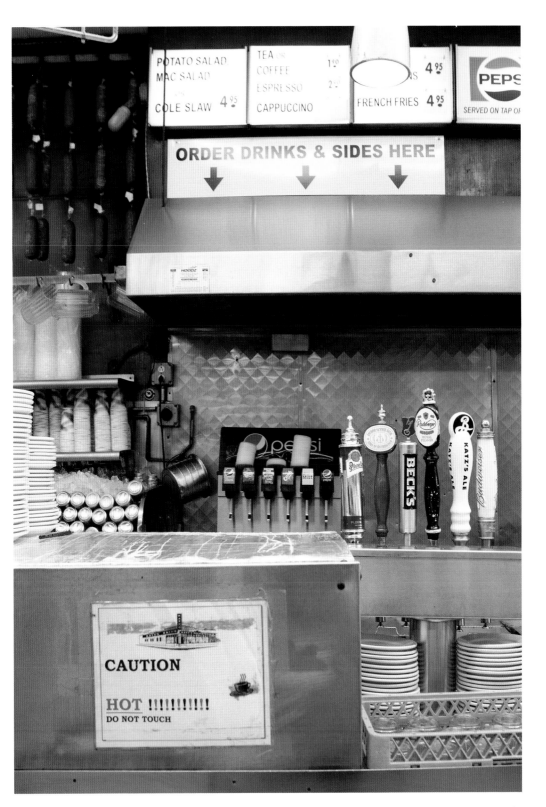

63

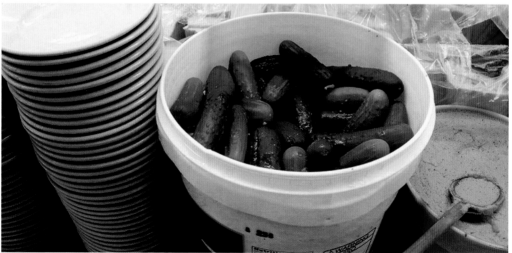

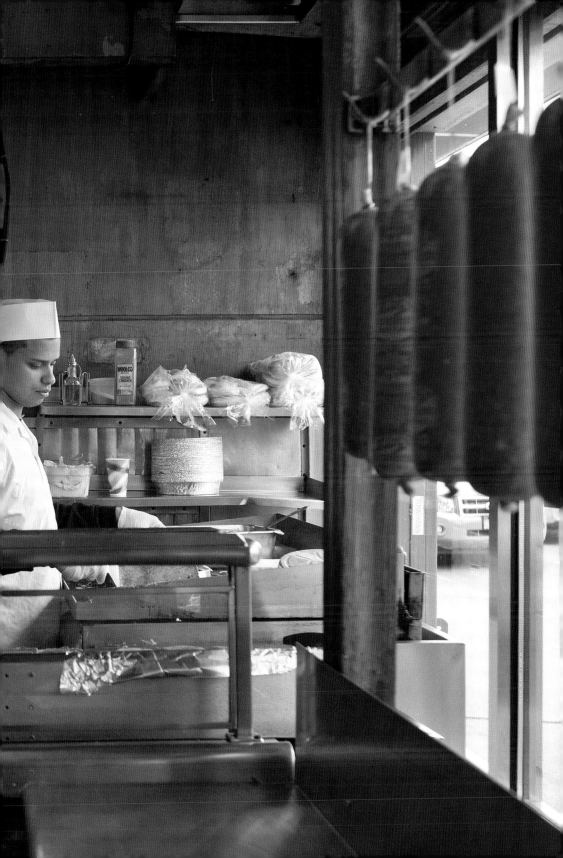

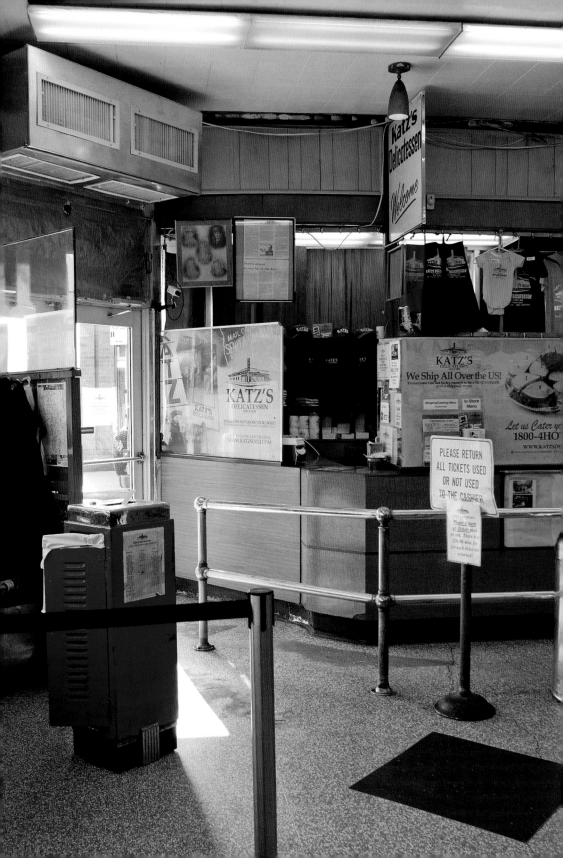

IT ALL BEGINS *with a* TICKET

STEP 1: Get a ticket.

STEP 2: Walk up to the counter. (Hint: Choose the shortest line.)

STEP 3: Place your order. (Hint: Know what you want when it's your turn.)

STEP 4: Enjoy the taste of meat the cutter offers.

STEP 5: Find a table and enjoy!

STEP 6: Don't lose your ticket.

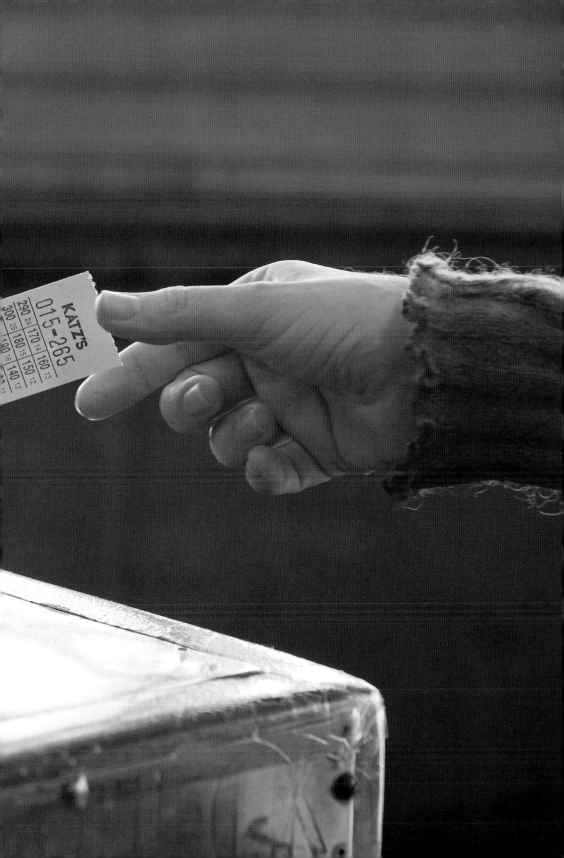

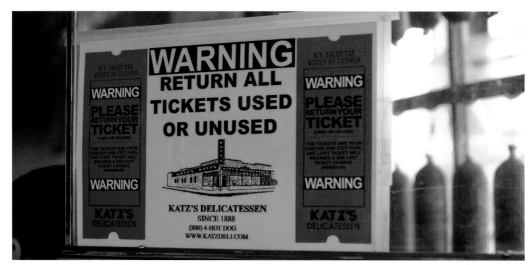

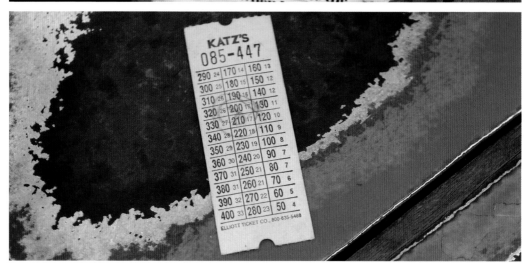

PLEASE RETURN ALL TICKETS USED OR NOT USED TO THE CASHIER

KATZ'S DELICATESSEN
ESTABLISHED 1888

Please Return all Tickets used

or not. There is a $50.00 min. fee for each ticket not returned!

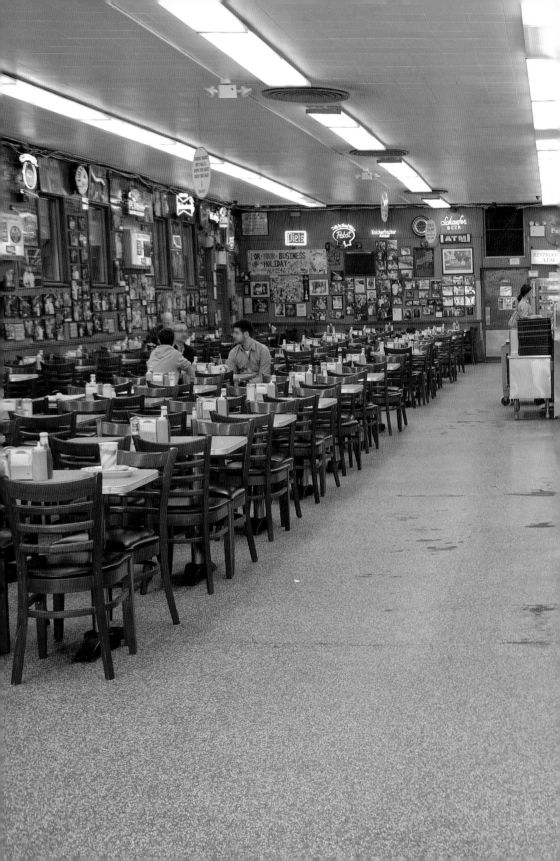

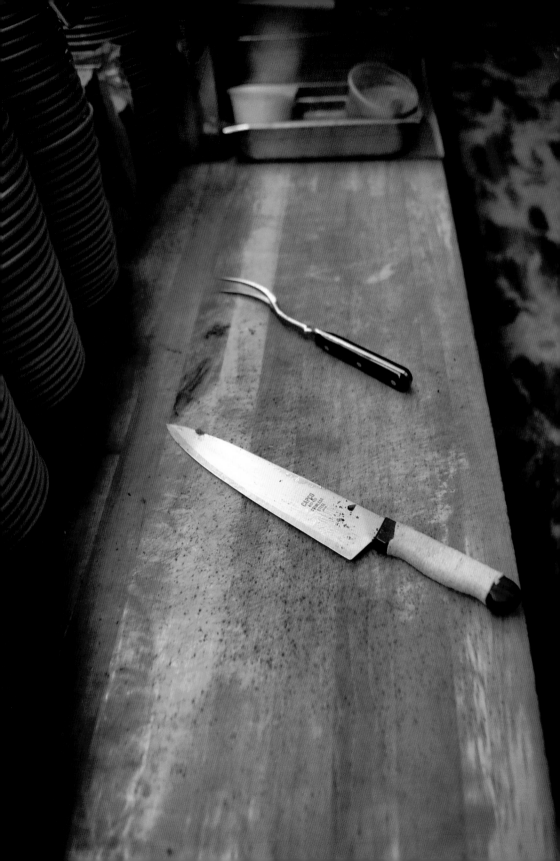

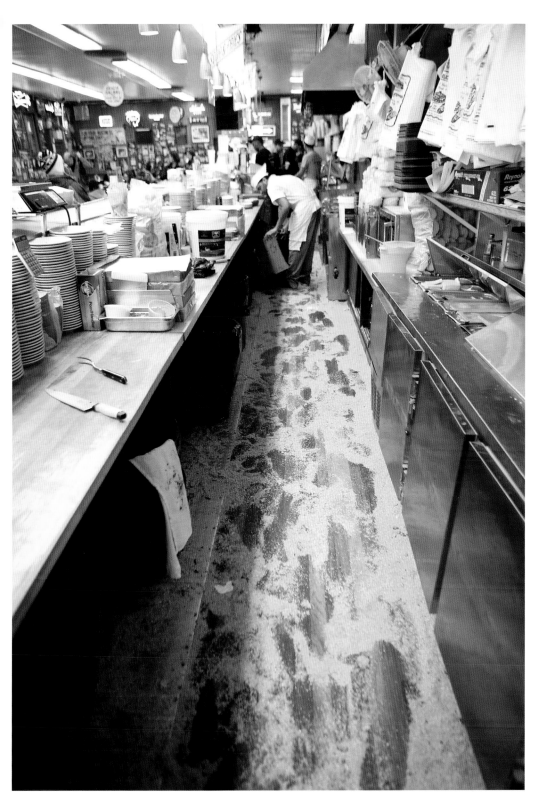

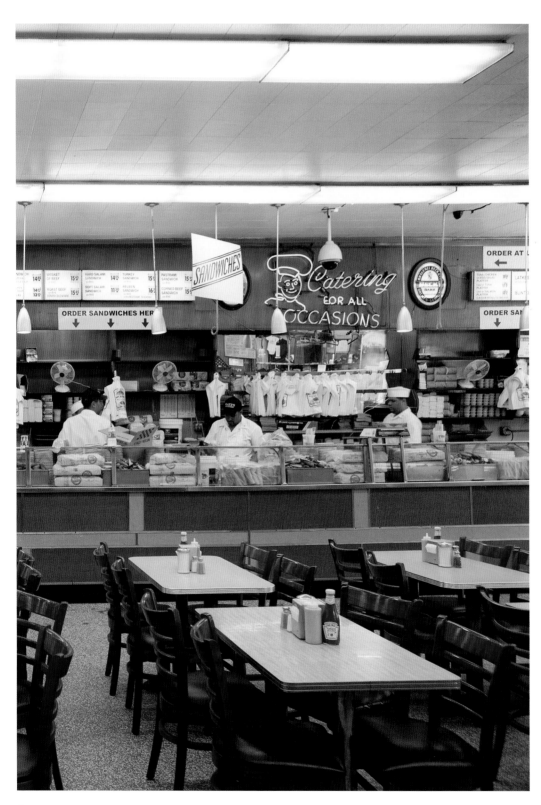

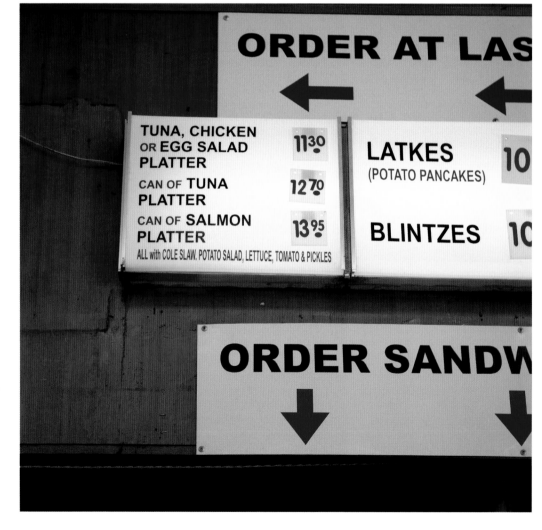

ORDER AT LAS

TUNA, CHICKEN
OR EGG SALAD
PLATTER 11³⁰

CAN OF TUNA
PLATTER 12⁷⁰

CAN OF SALMON
PLATTER 13⁹⁵

ALL with COLE SLAW, POTATO SALAD, LETTUCE, TOMATO & PICKLES

LATKES
(POTATO PANCAKES) 10

BLINTZES 10

ORDER SANDW

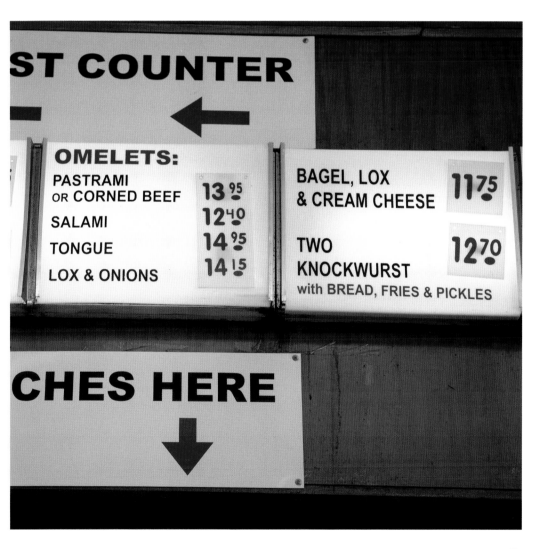

ST COUNTER
←

OMELETS:

PASTRAMI
OR CORNED BEEF 13 95

SALAMI 12 40

TONGUE 14 95

LOX & ONIONS 14 15

BAGEL, LOX
& CREAM CHEESE 11 75

TWO
KNOCKWURST 12 70
with BREAD, FRIES & PICKLES

CHES HERE
↓

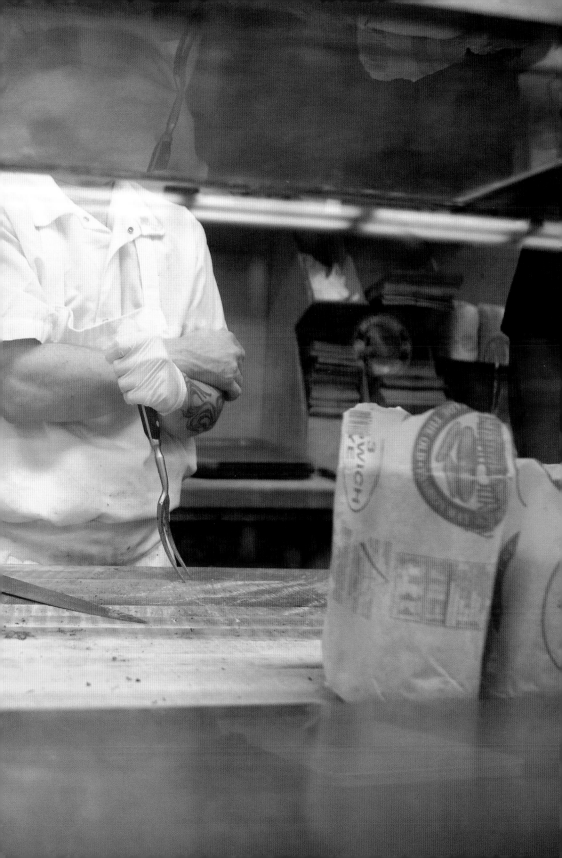

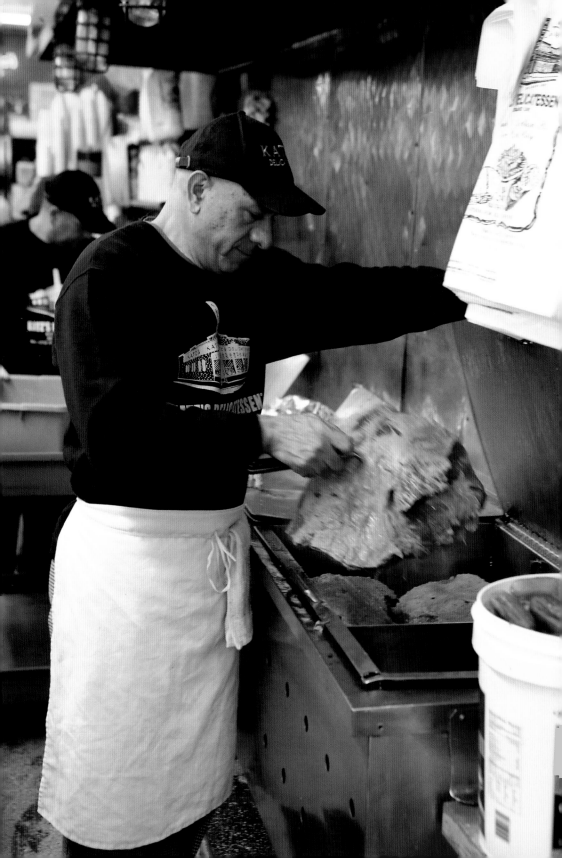

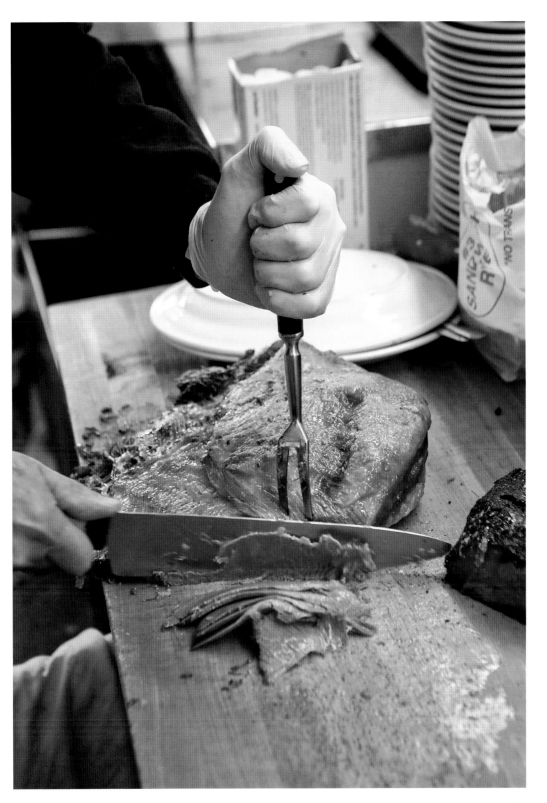

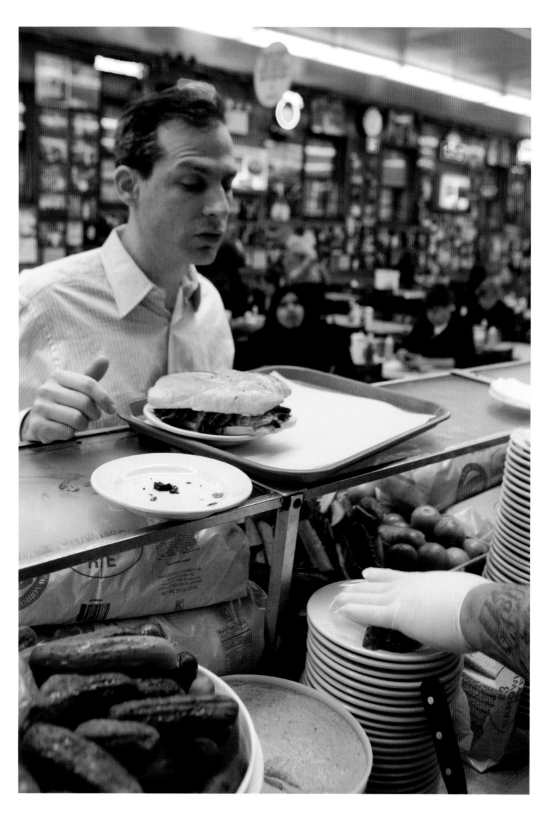

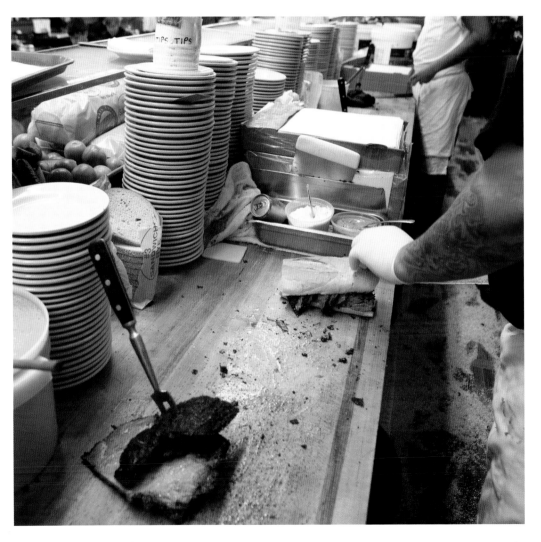

Matzoh
Brei

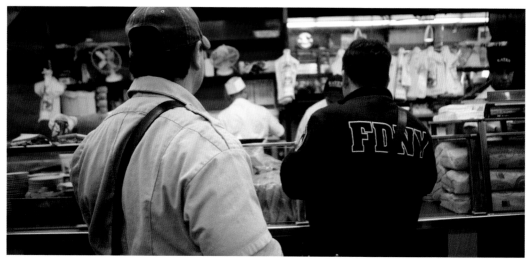

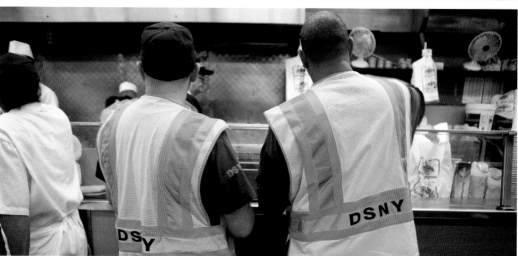

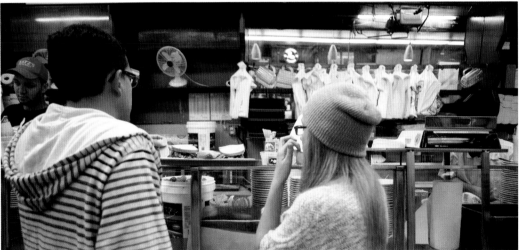

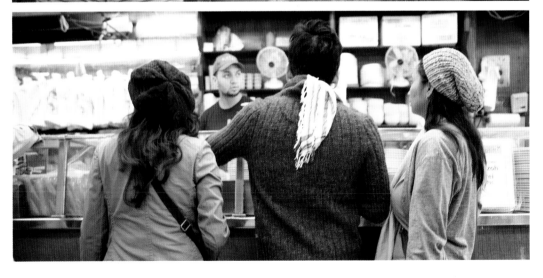

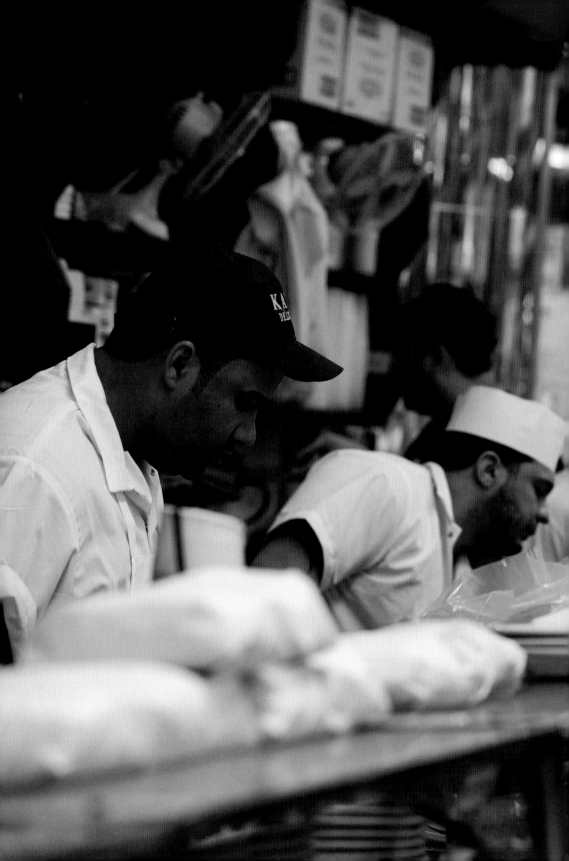

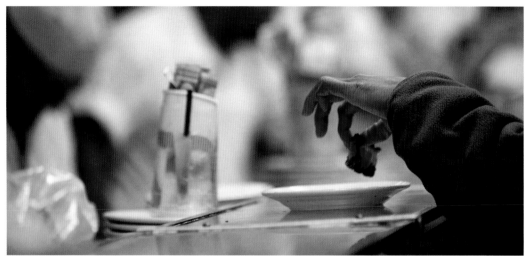

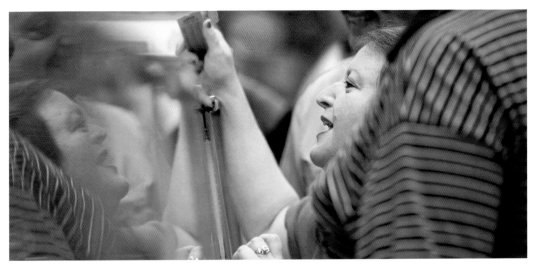

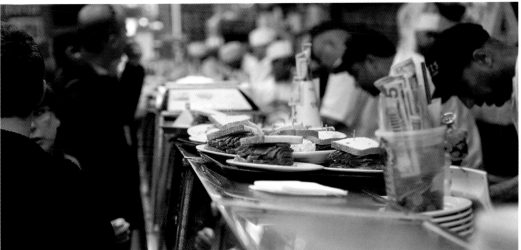

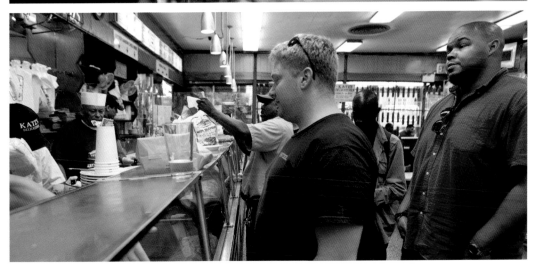

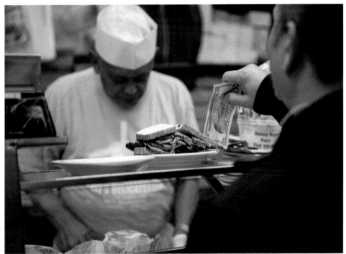

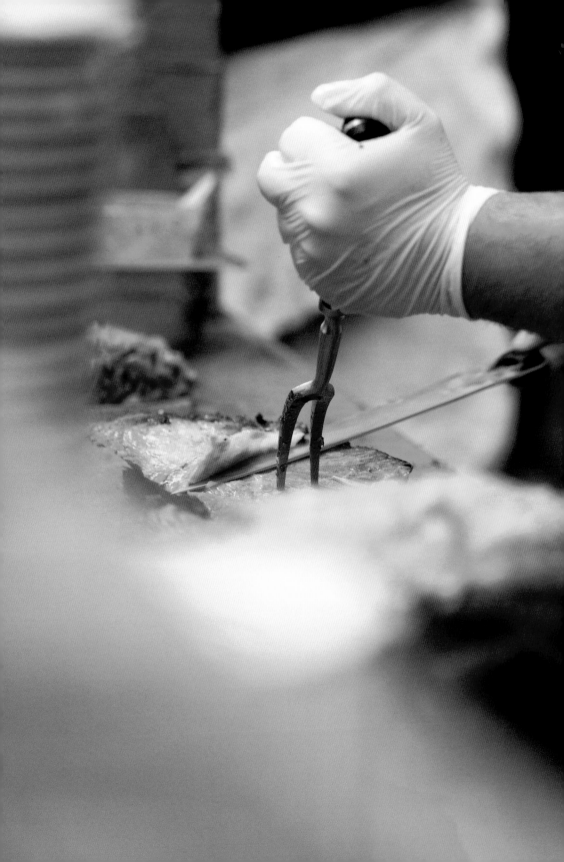

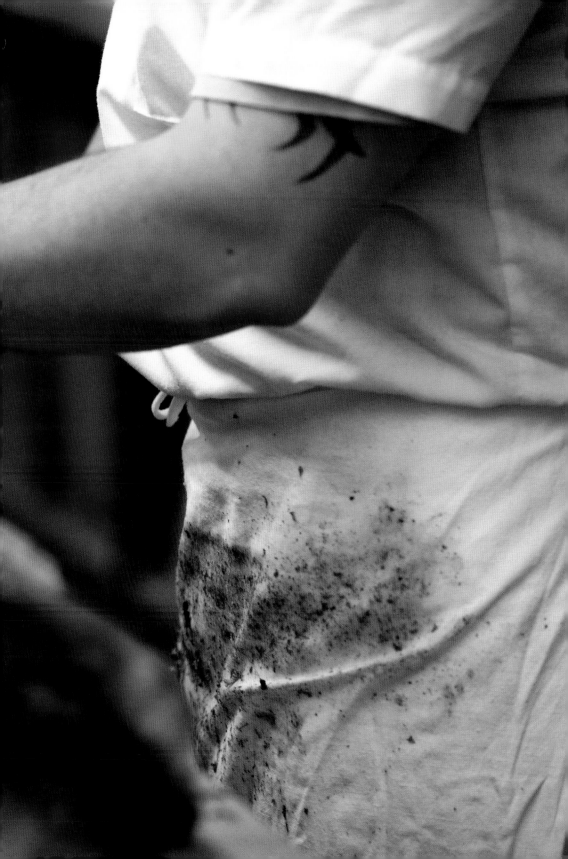

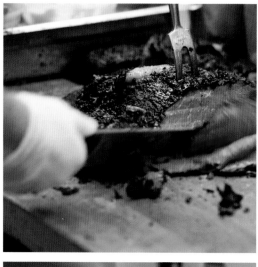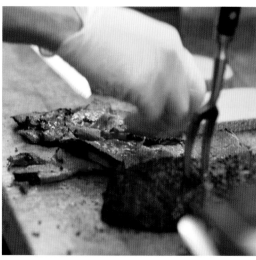
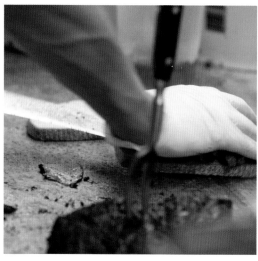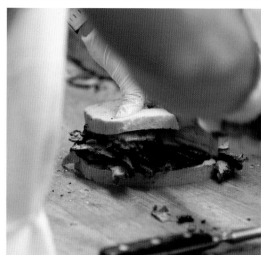
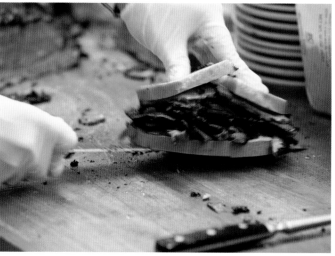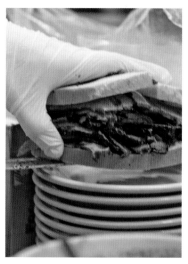

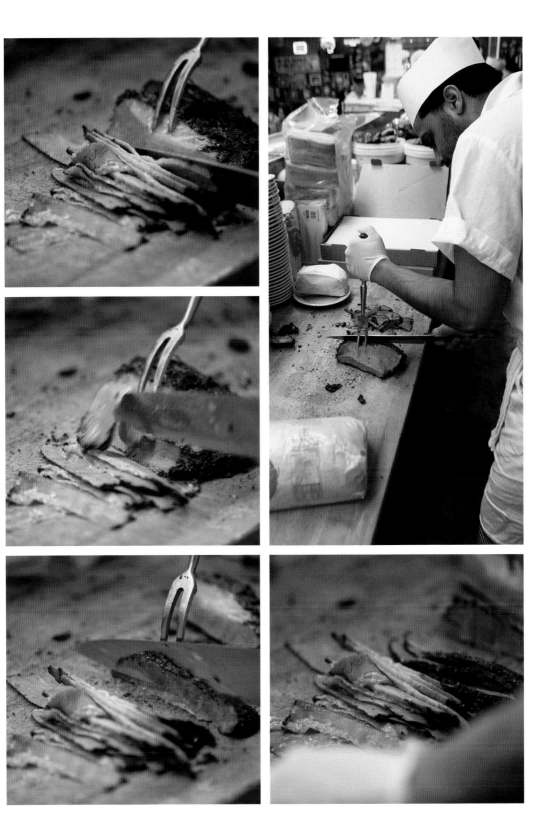

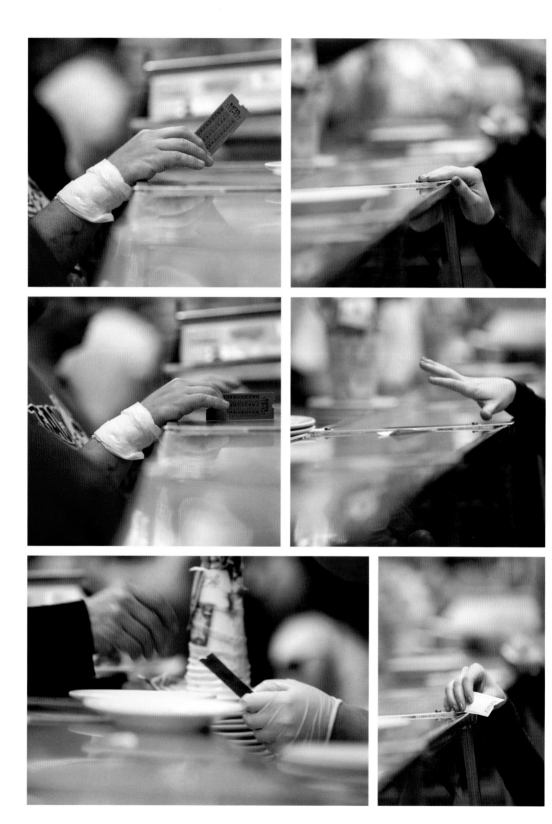

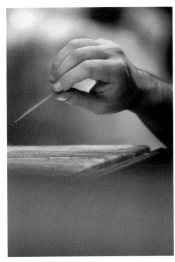
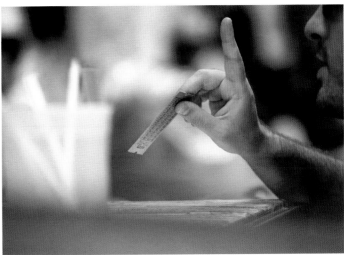

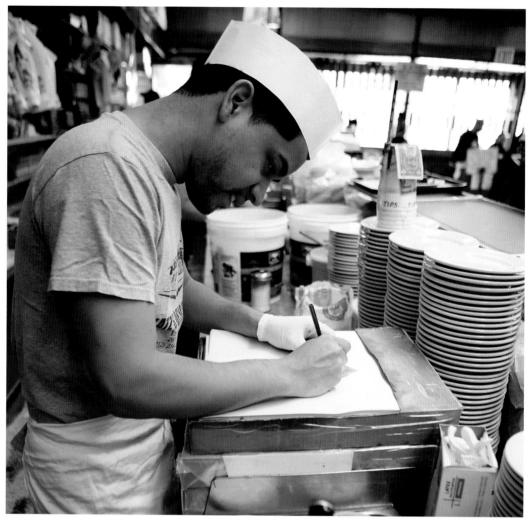

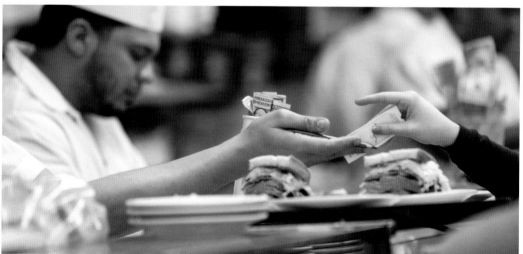

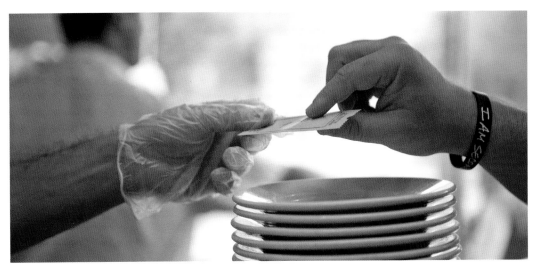

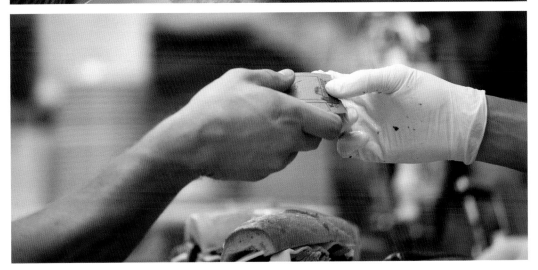

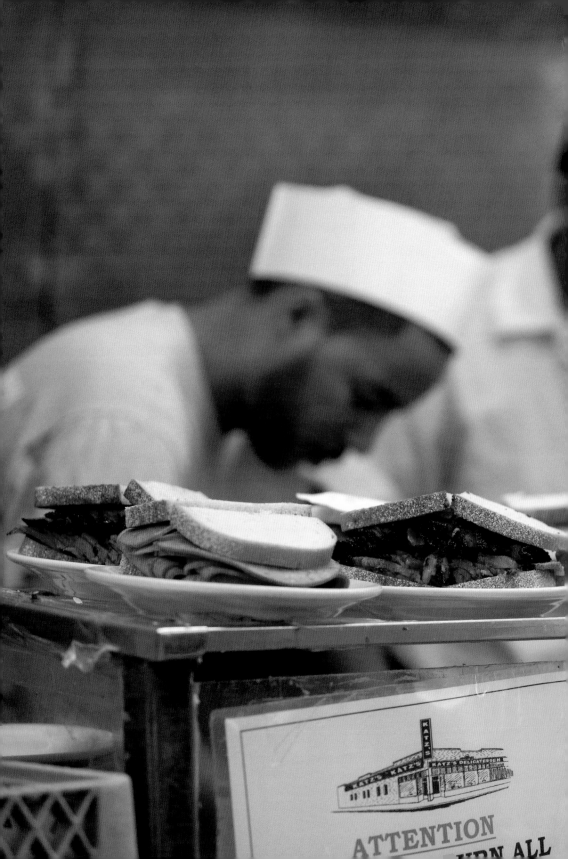

ATTENTION
[...]HEN ALL

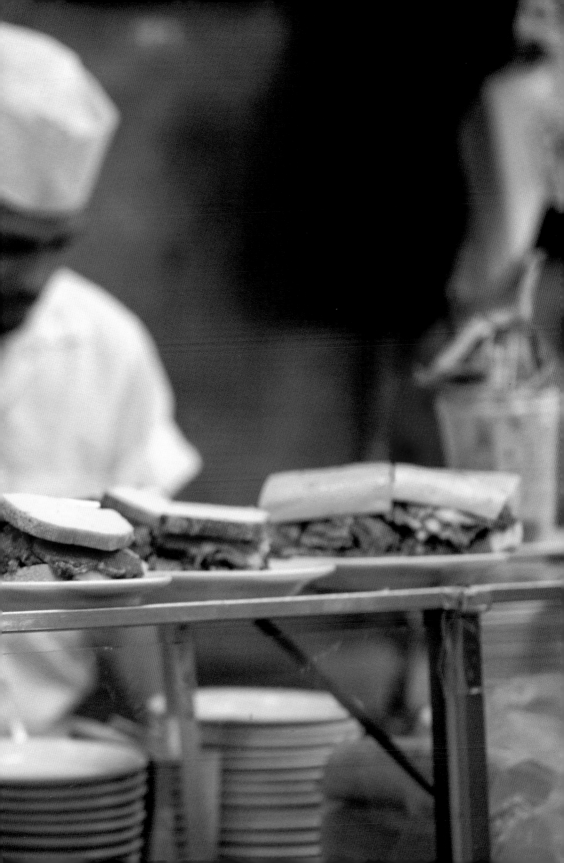

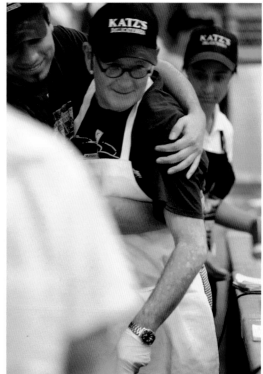

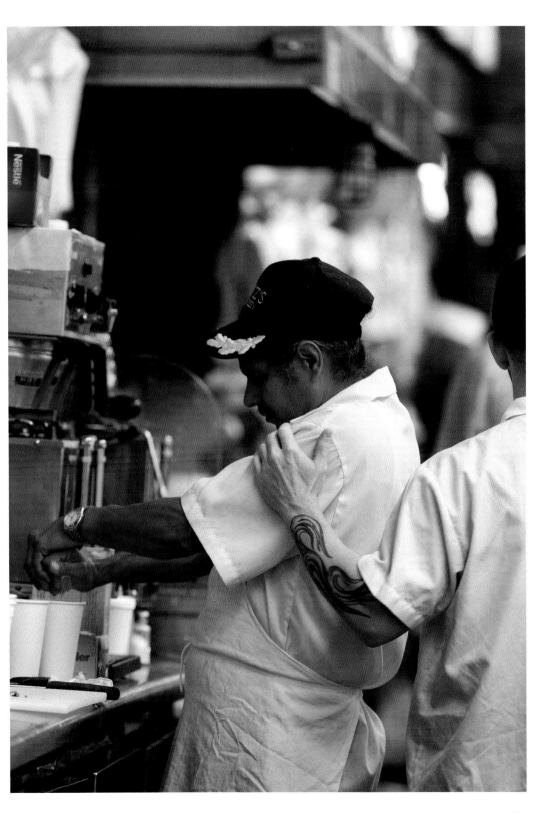

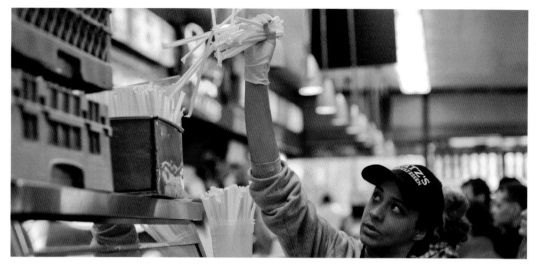

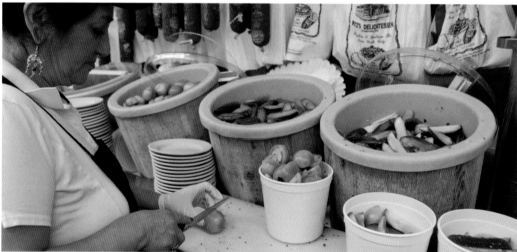

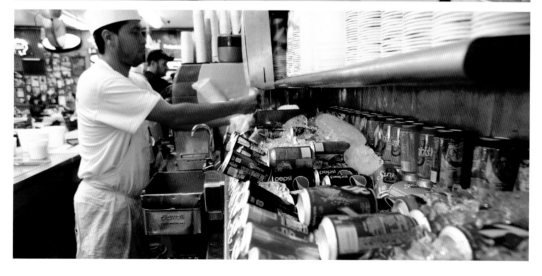

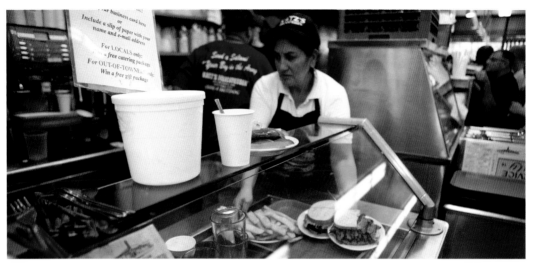

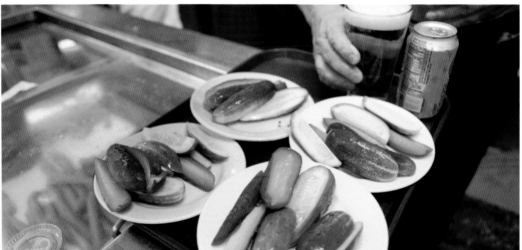

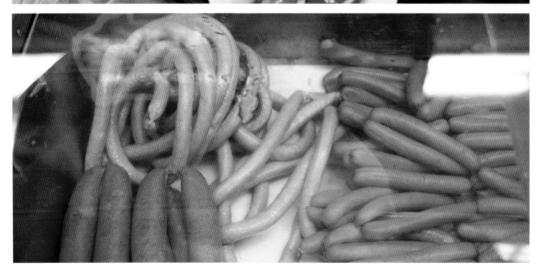

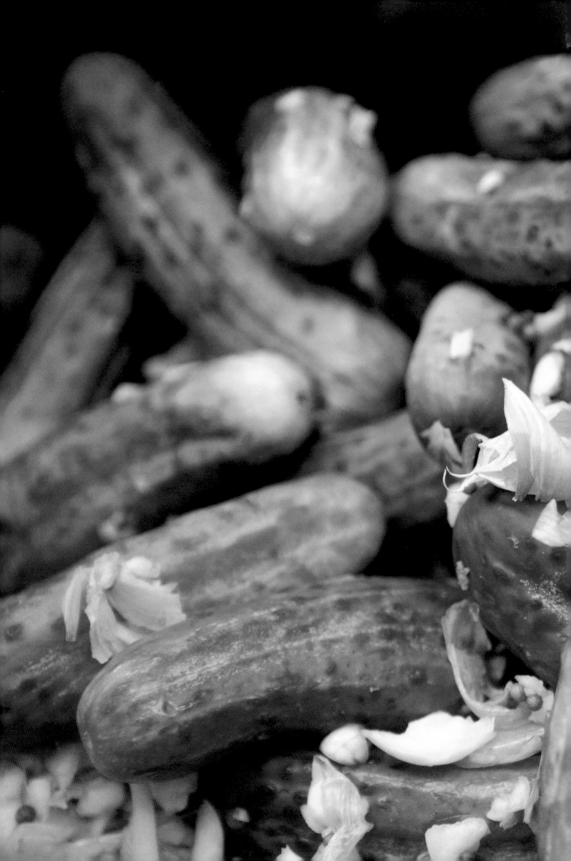

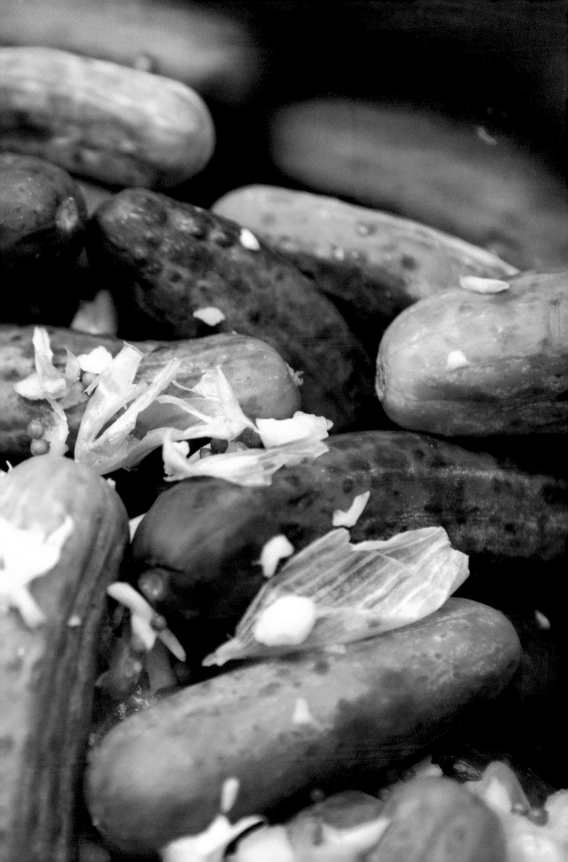

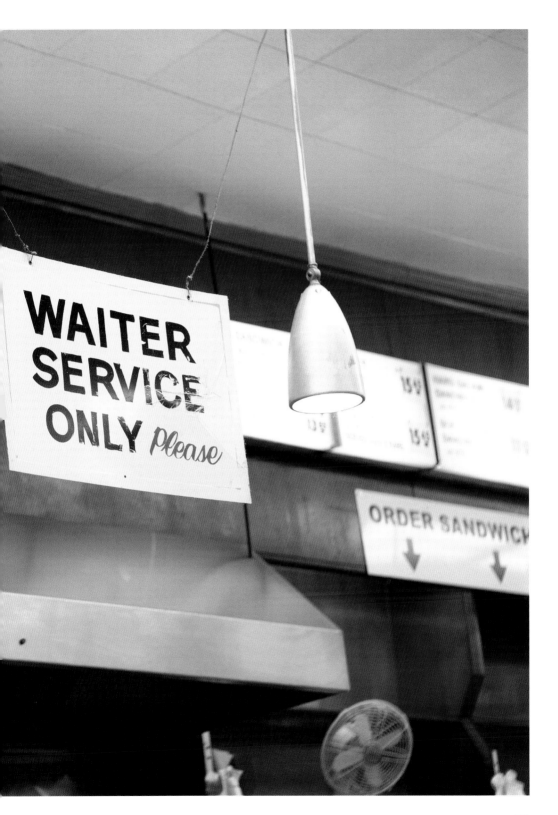

SANDWICHES
(RYE OR CLUB BREAD)

Hot Corned Beef ..
Hot Pastrami ..
Hot Brisket of Beef ..
Roast Beef ..
Tongue ..
Turkey ..
Salami ..
Bologna ...
Liverwurst ..
Chopped Liver ...
Garlic "Knobel" Wurst ..
Any Combination With Turkey ..
Any Other Combination ..
Home Made Tuna Salad ...
Home Made Chicken Salad ..
Home Made Egg Salad ..
Soup & Half Sandwich ...
Cold Heros ..

PLATTERS & SPECIALS
(WITH BREAD & PICKLES)

Assorted Meats ..
Assorted Meats & Turkey ..
Turkey ..
2 Hot Specials Bread & Pickles
Tuna Salad Platter ...
Egg Salad Platter ..
Chicken Salad Platter ..
Hot Open Turkey, Roast Beef or Brisket
Special Beef Stew, Chili ...

MEAT & EGG COMBINATIONS
(WITH FRENCH FRIES, BREAD & PICKLES)

Corned Beef & Eggs ...
Pastrami & Eggs ..
Tongue & Egg ...
Salami & Eggs ..
Bologna & Eggs ...
Lox, Eggs & Onions ...

BREAKFAST SPECIALS
(WEEKDAYS TILL 11:00 A.M. SAT. & SUN. TILL 11:30 A.M.) ALL WITH POTATOES, JUICE, COFFEE & TOAST

Eggs ..
Pancakes ..
French Toast ..
All Available with Home Made Sausage
Bagels, Cream Cheese & Lox ...
Cheese Blintzes ..
Fruit & Cheese Blintzes ..

KATZ'S D

ESTA

Houston

New

LUDLOW STREET

CATERING FO

Visit our Take Out Counter "Sen
Rent Out Katz's
Please Return All Tickets

- "A Delicatessen Since 1888"

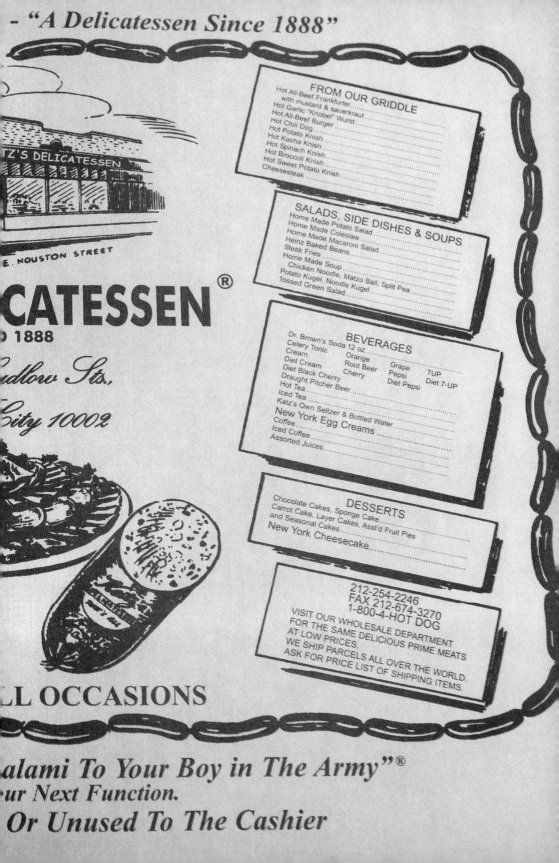

KATZ'S DELICATESSEN

E. HOUSTON STREET

CATESSEN ®

1888

...dlow Sts.

...ity 10002

FROM OUR GRIDDLE

Hot All-Beef Frankfurter
with mustard & sauerkraut
Hot Garlic "Knobel" Wurst
Hot All-Beef Burger
Hot Chili Dog
Hot Potato Knish
Hot Kasha Knish
Hot Spinach Knish
Hot Broccoli Knish
Hot Sweet Potato Knish
Cheesesteak

SALADS, SIDE DISHES & SOUPS

Home Made Potato Salad
Home Made Coleslaw
Home Made Macaroni Salad
Heinz Baked Beans
Steak Fries
Home Made Soup
Chicken Noodle, Matzo Ball, Split Pea
Potato Kugel, Noodle Kugel
Tossed Green Salad

BEVERAGES

Dr. Brown's Soda 12 oz.
Celery Tonic
Cream Orange Grape 7UP
Diet Cream Root Beer Pepsi Diet 7-UP
Diet Black Cherry Cherry Diet Pepsi
Draught Pitcher Beer
Hot Tea
Iced Tea
Katz's Own Seltzer & Bottled Water
New York Egg Creams
Coffee
Iced Coffee
Assorted Juices

DESSERTS

Chocolate Cakes, Sponge Cake
Carrot Cake, Layer Cakes, Asst'd Fruit Pies
and Seasonal Cakes
New York Cheesecake

212-254-2246
FAX 212-674-3270
1-800-4-HOT DOG
VISIT OUR WHOLESALE DEPARTMENT
FOR THE SAME DELICIOUS PRIME MEATS
AT LOW PRICES.
WE SHIP PARCELS ALL OVER THE WORLD.
ASK FOR PRICE LIST OF SHIPPING ITEMS.

...LL OCCASIONS

...alami To Your Boy in The Army" ®

...ur Next Function.

...Or Unused To The Cashier

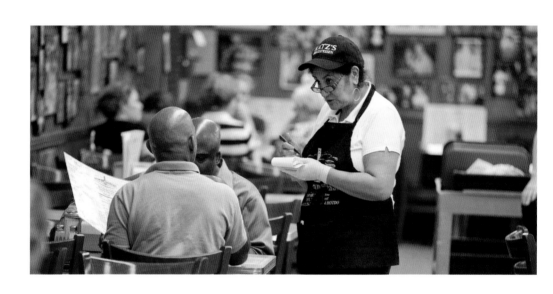

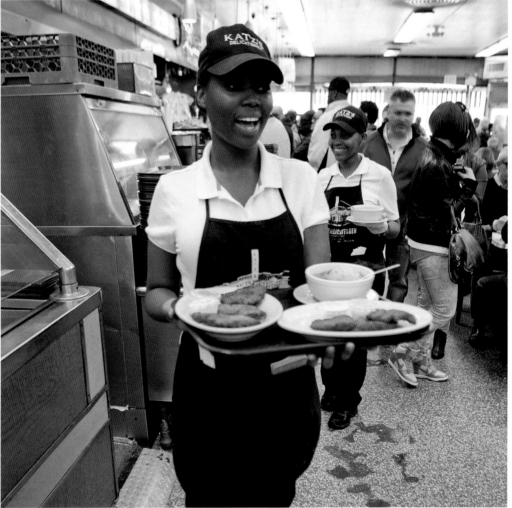

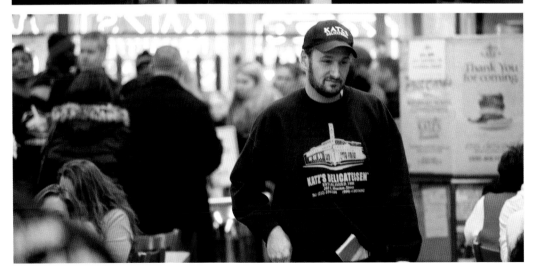

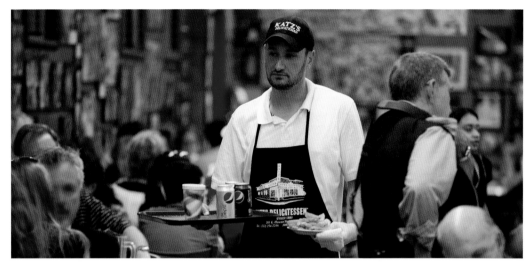

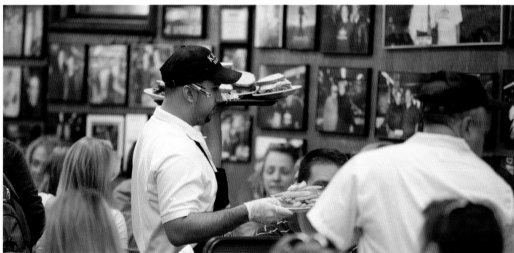

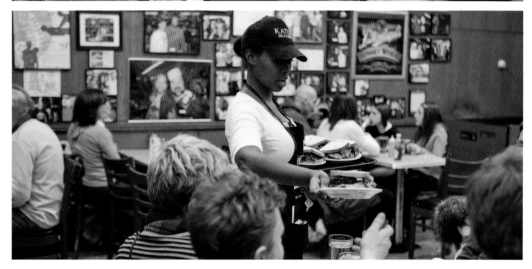

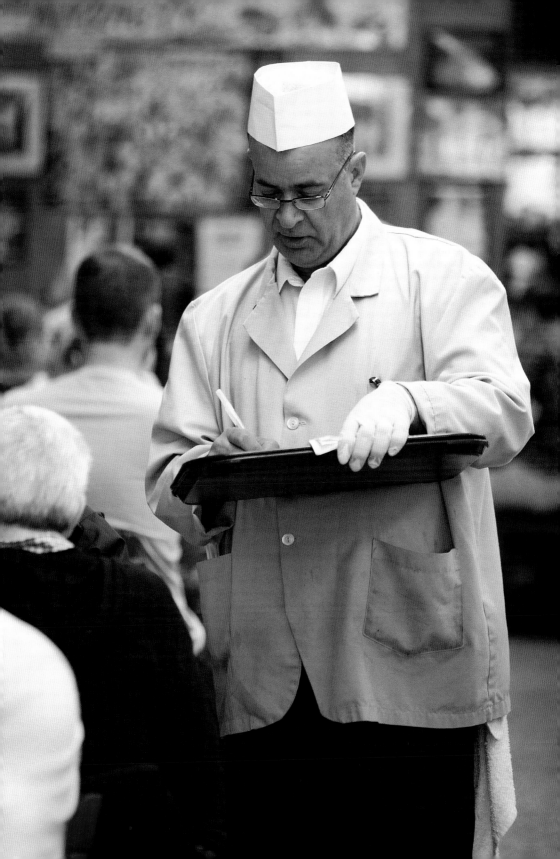

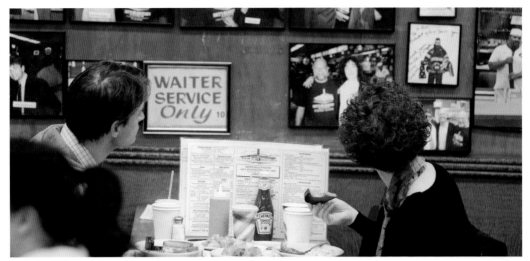

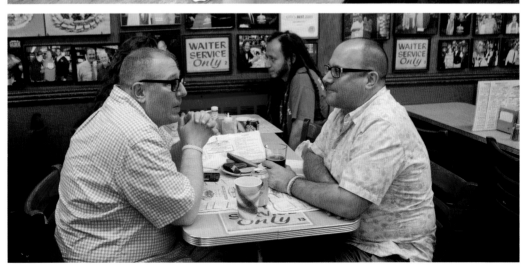

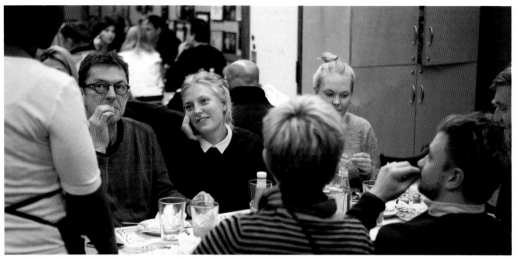

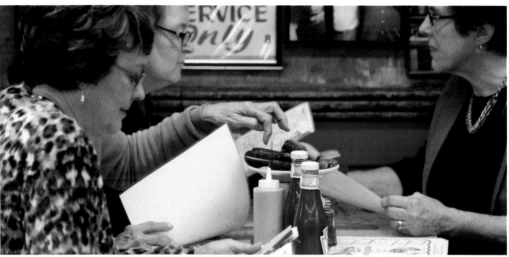

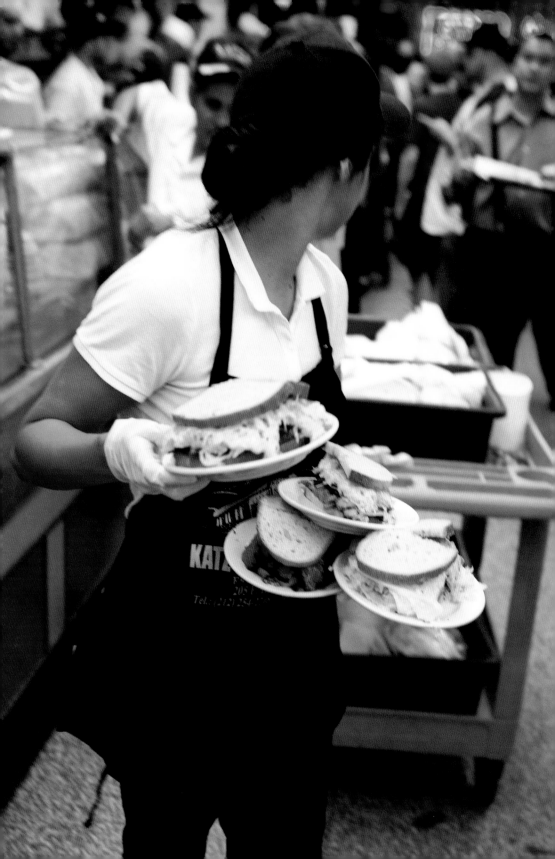

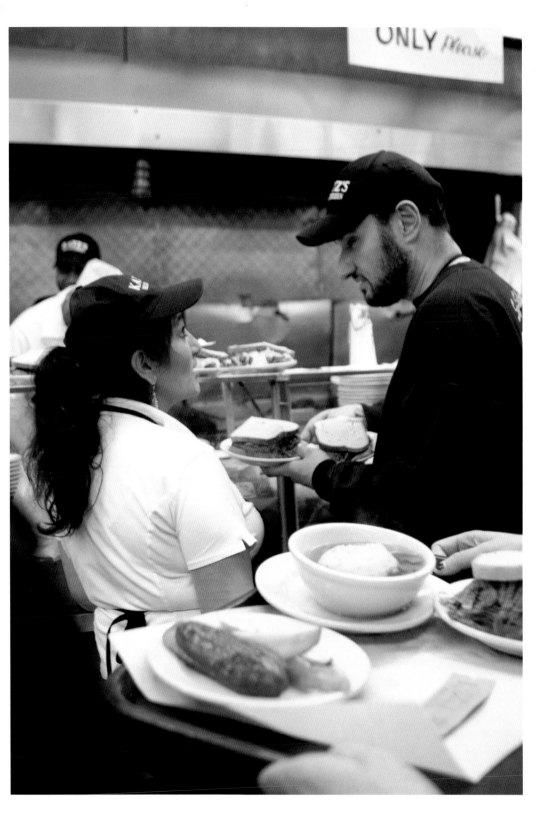

ONLY *Please*

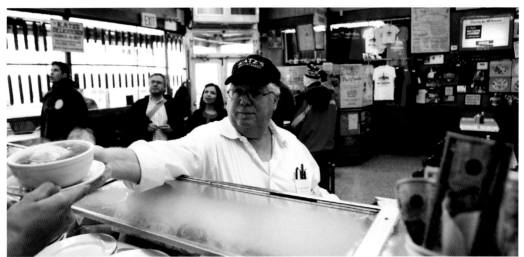

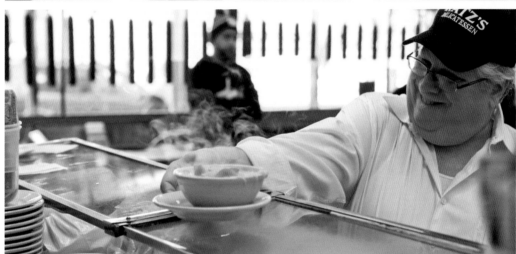

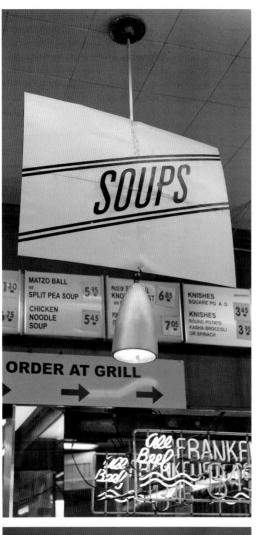

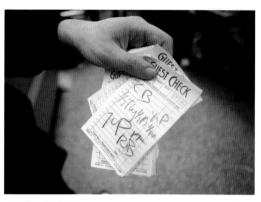

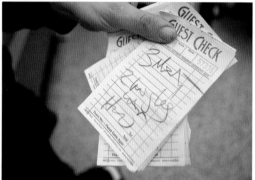

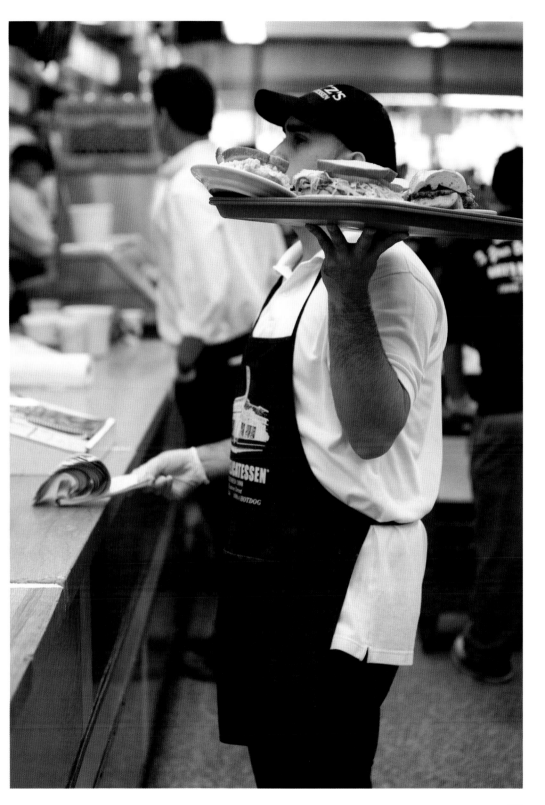

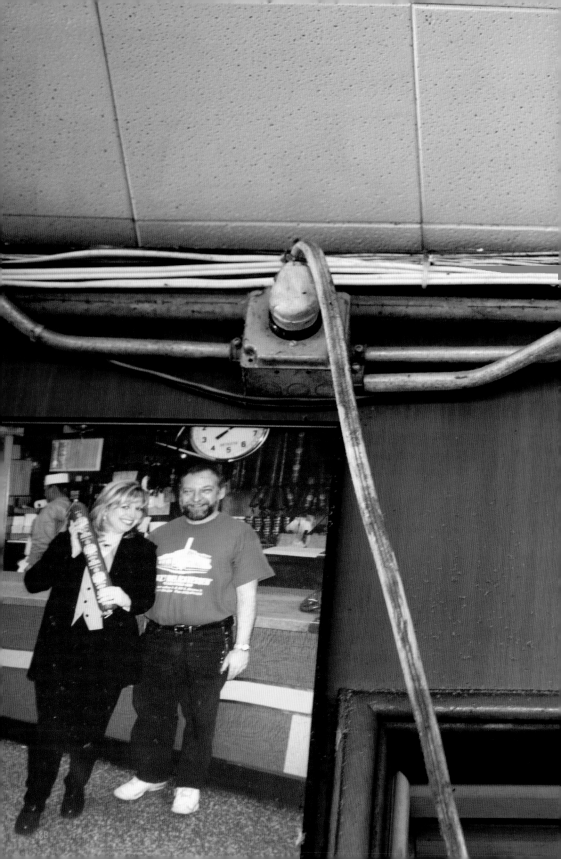

SERVICE
And
SELF SERVICE

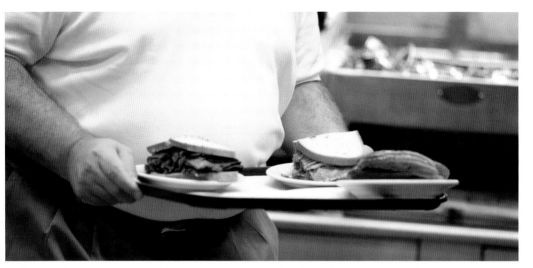

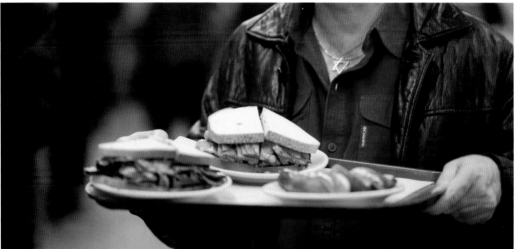

141

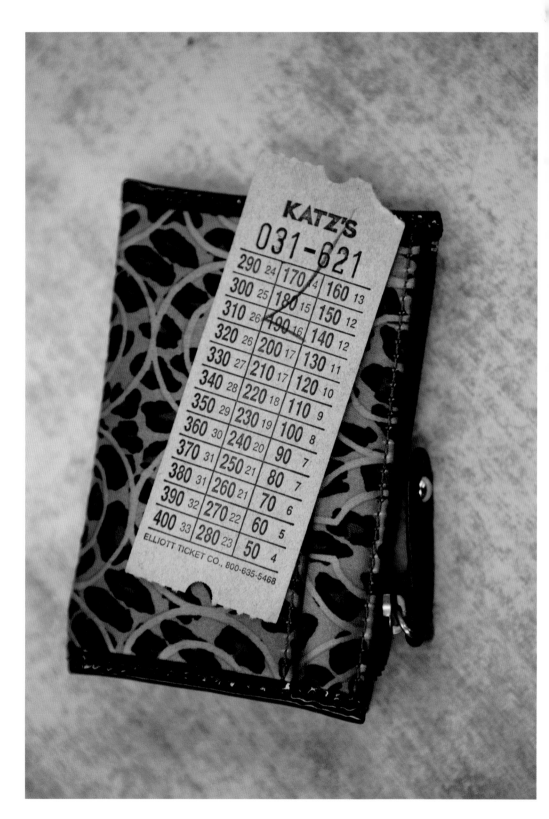

144

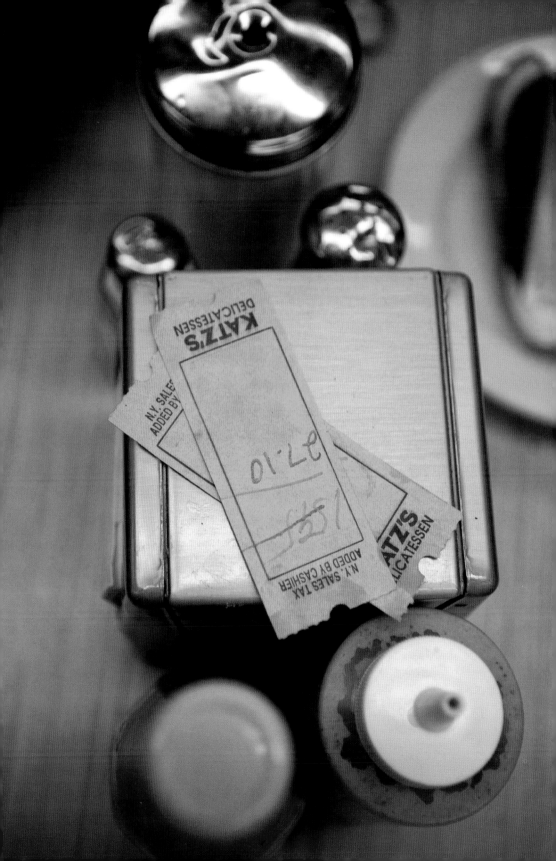

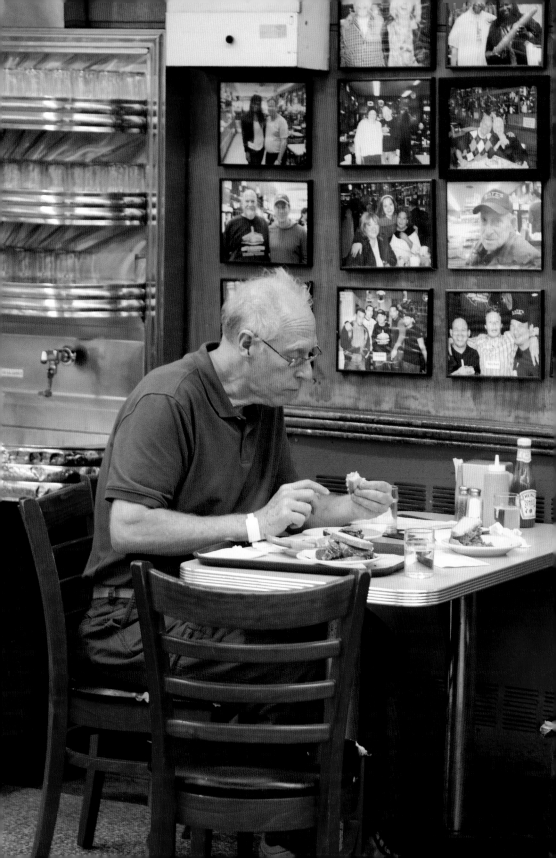

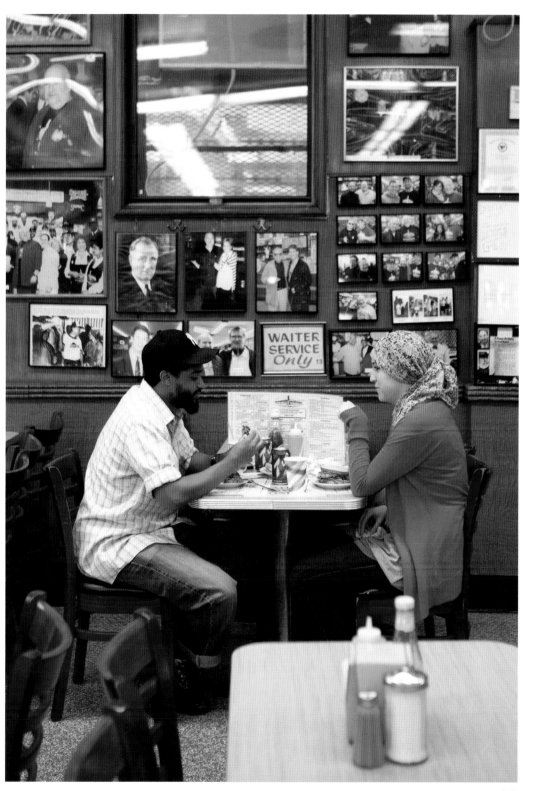

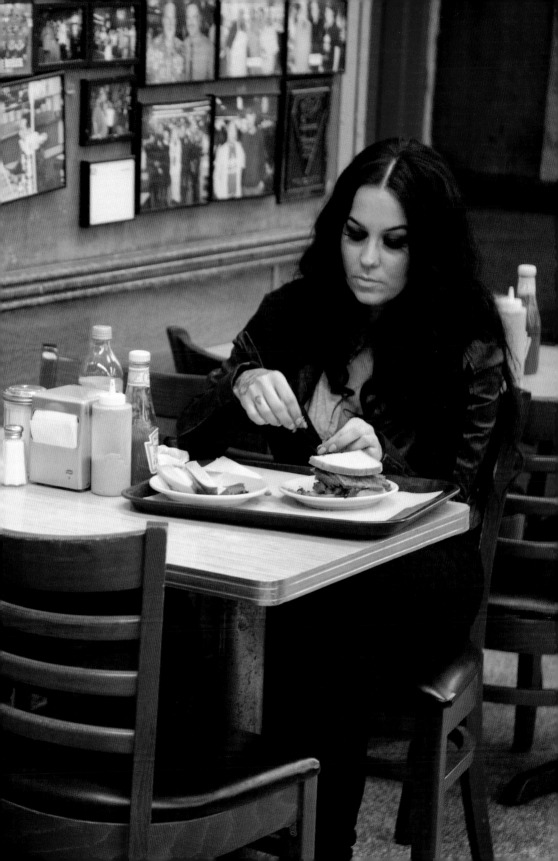

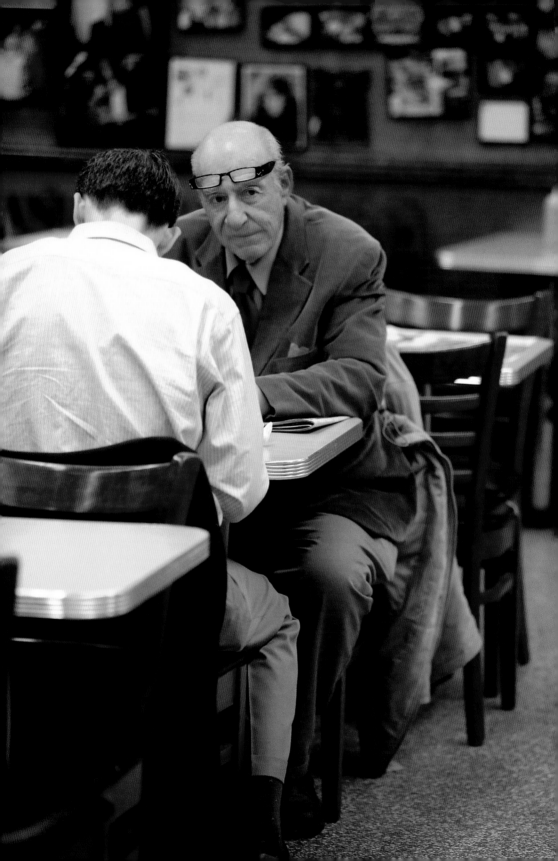

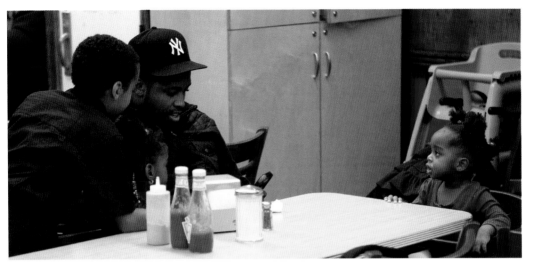

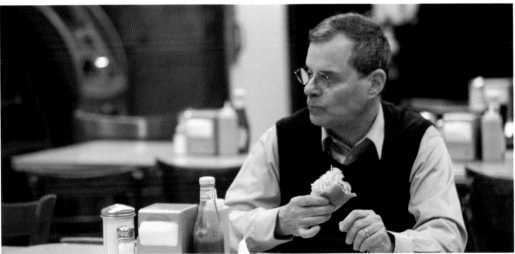

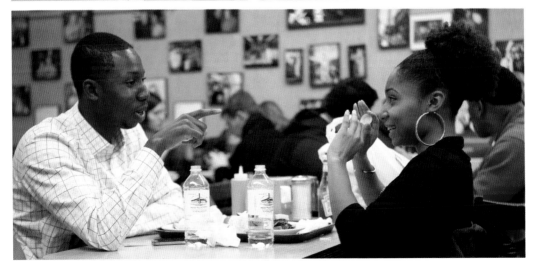

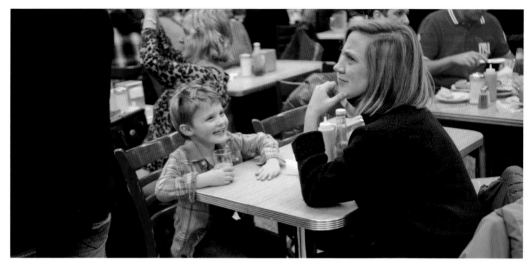

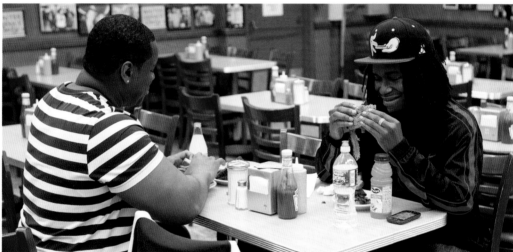

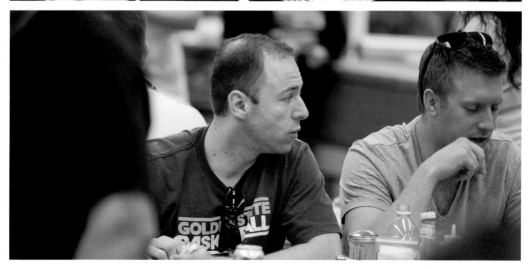

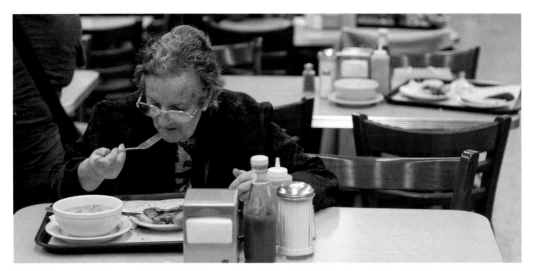

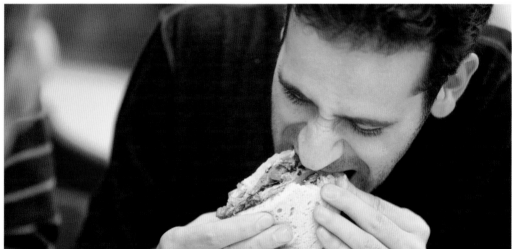

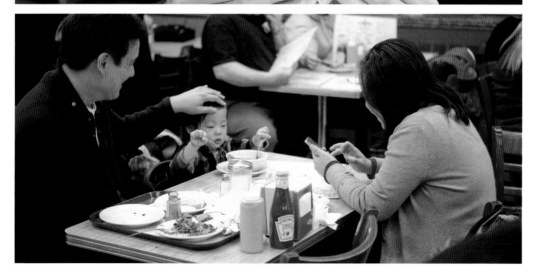

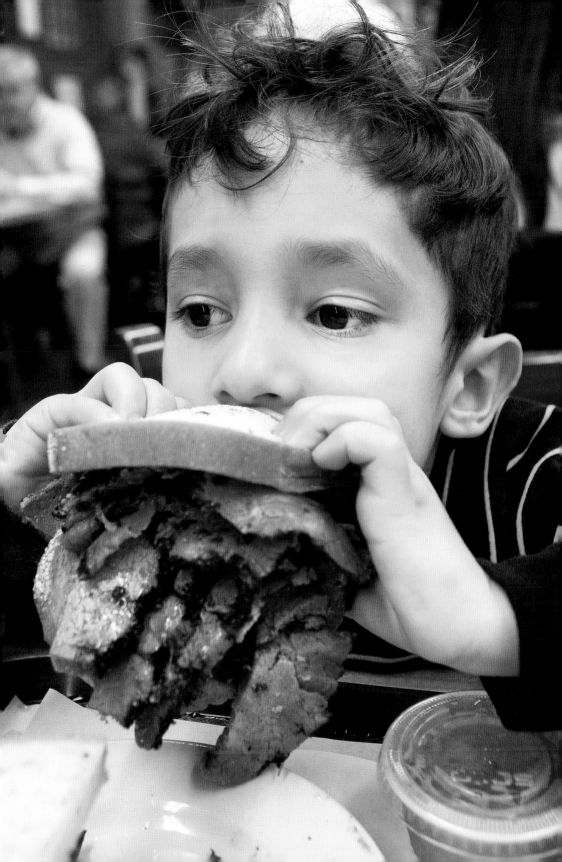

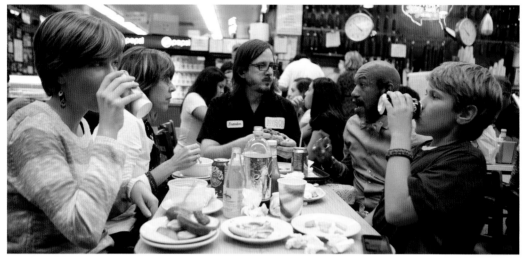

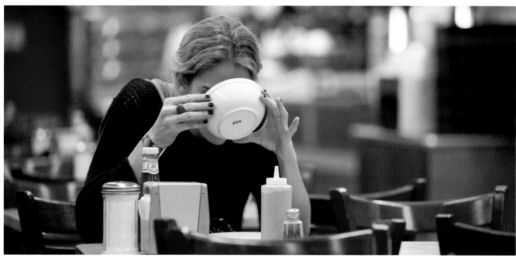

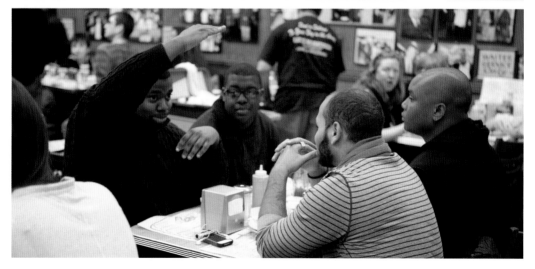

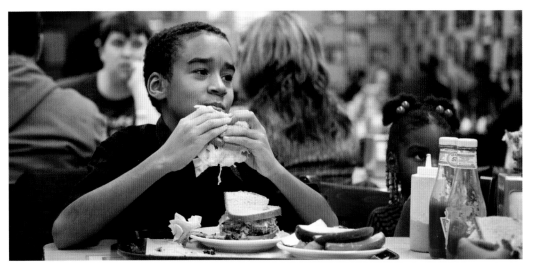

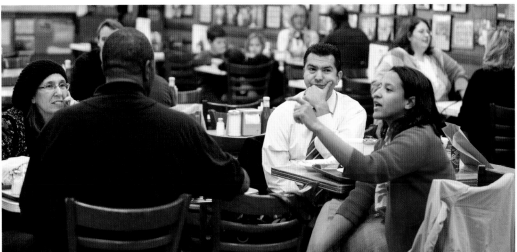

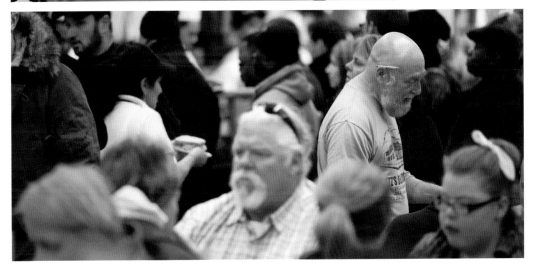

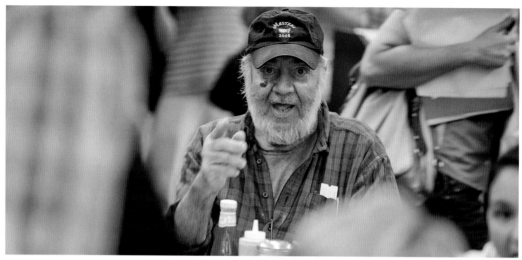

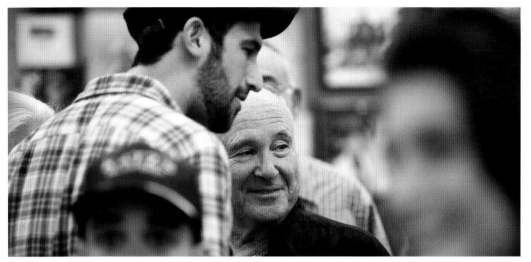

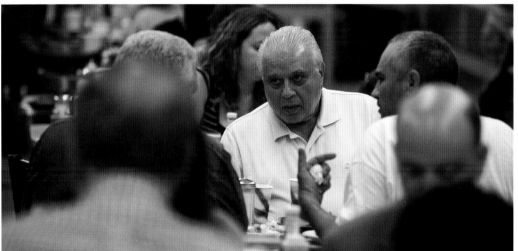

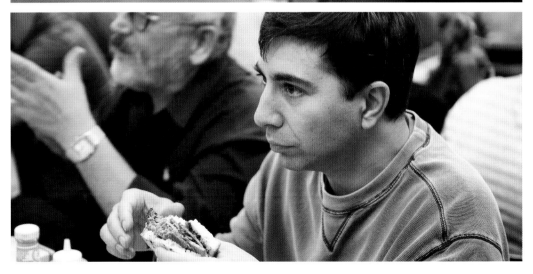

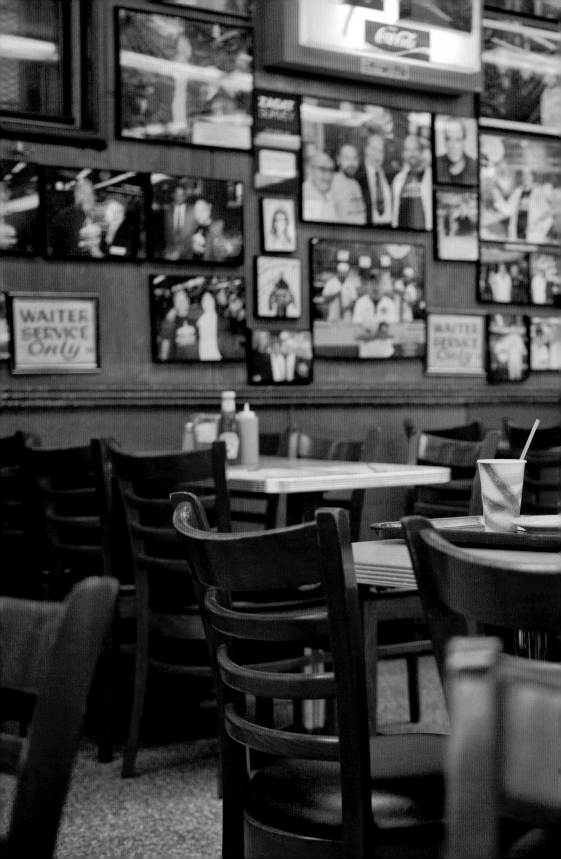

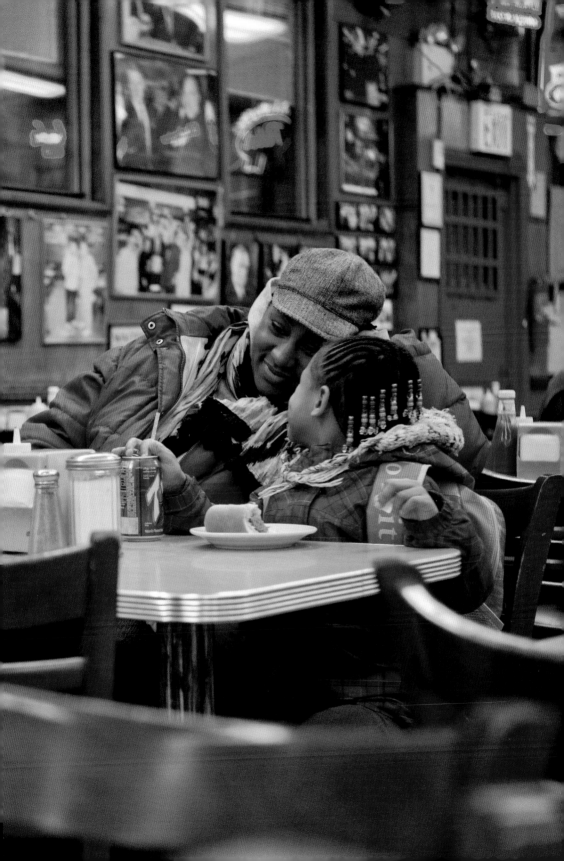

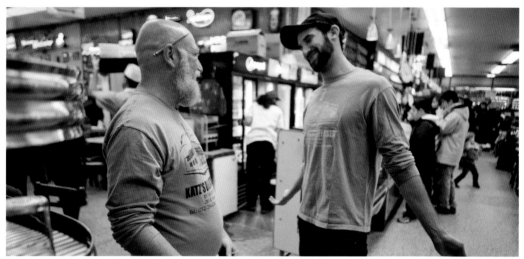

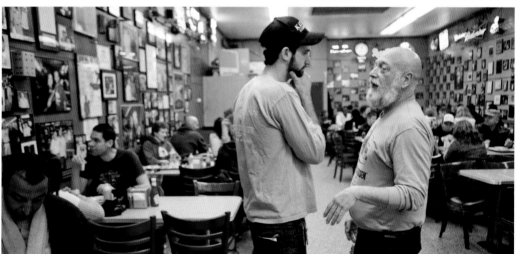

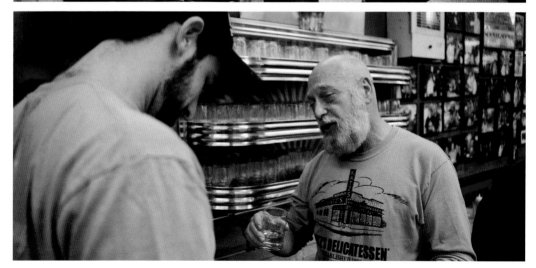

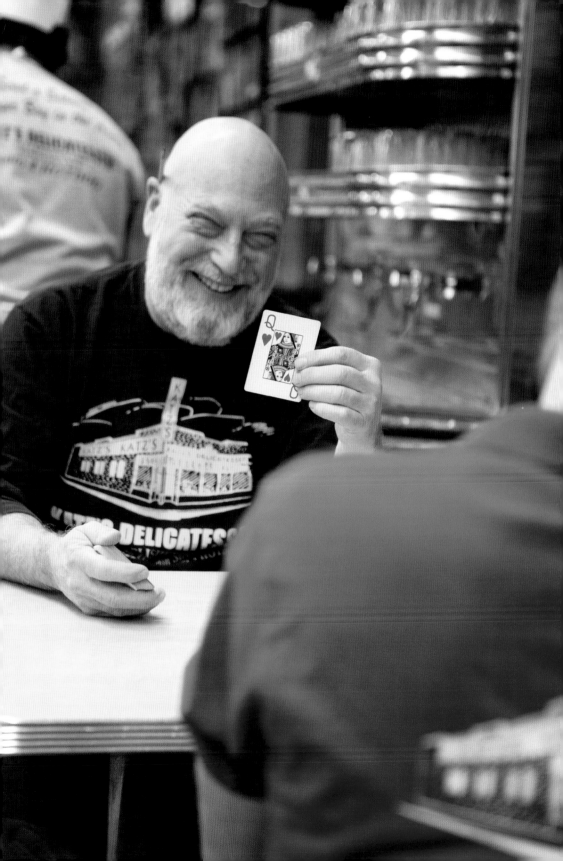

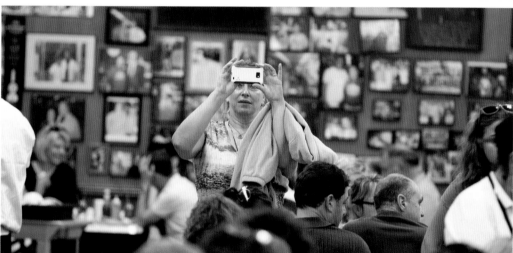

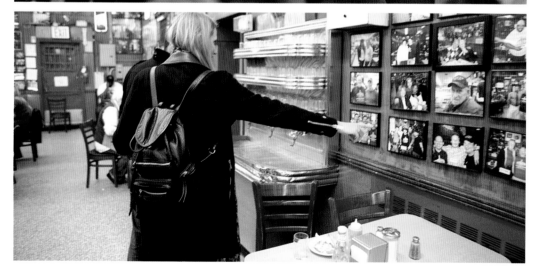

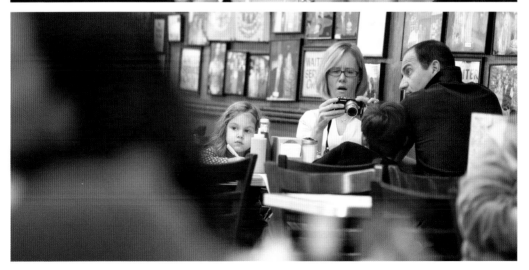

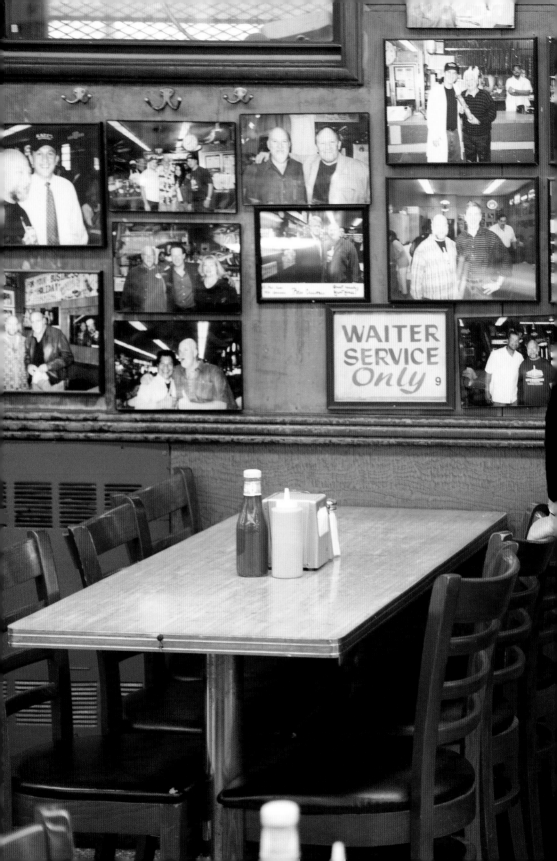

WAITER
SERVICE
Only 9

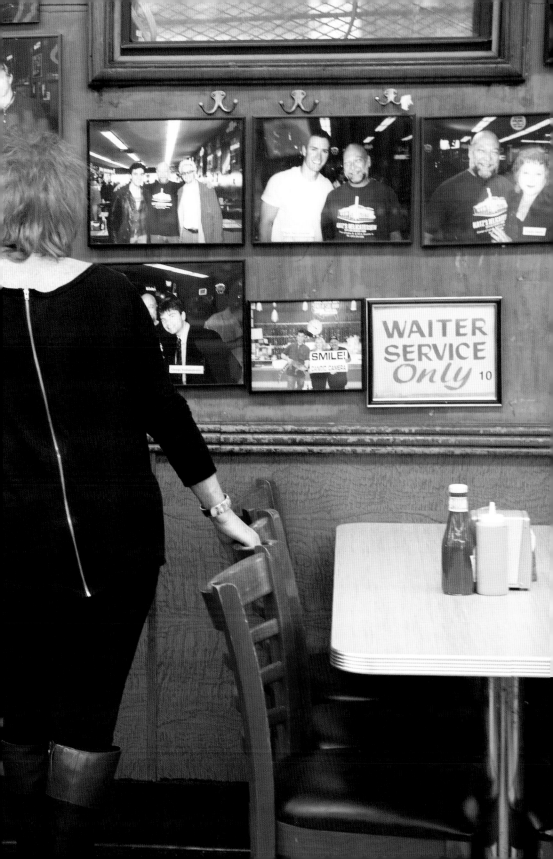

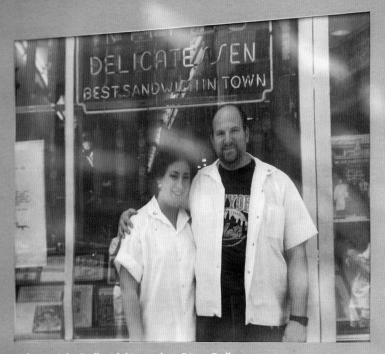

Above: Jake Dell with his mother, Diana Dell.
Below: Fred Austin and his wife, Juli Austin (Alan Dell's sister).

THE WALLS

Patrick Swayze

Judge Judy and Jerry Sheindlin

174

KATZ'S
205 E. Houston Street
(at Ludlow Street), Manhattan
(212) 254-2246

"Having a pastrami sandwich at Katz's is a quintessential New York experience."

—ROCCO DISPIRITO, UNION PACIFIC

Rocco DiSpirito at Katz's, having a 'quintessential New York experience.'

カッツ・デリカテッセン
Katz's Delicatessen

店の雰囲気も味わいたい、ジューシィなパストラミサンド

移民船が到着するエリス島から近距離にあるロウワーイーストサイドは、ニューヨーク移民史のなかで早くから開拓されてきた土地だ。このあたりには古い歴史に刻まれた老舗店がいくつかあるが、カッツ・デリカテッセンもそのひとつ。1888年にロシアから移民してきた一家によって始められ、ニューヨークで最も古いデリ、そして最も大きなデリとしてメジャーな存在であり続けている。

メニューは典型的な東欧のジューイッシュフードで、なかでも有名なのがこのパストラミ・サンドイッチだ。ホーム・メイドのジューシーなパストラミは、サーブする際のカットも熟練の技が要るという。まったくもって中身のほうがパンよりもボリューミーなアメリカンサイズのサンドイッチは、世界でもここだけでしか食べられない。創業者の末裔のロバートさんによれば「これまで何度となくフランチャイズしないか、という話はありましたが、品質もコントロールできないので断り続けてきました。カッツのサンドイッチはこの場所で食べてこそ」という。創業以来、ほとんど変わっていないというこの店の雰囲気もサンドイッチの大事な隠し味、なのである。

🏠205 East Houston Street, New York, NY 10002
☎(212) 254-2246
🚇2 AV
全日8時~22時45分（月～水）　8時~深夜2時45分（木）
8時~オールナイト（金）　8時~22時45分（日）　土曜日のみ24時間営業
休日　カード：A, D, M, V
http://katzsdelicatessen.com
MAP P101 F c-1

ライ麦パンのパストラミ・サンドイッチは映画『恋人たちの予感』にも登場。メグ・ライアン主演の同映画、聖人たちの予感にも登場している。

入口のロウワーイーストサイド博に在名なツアーイーストサイドへ、カウンターにて、注文方法

88年、100周年を頭に創始者一家はデリを手放したが、現在もなお創業当時の雰囲気を守りつつ経営が続けられている。

THANK YOU CHE
CAMP FALLUJAH. Al Anb

 Sunshine®

You Are Very Kind..

CHE

IRAQ

U.S.M.C.

Baked Snack Crackers

Hello, 2 JAN 08
I AM A US MARINE WRITING FROM
CAMP FALLUJAH, Al Anbar, Iraq.
A buddy got a stick of your
sausage in the mail today and
I had a knife. So, We cut it up
and before We were done We
had many new friends and they
were very nice to us until
the sausage was gone. THANK
You. THANK You. THANK You.
You made a delicious product
and you made many service
members happy this evening.
 Respectfully
THANKS AGAIN G.C. McLAIN
 US MARINE

LtCol McLain FREE
IIMEF(FWD) 6-3
Unit 75920
FPO AE
 09509

Katz's Delicatesse
205 E. Houston St
New York, NY
 10002

Paul Walker

John C. Reilly

Boy Scouts of America

lunch at
will not
New York

Brady
to the President
ss Secretary

WU-TANG

V.P. Al Gore

Believe It or Not!

Milla Jovovich

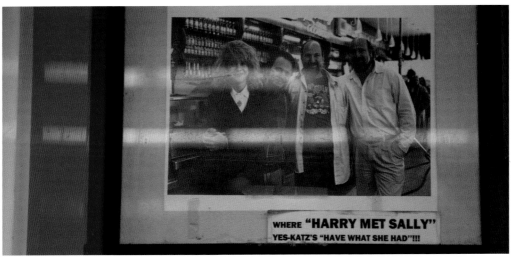

WHERE **"HARRY MET SALLY"**
YES-KATZ'S "HAVE WHAT SHE HAD"!!!

Mr.
Kat:
205
New

Mikhail Gorbachev

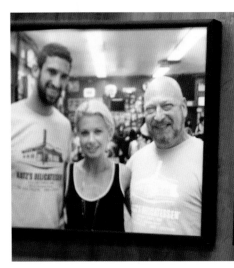

Mayor Bloomberg Mayor Koch

THE MOVIE VUER

A MONTHLY PROGRAM FOR THE MOVIE GOER

VOL. 1 NO. 5 MAY, 1971

ELLIOT GOULD AT BELLA'S BALL

Corned beef, knishes and pickles to the tune of $30 a head — and honored guest Bella Abzug — lit up Katz' delicatessen on the Lower East Side recently. It was Elliot Gould's and Jane Fonda's Ball for Bella to raise money for their favorite lady politician. Host Elliot Gould was there munching hot dogs in his Stetson hat with his young friend Jenny.

Nie wolno palic
VIETATO FUMARE
NEVALE RUKYT
TILOS A DOHÁNYZÁS
Rauchen Verboten
KADITI PREPOVEDANO
Es Prohibido Fumar
Воспрещается КУРИТЬ
DEFENSE de FUMER
ΑΠΑΓΟΡΕΥΕΤΑΙ ΤΟ ΚΑΠΝΙΣΜΑ
SIGARA İÇİLMEZ
RÖKNING FÖRBJUDES
RÖGNING FORBUDT
É Prohibido Fumar
Duhani Esht i Ndaluar
IN OTHER WORDS
NO SMOKING

Et bjerg af kod

Ron Jeremy

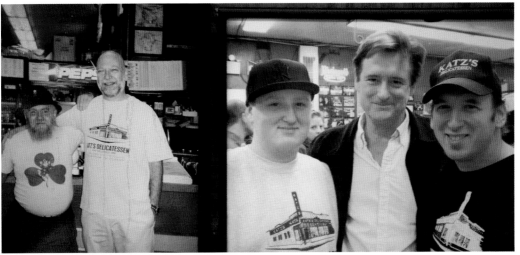

Spike Lee

Nick Cannon

Gilberto Santa Rosa

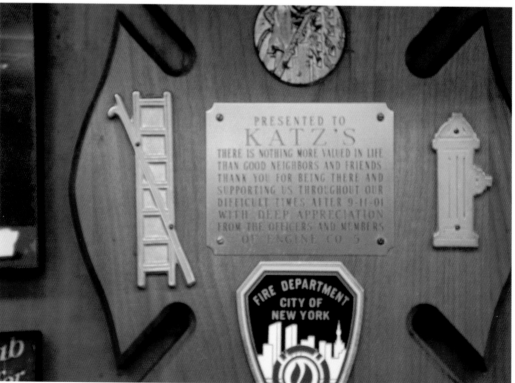

EVENING COMES *to* KATZ'S

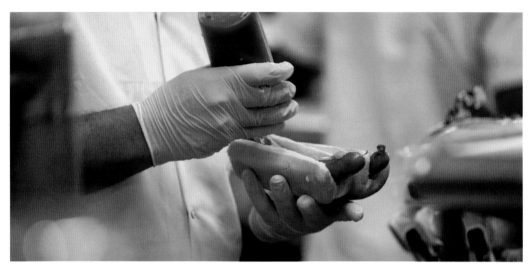

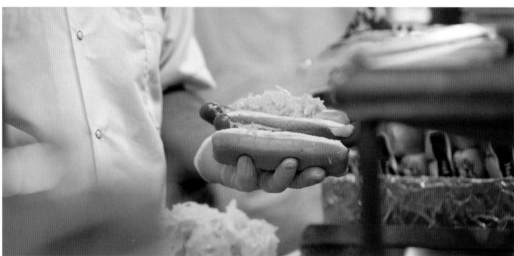

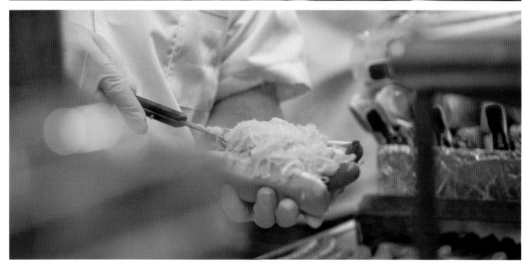

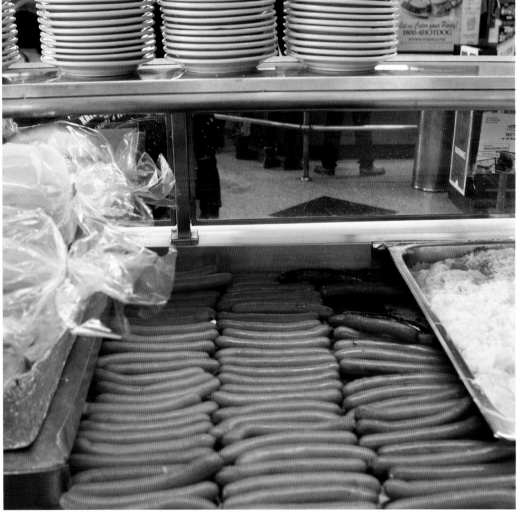

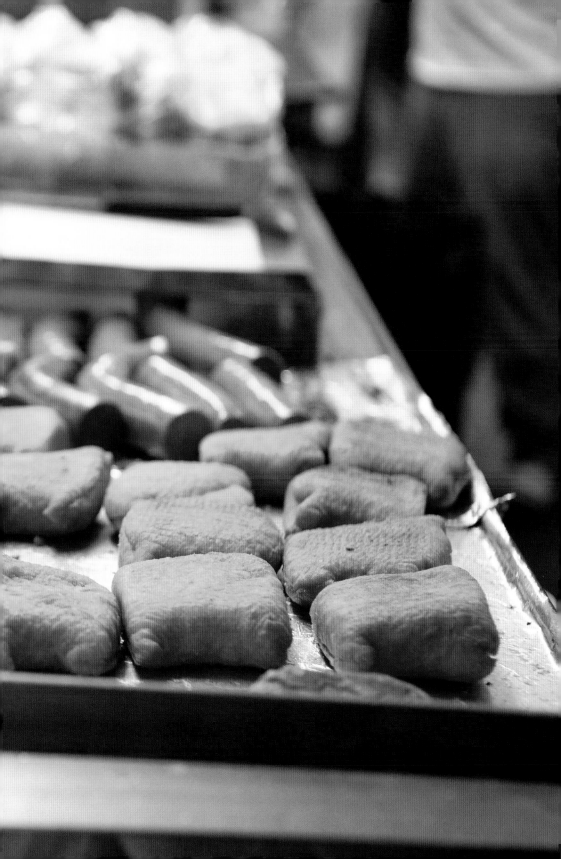

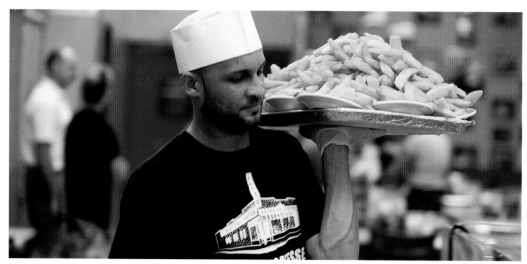

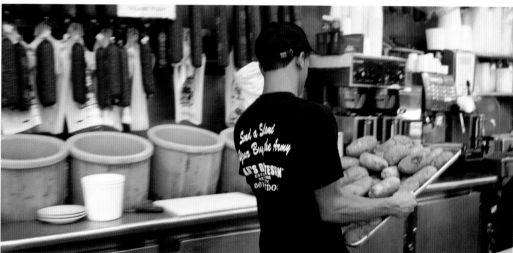

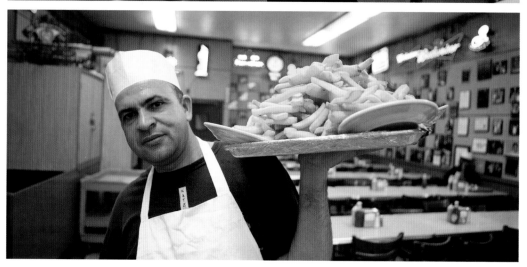

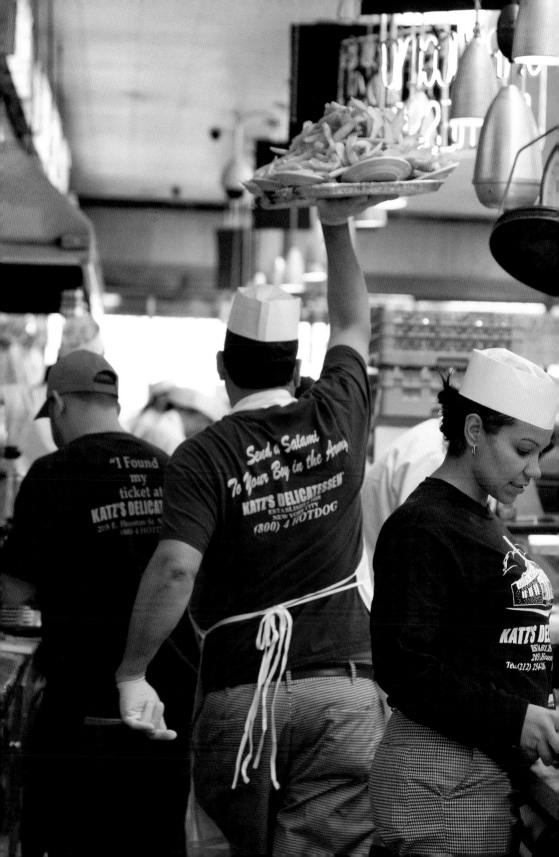

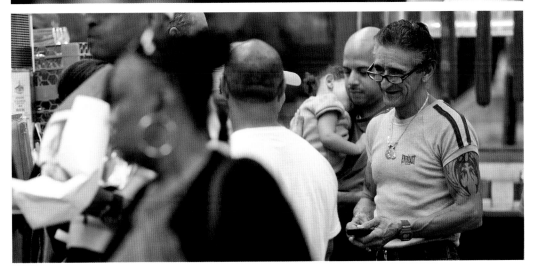

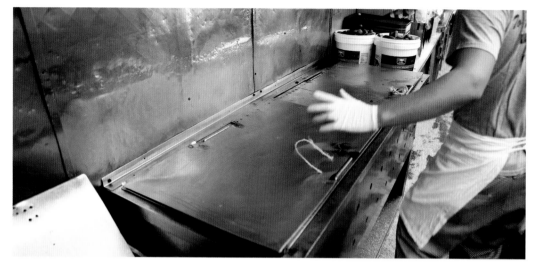

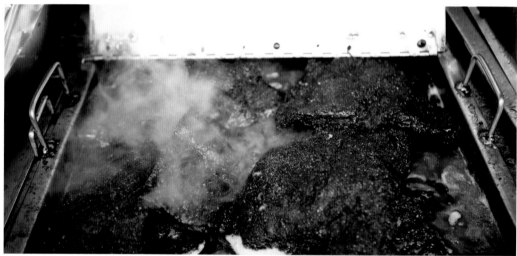

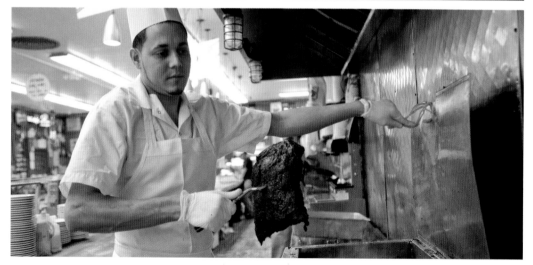

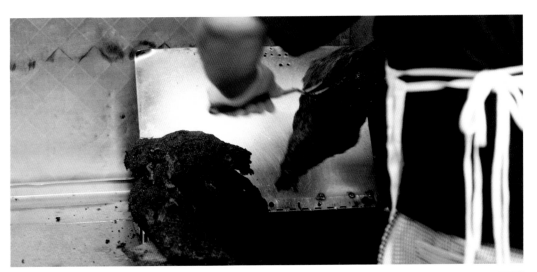

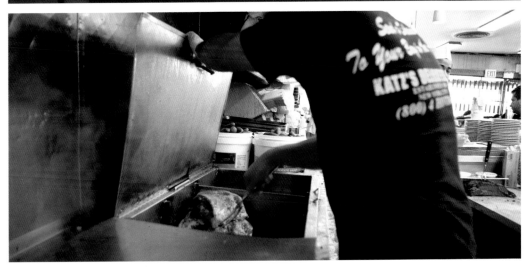

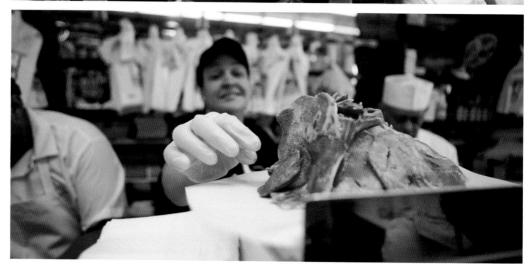

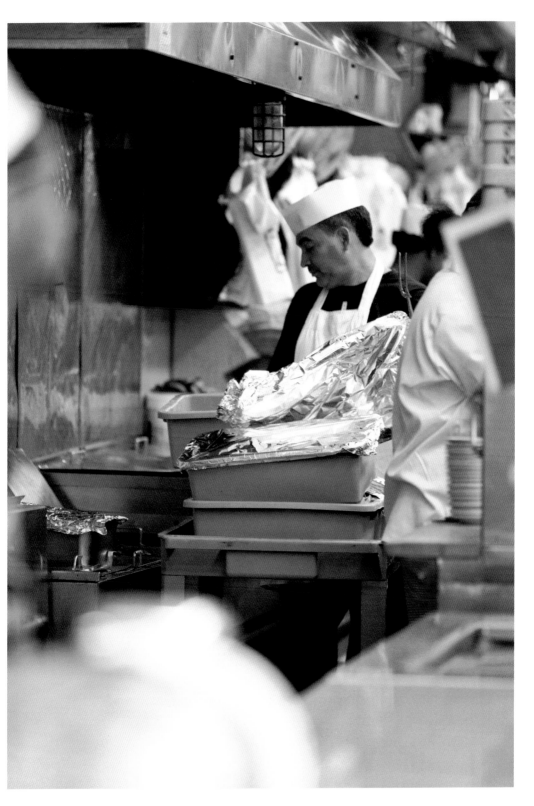

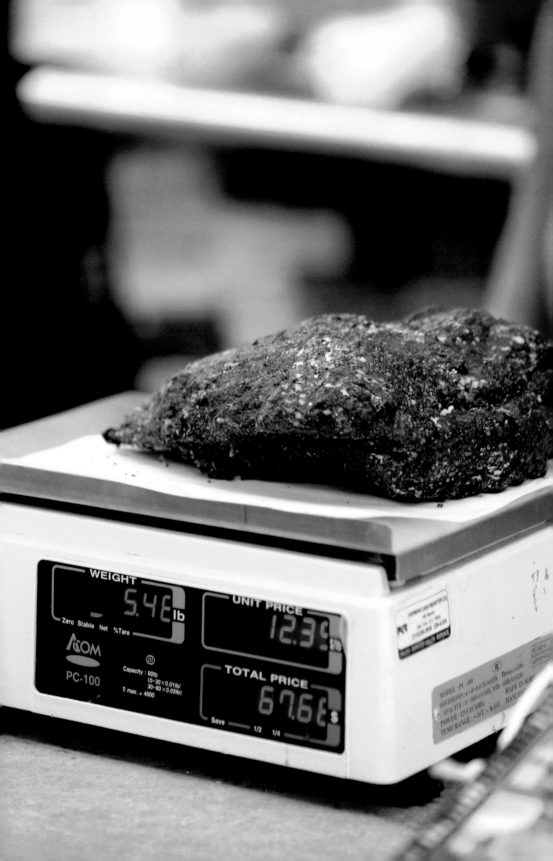

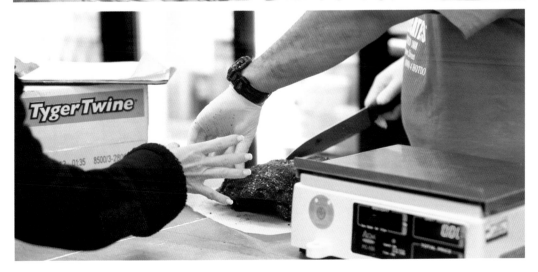

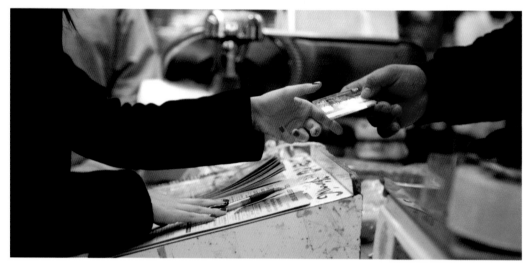

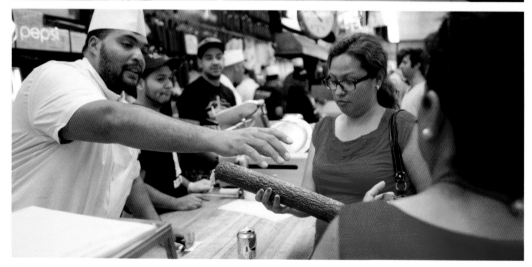

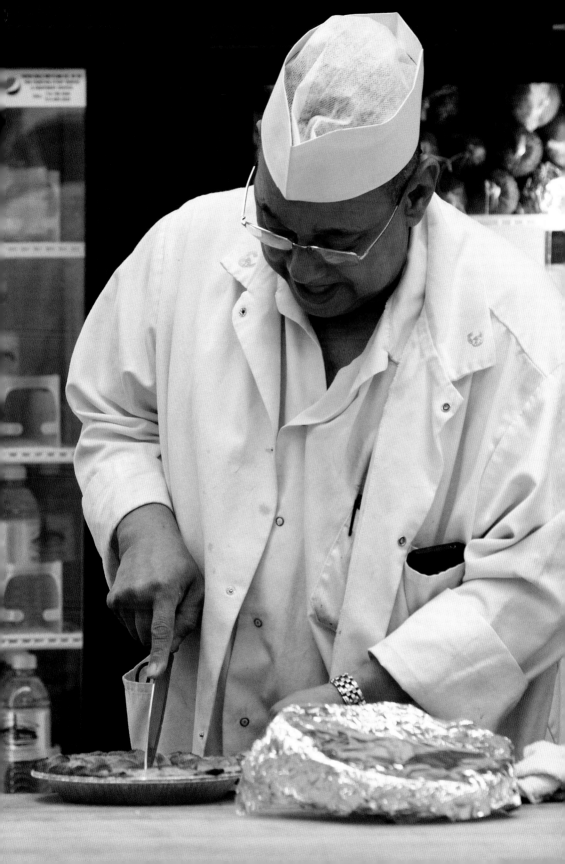

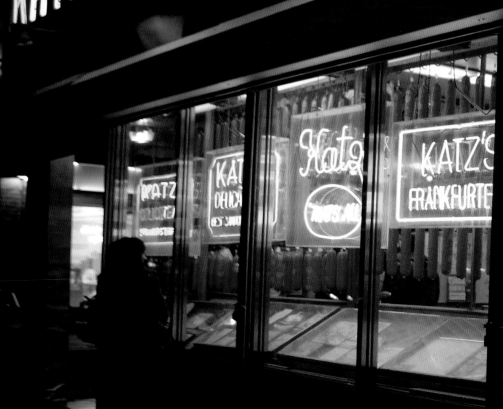

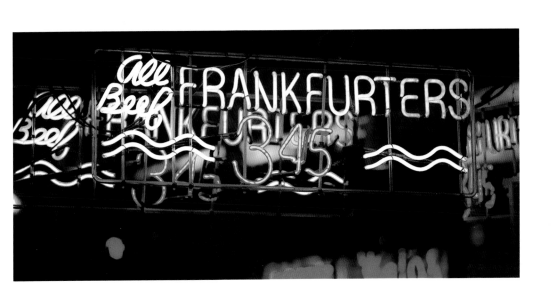

3:00 A.M.

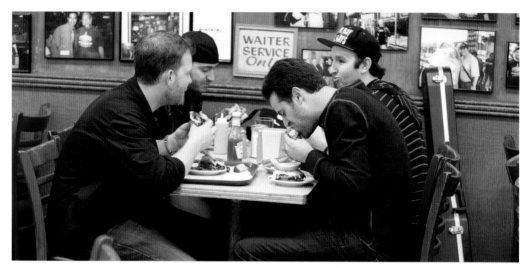

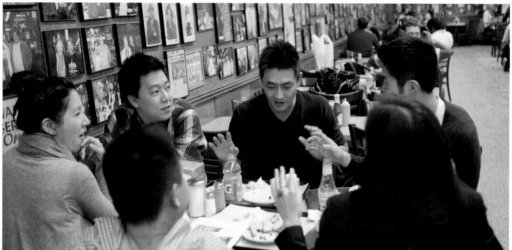

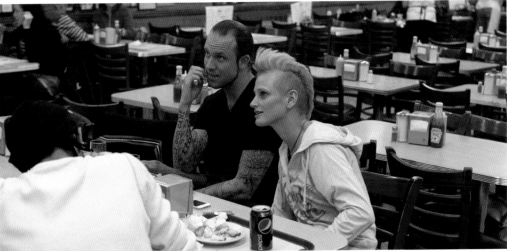

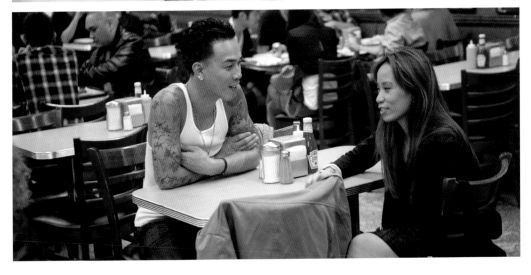

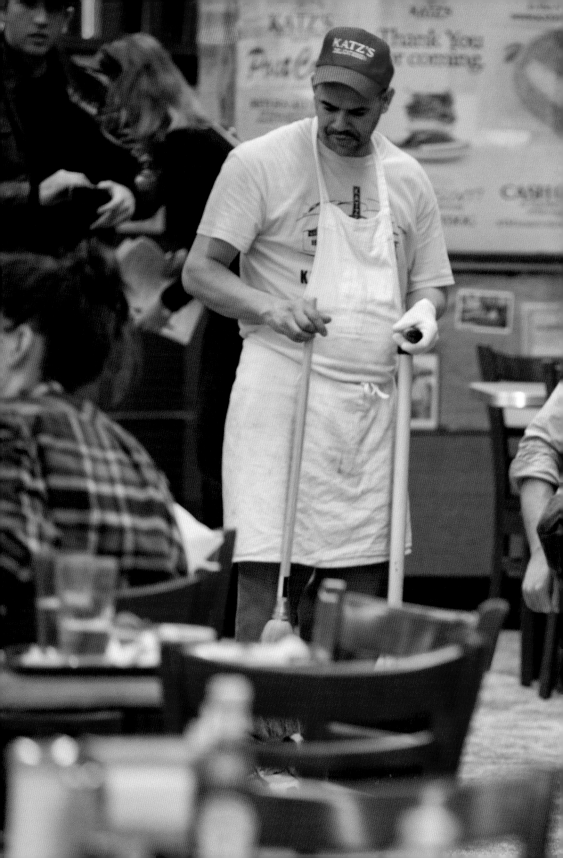

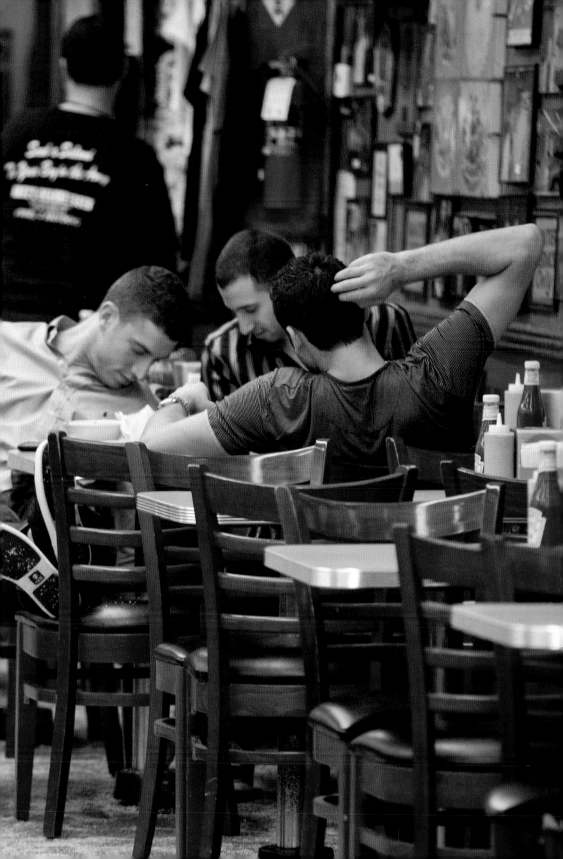

DECEMBER *at* KATZ'S

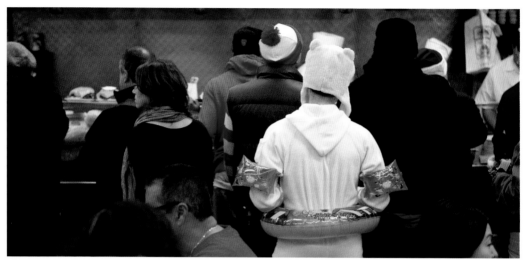

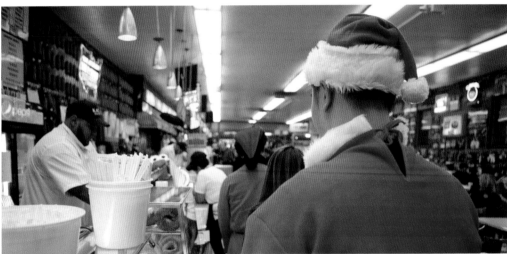

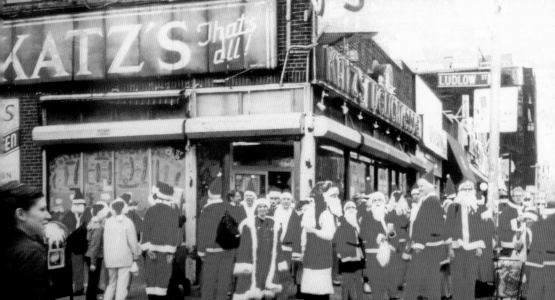

One day in December a class of first graders came to Katz's.
One of the kids asked if Santa ever came to the deli. I told him,
"No, it's a Jewish delicatessen." I forgot about Santacon!

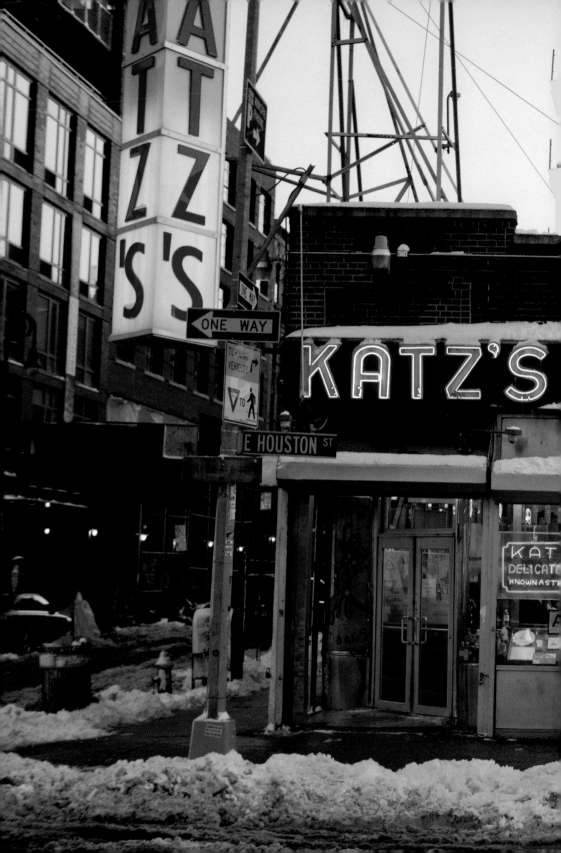

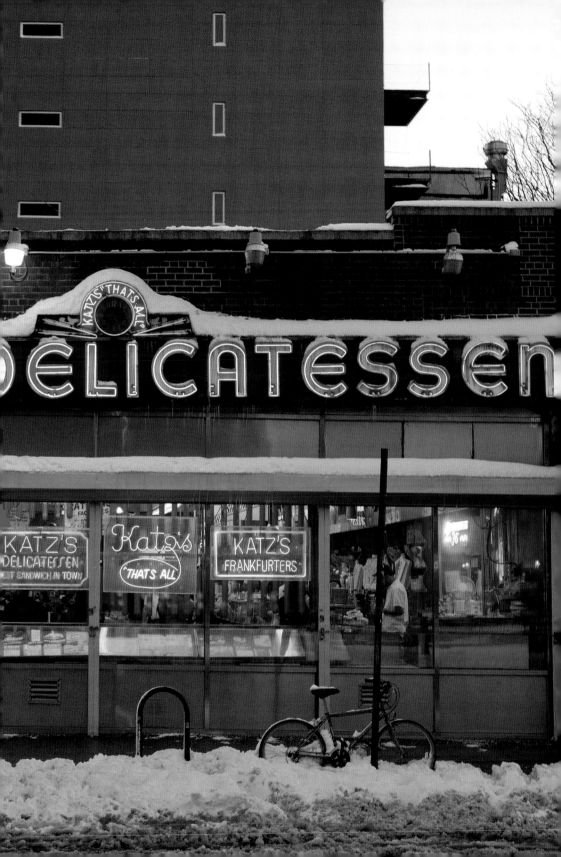

Catering

FOR ALL

ASIONS

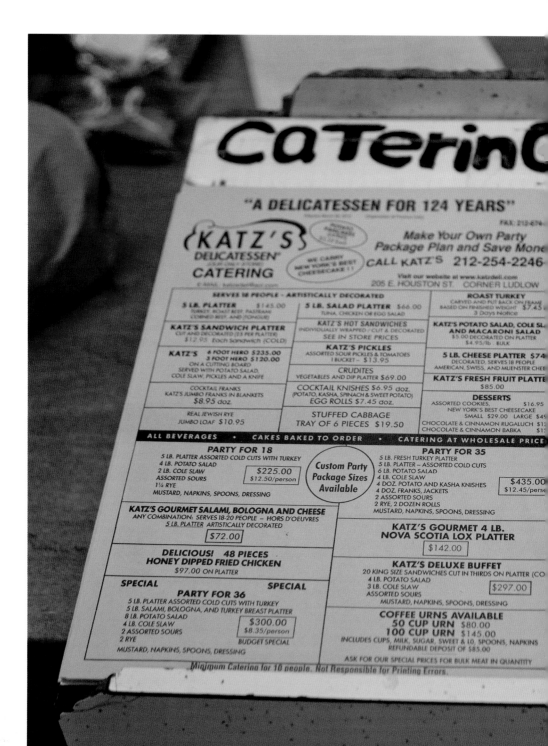

CaTerinG

"A DELICATESSEN FOR 124 YEARS"

FAX: 212-674-

KATZ'S DELICATESSEN CATERING

WE CARRY NEW YORK'S BEST CHEESECAKE!!

Make Your Own Party Package Plan and Save Mone

CALL KATZ'S 212-254-2246

Visit our website at www.katzdeli.com
205 E. HOUSTON ST. CORNER LUDLOW

SERVES 18 PEOPLE - ARTISTICALLY DECORATED		ROAST TURKEY
5 LB. PLATTER $145.00 TURKEY, ROAST BEEF, PASTRAMI CORNED BEEF, AND TONGUE	**5 LB. SALAD PLATTER** $66.00 TUNA, CHICKEN OR EGG SALAD	CARVED AND PUT BACK ON FRAME BASED ON FINISHED WEIGHT $7.45 3 Days Notice
KATZ'S SANDWICH PLATTER CUT AND DECORATED (15 PER PLATTER) $12.95 Each Sandwich (COLD)	**KATZ'S HOT SANDWICHES** INDIVIDUALLY WRAPPED / CUT & DECORATED SEE IN STORE PRICES	**KATZ'S POTATO SALAD, COLE SL AND MACARONI SALAD** $5.00 DECORATED ON PLATTER $4.95/lb - BULK
KATZ'S 6 FOOT HERO $235.00 3 FOOT HERO $120.00 ON A CUTTING BOARD SERVED WITH POTATO SALAD, COLE SLAW, PICKLES AND A KNIFE	**KATZ'S PICKLES** ASSORTED SOUR PICKLES & TOMATOES 1 BUCKET – $13.95	**5 LB. CHEESE PLATTER** $74 DECORATED, SERVES 18 PEOPLE AMERICAN, SWISS, AND MUENSTER CHEE
	CRUDITES VEGETABLES AND DIP PLATTER $69.00	**KATZ'S FRESH FRUIT PLATTE** $85.00
COCKTAIL FRANKS KATZ'S JUMBO FRANKS IN BLANKETS $8.95 doz.	**COCKTAIL KNISHES** $6.95 doz. (POTATO, KASHA, SPINACH & SWEET POTATO) **EGG ROLLS** $7.45 doz.	**DESSERTS** ASSORTED COOKIES $16.95 NEW YORK'S BEST CHEESECAKE SMALL $29.00 LARGE $49
REAL JEWISH RYE JUMBO LOAF $10.95	**STUFFED CABBAGE** TRAY OF 6 PIECES $19.50	CHOCOLATE & CINNAMON RUGALUCH $13 CHOCOLATE & CINNAMON BABKA $13

ALL BEVERAGES • CAKES BAKED TO ORDER • CATERING AT WHOLESALE PRICE

PARTY FOR 18
5 LB. PLATTER ASSORTED COLD CUTS WITH TURKEY
4 LB. POTATO SALAD
2 LB. COLE SLAW
ASSORTED SOURS
1¼ RYE
MUSTARD, NAPKINS, SPOONS, DRESSING

$225.00
$12.50/person

Custom Party Package Sizes Available

PARTY FOR 35
5 LB. FRESH TURKEY PLATTER
5 LB. PLATTER – ASSORTED COLD CUTS
6 LB. POTATO SALAD
4 LB. COLE SLAW
4 DOZ. POTATO AND KASHA KNISHES
4 DOZ. FRANKS, JACKETS
2 ASSORTED SOURS
2 RYE, 2 DOZEN ROLLS
MUSTARD, NAPKINS, SPOONS, DRESSING

$435.00
$12.45/perso

KATZ'S GOURMET SALAMI, BOLOGNA AND CHEESE
ANY COMBINATION: SERVES 18-20 PEOPLE – HORS D'OEUVRES
5 LB. PLATTER ARTISTICALLY DECORATED

$72.00

KATZ'S GOURMET 4 LB. NOVA SCOTIA LOX PLATTER
$142.00

DELICIOUS! 48 PIECES HONEY DIPPED FRIED CHICKEN
$97.00 ON PLATTER

KATZ'S DELUXE BUFFET
20 KING SIZE SANDWICHES CUT IN THIRDS ON PLATTER (CO
4 LB. POTATO SALAD
3 LB. COLE SLAW
ASSORTED SOURS
MUSTARD, NAPKINS, SPOONS, DRESSING

$297.00

SPECIAL PARTY FOR 36 SPECIAL
5 LB. PLATTER ASSORTED COLD CUTS WITH TURKEY
5 LB. SALAMI, BOLOGNA, AND TURKEY BREAST PLATTER
8 LB. POTATO SALAD
4 LB. COLE SLAW
2 ASSORTED SOURS
2 RYE
MUSTARD, NAPKINS, SPOONS, DRESSING

$300.00
$8.35/person
BUDGET SPECIAL

COFFEE URNS AVAILABLE
50 CUP URN $80.00
100 CUP URN $145.00
INCLUDES CUPS, MILK, SUGAR, SWEET & LO, SPOONS, NAPKINS
REFUNDABLE DEPOSIT OF $85.00

ASK FOR OUR SPECIAL PRICES FOR BULK MEAT IN QUANTITY

Minimum Catering for 10 people. Not Responsible for Printing Errors.

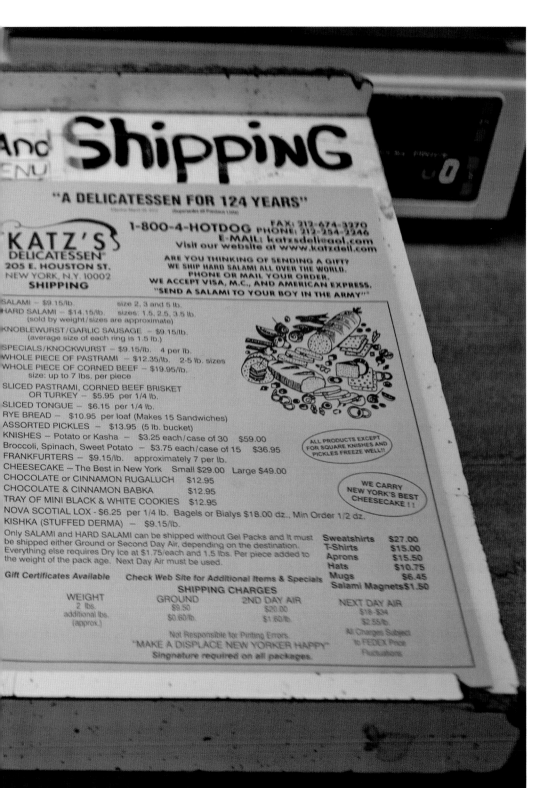

SHIPPING

"A DELICATESSEN FOR 124 YEARS"

FAX: 212-674-3270
1-800-4-HOTDOG PHONE: 212-254-2246
E-MAIL: katzsdeli@aol.com
Visit our website at www.katzdeli.com

KATZ'S DELICATESSEN
205 E. HOUSTON ST.
NEW YORK, N.Y. 10002
SHIPPING

ARE YOU THINKING OF SENDING A GIFT?
WE SHIP HARD SALAMI ALL OVER THE WORLD.
PHONE OR MAIL YOUR ORDER.
WE ACCEPT VISA, M.C., AND AMERICAN EXPRESS.
"SEND A SALAMI TO YOUR BOY IN THE ARMY"

SALAMI — $9.15/lb. size 2, 3 and 5 lb.
HARD SALAMI — $14.15/lb. sizes: 1.5, 2.5, 3.5 lb.
 (sold by weight/sizes are approximate)
KNOBLEWURST/GARLIC SAUSAGE — $9.15/lb.
 (average size of each ring is 1.5 lb.)
SPECIALS/KNOCKWURST — $9.15/lb. 4 per lb.
WHOLE PIECE OF PASTRAMI — $12.35/lb. 2-5 lb. sizes
WHOLE PIECE OF CORNED BEEF — $19.95/lb.
 size: up to 7 lbs. per piece
SLICED PASTRAMI, CORNED BEEF BRISKET
 OR TURKEY — $5.95 per 1/4 lb.
SLICED TONGUE — $6.15 per 1/4 lb.
RYE BREAD — $10.95 per loaf (Makes 15 Sandwiches)
ASSORTED PICKLES — $13.95 (5 lb. bucket)
KNISHES — Potato or Kasha — $3.25 each/case of 30 $59.00
Broccoli, Spinach, Sweet Potato — $3.75 each/case of 15 $36.95
FRANKFURTERS — $9.15/lb. approximately 7 per lb.
CHEESECAKE — The Best in New York Small $29.00 Large $49.00
CHOCOLATE or CINNAMON RUGALUCH $12.95
CHOCOLATE & CINNAMON BABKA $12.95
TRAY OF MINI BLACK & WHITE COOKIES $12.95
NOVA SCOTIAL LOX - $6.25 per 1/4 lb. Bagels or Bialys $18.00 dz., Min Order 1/2 dz.
KISHKA (STUFFED DERMA) — $9.15/lb.

ALL PRODUCTS EXCEPT
FOR SQUARE KNISHES AND
PICKLES FREEZE WELL!!

WE CARRY
NEW YORK'S BEST
CHEESECAKE!!

Only SALAMI and HARD SALAMI can be shipped without Gel Packs and It must
be shipped either Ground or Second Day Air, depending on the destination.
Everything else requires Dry Ice at $1.75/each and 1.5 lbs. Per piece added to
the weight of the pack age. Next Day Air must be used.

Sweatshirts $27.00
T-Shirts $15.00
Aprons $15.50
Hats $10.75
Mugs $6.45
Salami Magnets $1.50

Gift Certificates Available Check Web Site for Additional Items & Specials

SHIPPING CHARGES

WEIGHT	GROUND	2ND DAY AIR	NEXT DAY AIR
2 lbs.	$9.50	$20.00	$18-$34
additional lbs.	$0.60/lb.	$1.60/lb.	$2.55/lb.
(approx.)			

Not Responsible for Printing Errors.
"MAKE A DISPLACE NEW YORKER HAPPY"
Singnature required on all packages.

All Charges Subject
to FEDEX Price
Fluctuations.

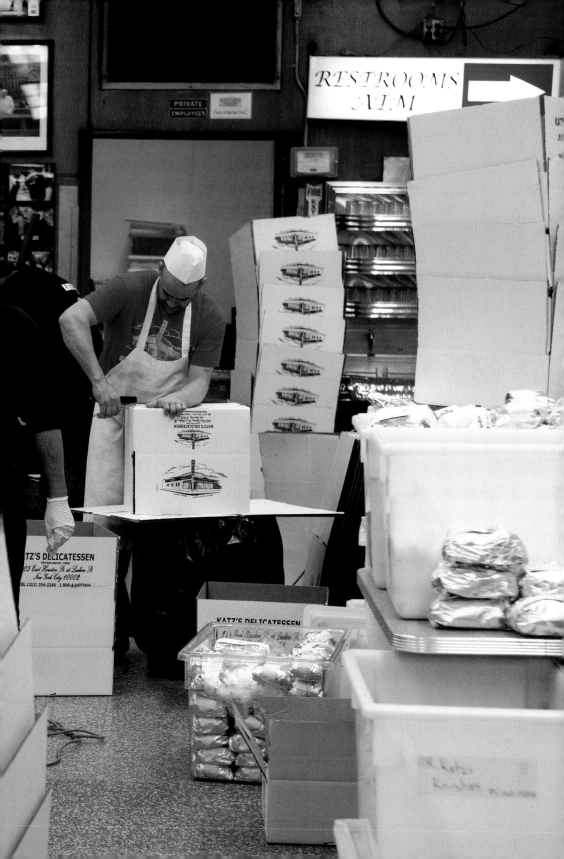

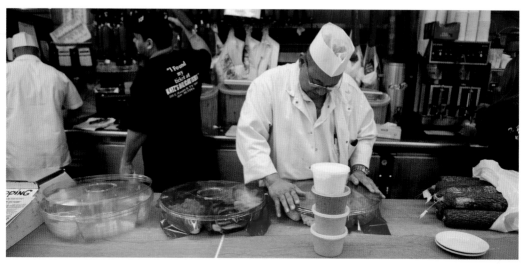

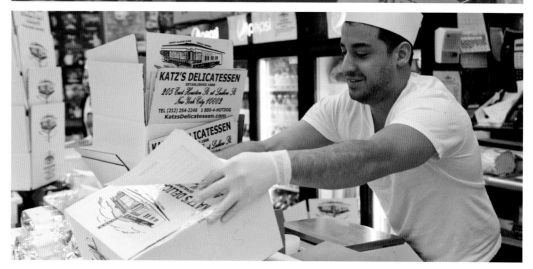

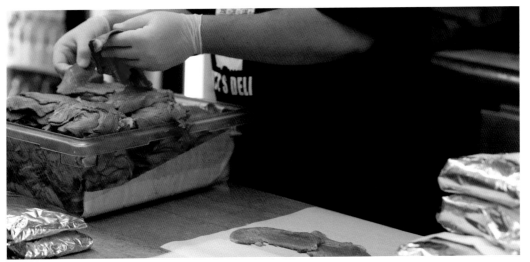

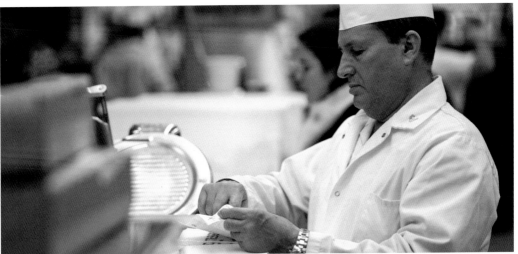

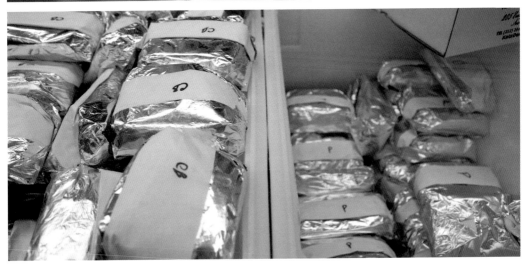

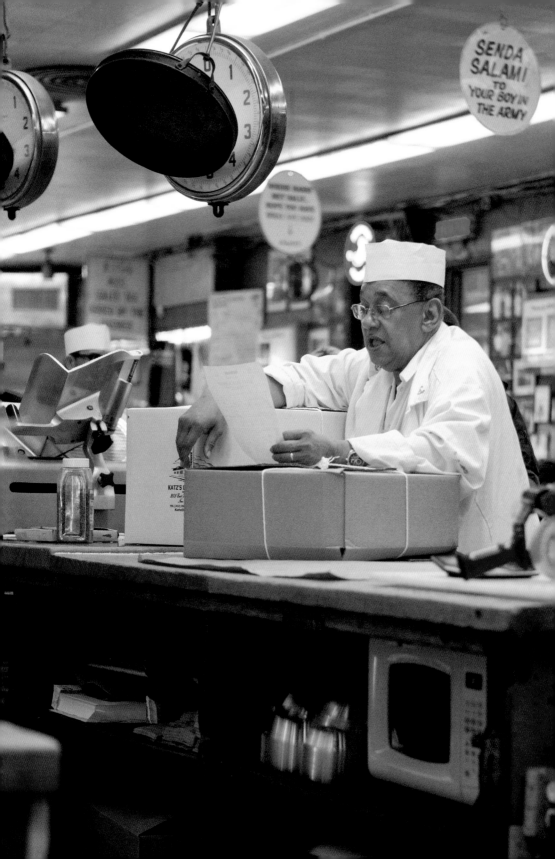

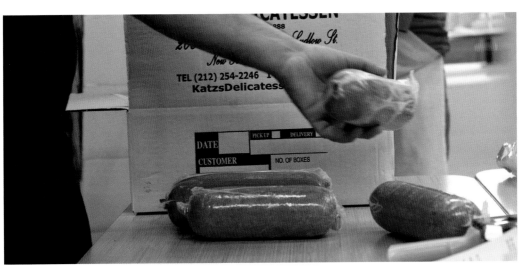

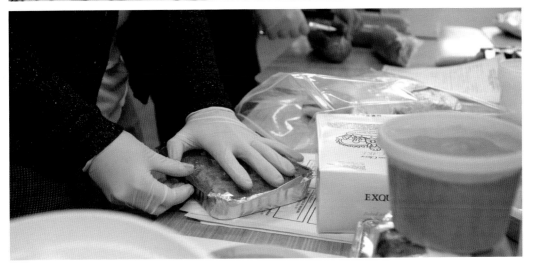

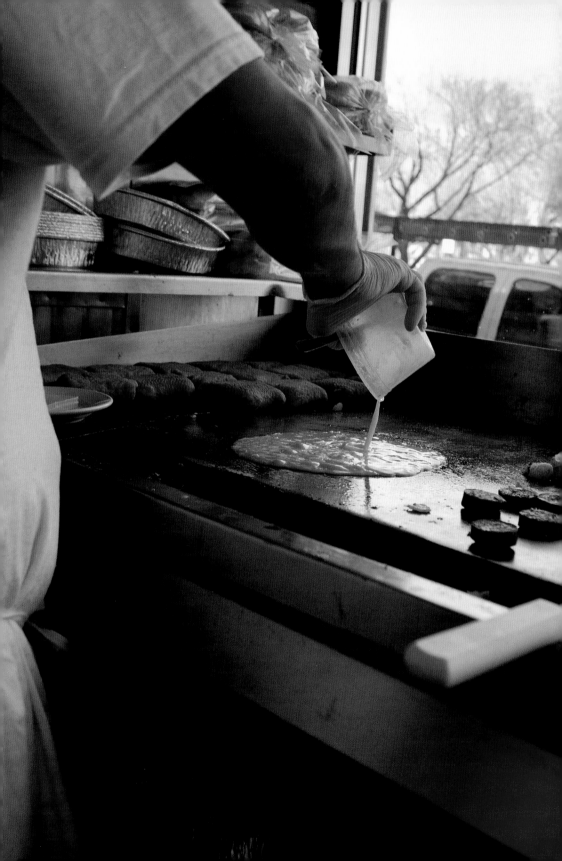

NIGHT TURNS *into* DAY

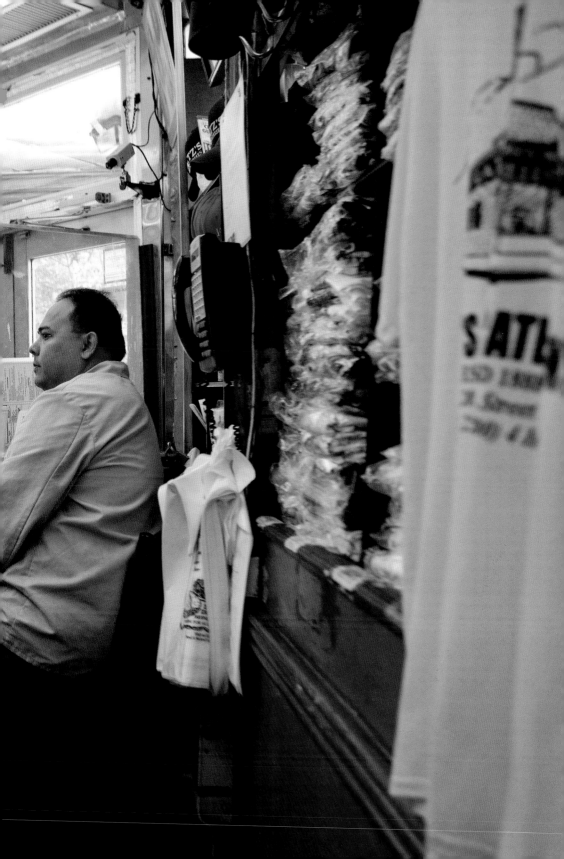

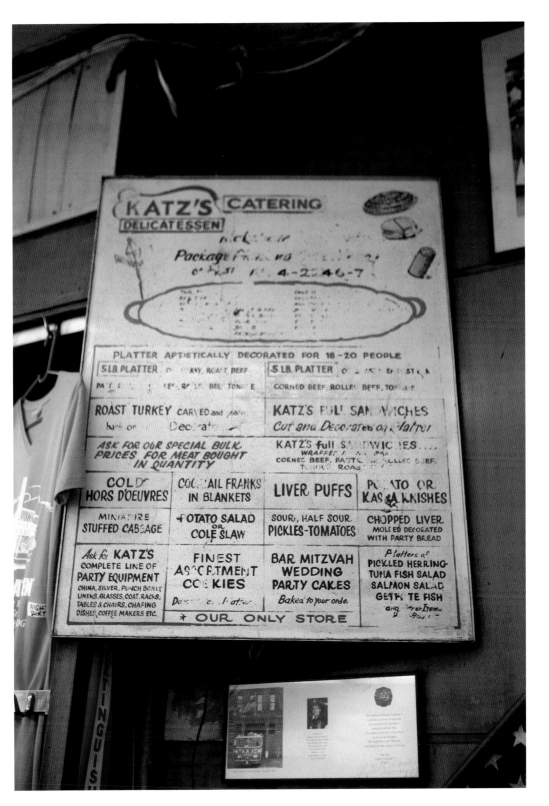

KATZ'S DELICATESSEN — CATERING

Package *[illegible]*

[illegible] 4-2246-7

PLATTER ARTISTICALLY DECORATED FOR 18–20 PEOPLE

5 LB. PLATTER OF TURKEY, ROAST BEEF *[illegible]*	**5 LB. PLATTER** OF *[illegible]* BRISKET *[illegible]* CORNED BEEF, ROLLED BEEF, TONGUE
ROAST TURKEY CARVED and *[illegible]* Decorat *[illegible]*	**KATZ'S FULL SANDWICHES** *Cut and Decorated on Platter*
ASK FOR OUR SPECIAL BULK PRICES FOR MEAT BOUGHT IN QUANTITY	**KATZ'S full SANDWICHES....** WRAPPED *[illegible]* CORNED BEEF, PASTR *[illegible]* ROLLED BEEF, TONGUE ROAS *[illegible]*

COLD HORS D'OEUVRES	COCKTAIL FRANKS IN BLANKETS	**LIVER PUFFS**	POTATO OR KASHA KNISHES
MINIATURE STUFFED CABBAGE	POTATO SALAD OR COLE SLAW	SOUR, HALF SOUR PICKLES-TOMATOES	CHOPPED LIVER MOLDED DECORATED WITH PARTY BREAD
Ask for **KATZ'S** COMPLETE LINE OF **PARTY EQUIPMENT** CHINA, SILVER, PUNCH BOWLS LINENS, GLASSES, COAT RACKS, TABLES & CHAIRS, CHAFING DISHES, COFFEE MAKERS ETC.	**FINEST ASSORTMENT COOKIES** *Do* *[illegible]* *on Platter*	**BAR MITZVAH WEDDING PARTY CAKES** *Baked to your order*	*Platters of* **PICKLED HERRING TUNA FISH SALAD SALMON SALAD GEFILTE FISH** *and* *[illegible]*

*** OUR ONLY STORE**

277

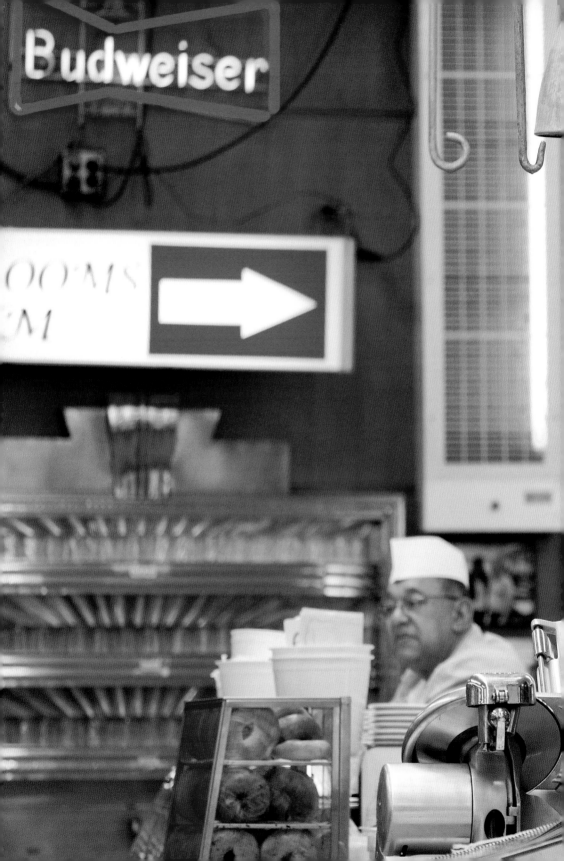

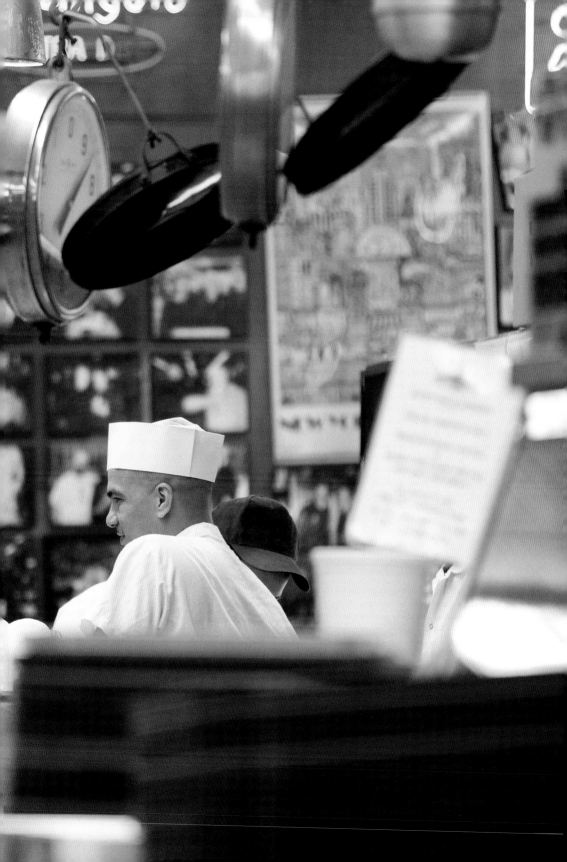

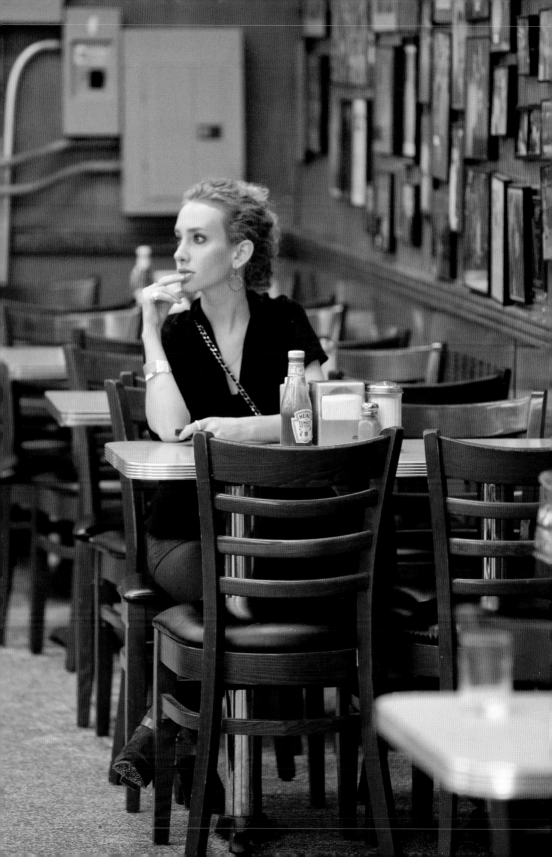

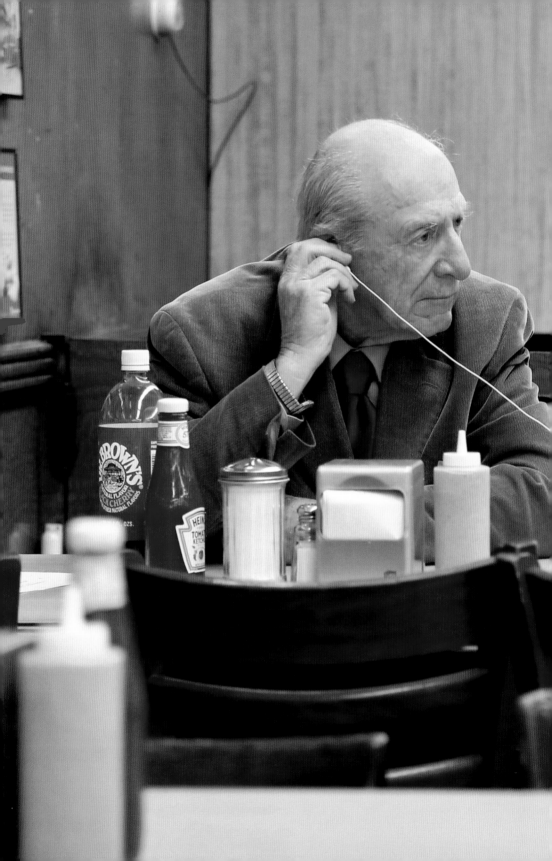

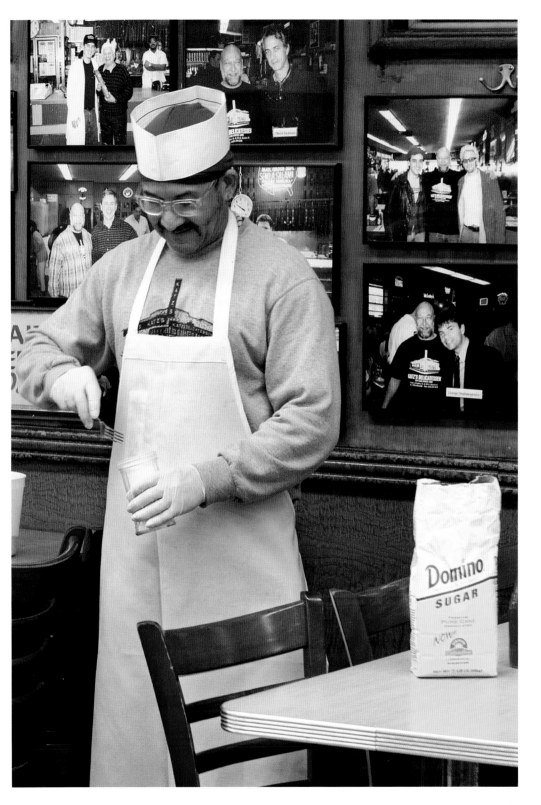

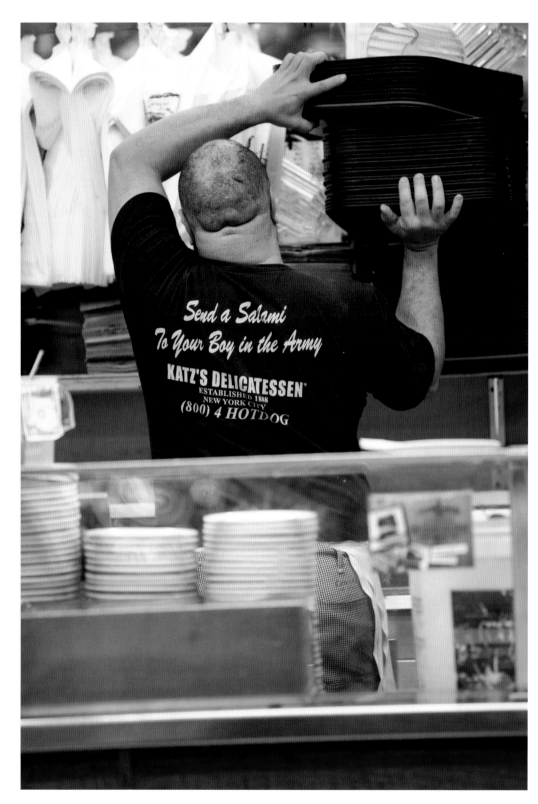

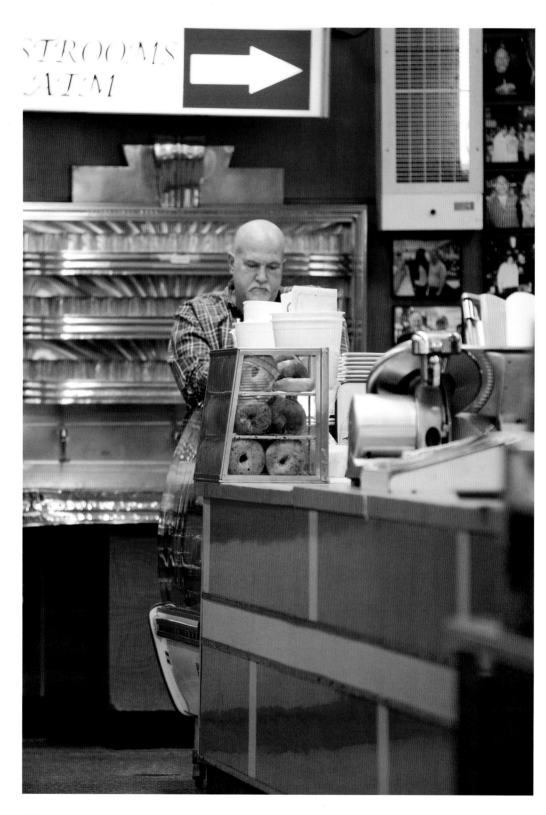

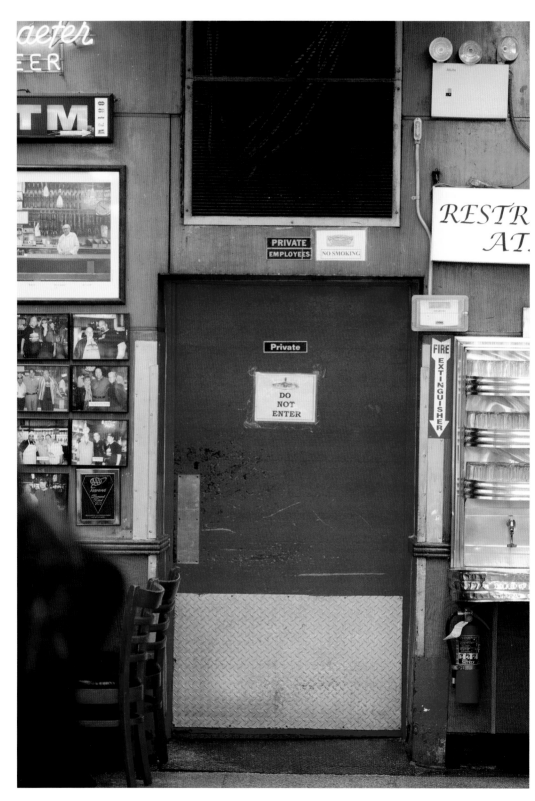

BEWARE OF
ATTACK BOSS.

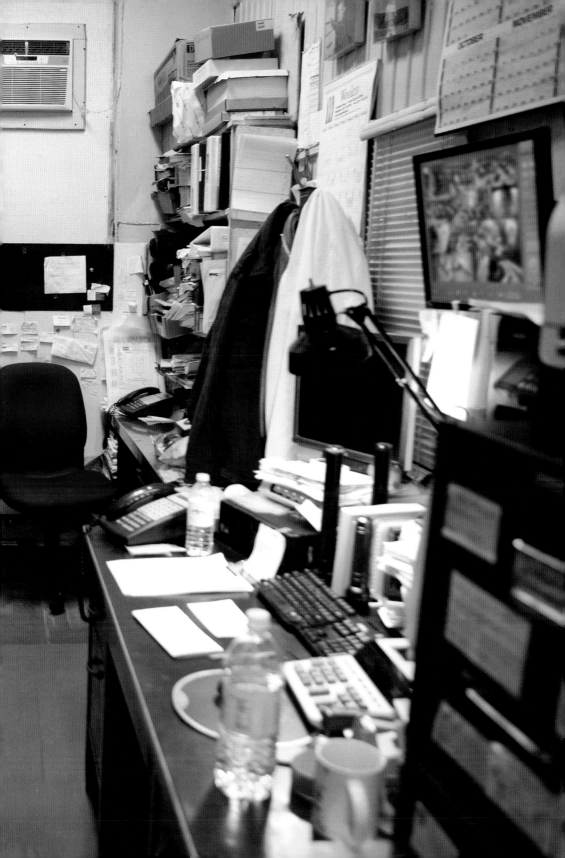

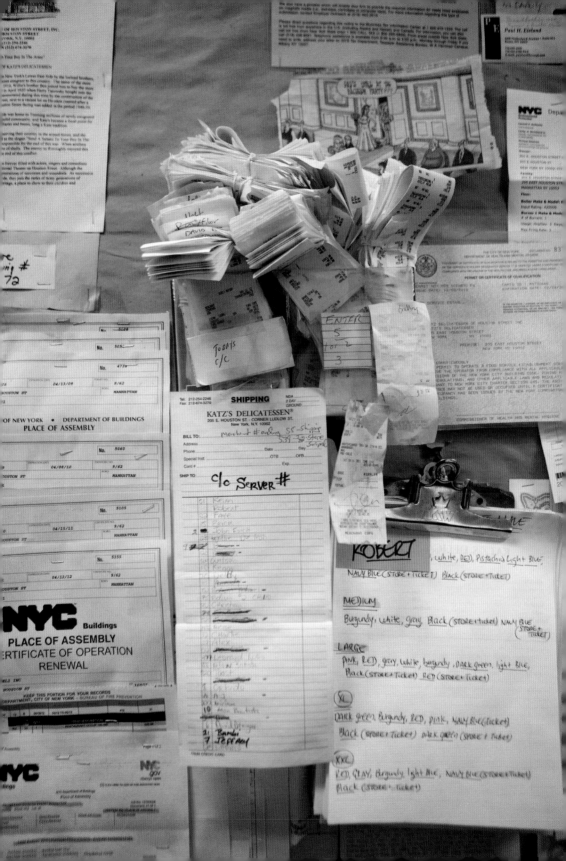

Arizona Daily St

Wednesday, June 5, 1991

z's Finest
ami goes
ere GIs go

L. Penenberg
New York Times

ORK — There is a branch of the
the Lower East Side of Manhattan
soldiers temporarily escape the
of K rations.

wn as Katz's Delicatessen,
ers for soldier's salami.

is especially busy during wartime,
maintains a presence in the Persian
e it sends between 20 and 30
week from concerned parents,
d friends to remaining soldiers.

salamis to the front was popular in
II and every war since, said Dave
who is in his 70s.

at Katz's in 1944, and the tradition
the same way," Tarowsky said.

y we've been in business for 103

e have these signs here, 'Send a
Your Boy in the Army,'" he said,
Army with salami and tapping his
e table. He wears a pinky ring with
tting out to cut string for wrapping
n him it looks like an essential piece

in the front of the store is a letter
uring the Vietnam War, dated Oct. 31,
ar Sir," it begins. "I recently tasted
ur salamis that a fellow pilot's family
and it was delicious. The salami is
et long and 2½ inches in diameter
rked 'Katz's Finest Salami.' Could
ne one? Sincerely, Donald J.

being shipped to military bases,
d other destinations around the
salamis must be prepared.

them here first for a month, or two
Tarowsky said. "Then they won't
e time the soldiers or anybody else
" The moisture evaporates, leaving
picy taste.

egend has it that in World War II,
to the front was particularly slow, a
ceived a salami in which the casing

Frank Sinatra, Alan King and Mickey
Rooney have eaten here, as has former
President Jimmy Carter. A photograph of Neil
Armstrong is displayed in the window with the
caption, "he travels far for . . . great food." A
scene from the movie "When Harry Met Sally
. . ." was filmed at Katz's, and the table Billy
Crystal and Meg Ryan sat at is now labeled
with a sign.

The Katz salami recipe, invented 60 years
ago by Tarowsky's brother Harry, who died 11
years ago, is a well-guarded secret, but
Tarowsky assures that all Katz's salamis are
all beef, kosher and made to Katz's
specifications by local manufacturers. (Dairy
products are not available on the premises,
but Katz's is open on Saturday.)

There have been three generations of
Tarowskys working the salami counter at
Katz's, which was founded more than a
century ago by two cousins, Willie and Benny
Katz. Harry Tarowsky, who became a
part-owner with Willie's son Lenny before
World War II, helped the rest of his family
come over from Russia.

Kevin Albinder, Dave Tarowsky's grandson,
has worked at Katz's for 10 years. He started
at the french-fry counter before graduating to
the salami counter.

"As much as I don't like admitting that I'll
be here for the rest of my life," Albinder said,
"I can't imagine not being here." Even his
grandfather, who has worked at Katz's for 47
years, said he had had no idea he would stay
so long.

Four years ago, Katz's was bought by Alan
Dell and Fred Austin, who have been in the
deli business for years.

The two have taken a hands-off approach to
the business, which occupies the same spot at
the corner of East Houston Street and Ludlow
Street as it always has. The Tarowskys,
however, have seen dramatic changes in the
neighborhood over the years.

Gone are the overcrowded tenements
overflowing with newly arrived Jewish
immigrants from Eastern Europe in search of
a better life.

Now there is a large Hispanic population,
and myriad Spanish stores and restaurants.
Many tenements have been renovated by the
growing population of artists.

Tarowsky keeps the tradition going at
Katz's. Whether mailing salamis to soldiers
and students or offering a small taste of
salami to a customer, Tarowsky keeps
everyone in touch with the past.

"I still stay on here and tell them, 'Look, you
have to have the tradition.' That's the story.
I've told you the story."

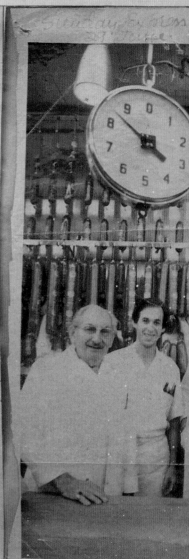

DELI

"We take a little
piece from the top, a
little piece from the
centre, a little piece
from the bottom to
get a blend of taste.
Then we add a little
more to get a quarter
pound of meat on
each 4.40-dollar sand-
wich. The mechanical
slicer just goes zip,
zip, zip right through
the centre of it, fat
and all."

Katz Delicatessen at

Isador Tarows
whose father st
the business w
partners from
in 1912.

This jolly del
full of family ar
mouth watering
aroma of pickle
garlic, onions, r
ard, fresh brea
Over the
counter there ar
strange injunct
"Send a salami
boy in the Arm
which originate
the Second W

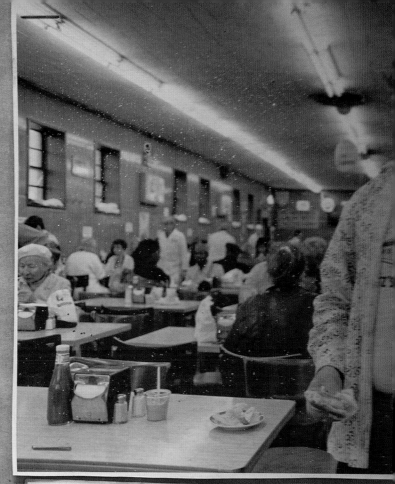

KATZ'S DELICATESSEN OF HOUS
205 E. HOUSTON
NEW YORK, N.Y
(212) 254-2
FAX (212) 674-

"Send A Salami To Your Boy

A SHORT HISTORY OF KATZ'S

RESTOCKING *for the* WEEK

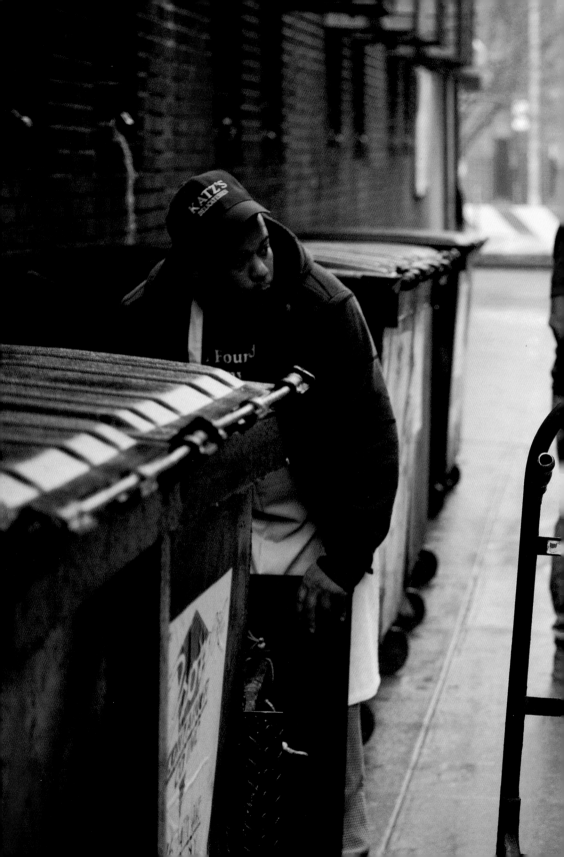

Blc #307

CONTAINER
CO. INC

126-46 34TH AVE. FLUSHING, N.Y.

718-335-6945

US DOT 113658

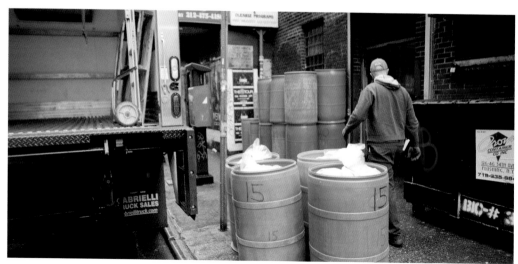

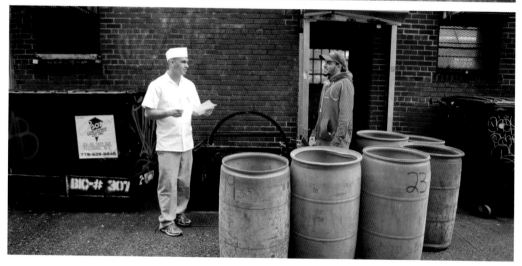

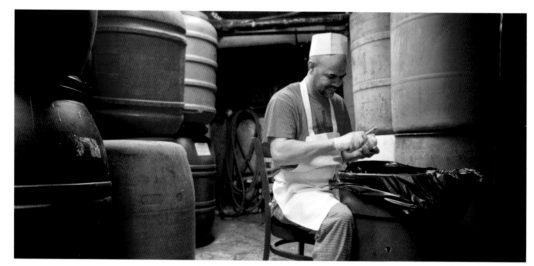

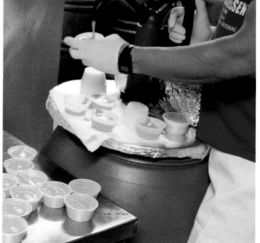

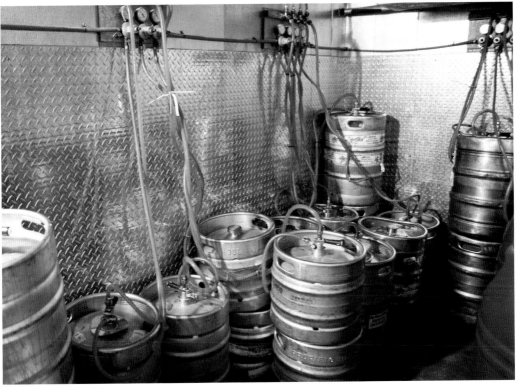

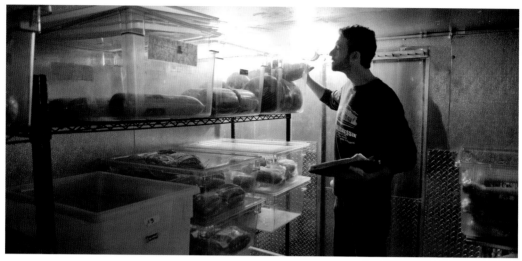

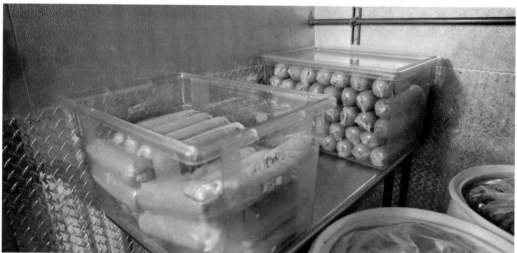

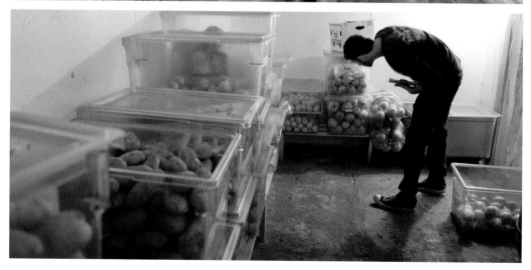

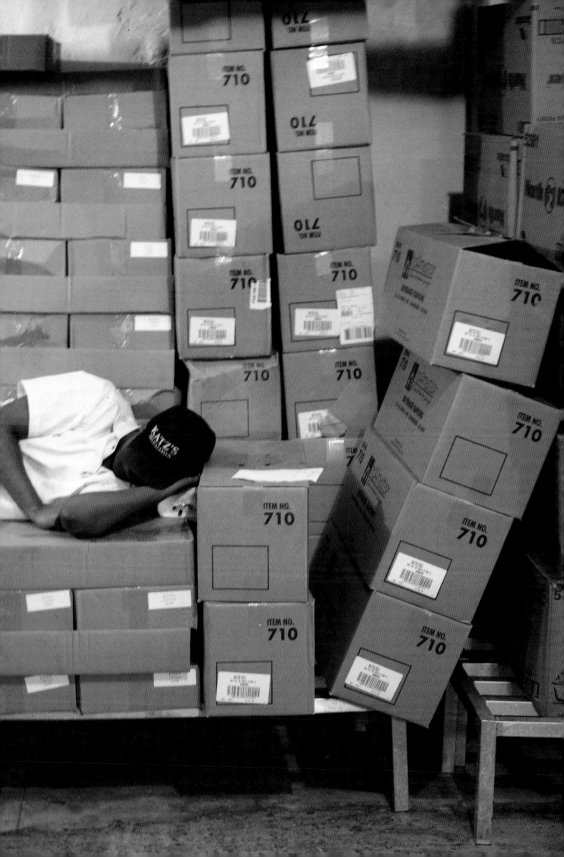

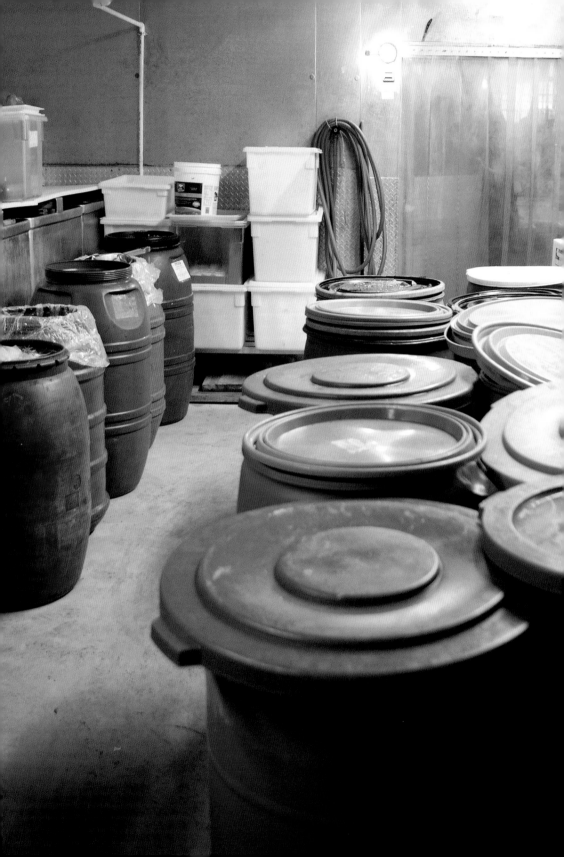

THE MAIN PICKLING ROOM

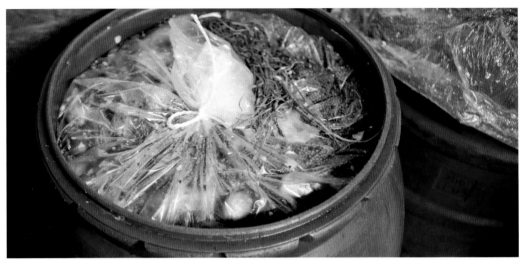

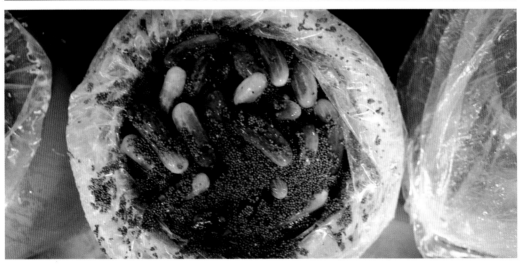

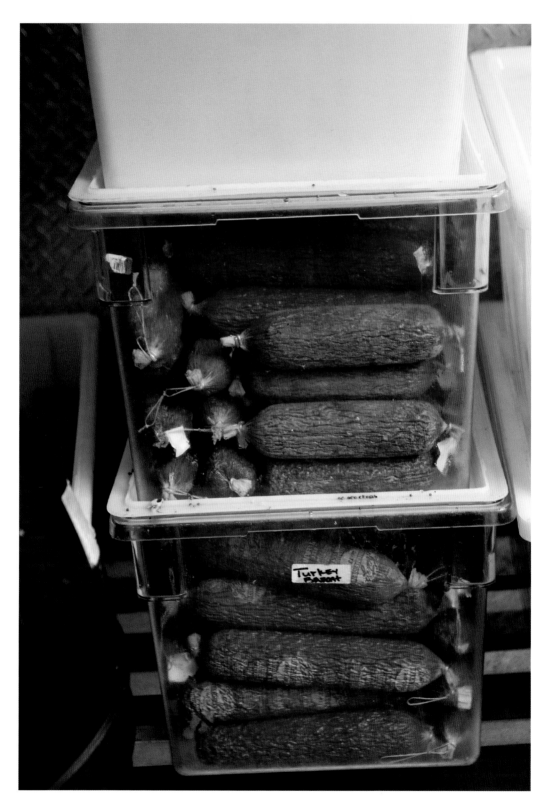

REQUIRES A LAMP THAT
PRODUCES 40 LUMENS
PER WATT OR GREATER

WARNING!
DO NOT CONNECT POWER TO DOOR
UNTIL BROUGHT DOWN TO TEMPERATURE.
CHECK INSTALLATION MANUAL
FOR PROPER WIRING
INSTRUCTIONS AND VOLTAGE.

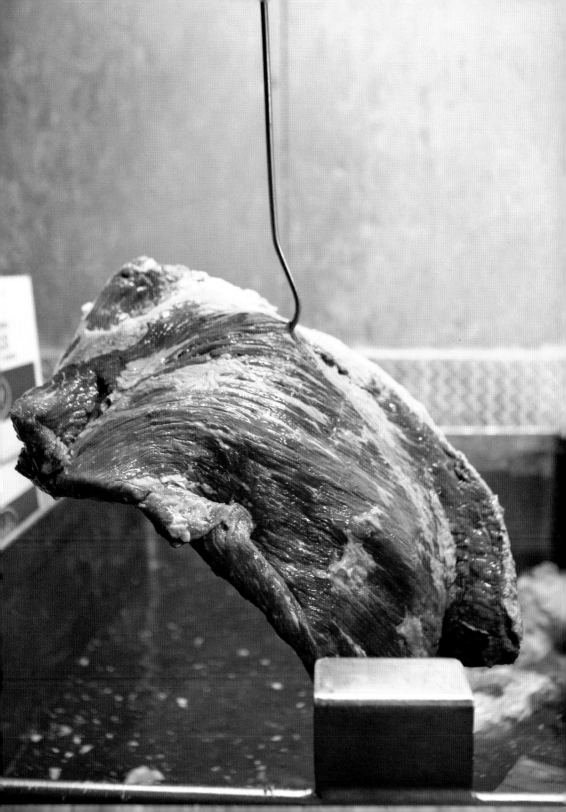

THE KITCHEN

334

Las alergias a los alimentos pueden ser graves

Hasta una pequeña cantidad del alimento que produce una alergia puede ser perjudicial

Los 8 alimentos más comunes que producen alergias son:

Maníes

Huevos

Frutos secos

Leche

Pescado

Trigo

Moluscos

Soja

Si un cliente le informa a un mesero que tiene una reacción alérgica a un alimento, el mesero deberá:

- Preguntarle al chef o al encargado si el alimento que causa la alergia se encuentra en la comida que el cliente ordenó o si ese alimento estuvo en contacto con el plato que el cliente pidió
- Decirle al cliente lo que el chef o el encargado le informó
- *¡Nunca adivine! ¡Debe hacer preguntas!*

El personal de cocina y los meseros pueden hacer lo siguiente para prevenir la contaminación cruzada:

- Controlar todos los ingredientes y leer las etiquetas de los alimentos envasados
- Lavarse las manos
- Cambiarse los guantes
- Limpiar las superficies de trabajo
- Nunca usar un equipo o los utensilios que se utilizaron para preparar otras comidas
- Nunca usar los aceites que se utilizaron para preparar otras comidas
- Evitar salpicaduras y derrames
- Mantener el plato terminado lejos de los demás pedidos

NYC — Llame al 911 si el cliente tiene una reacción alérgica

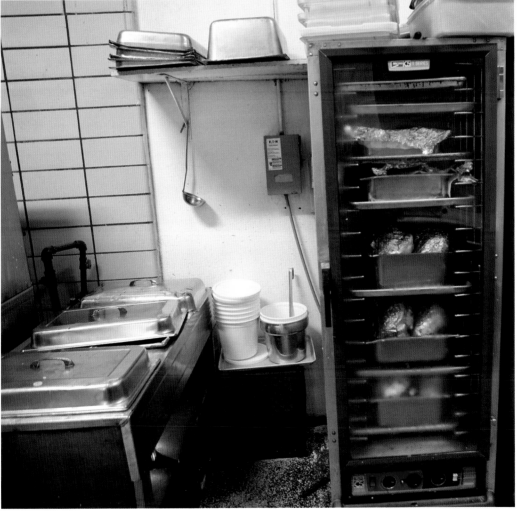

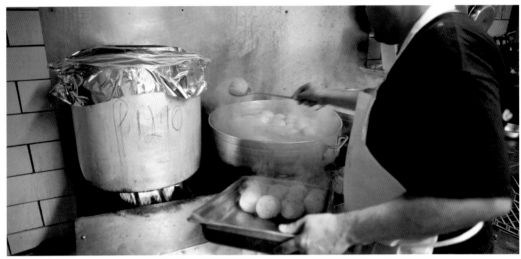

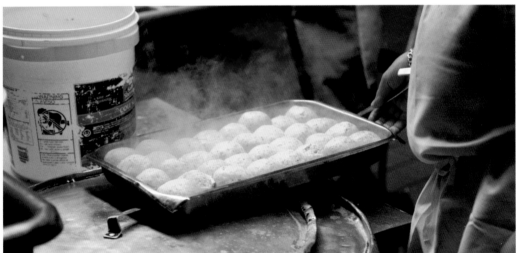

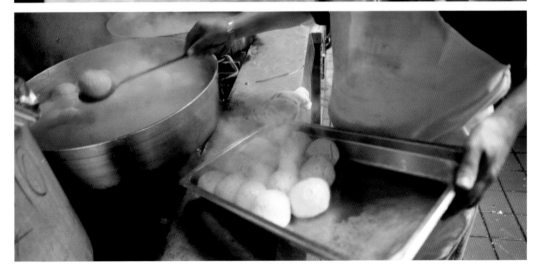

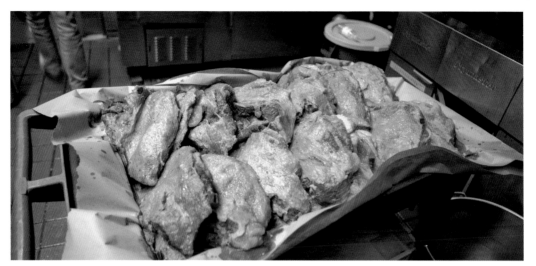

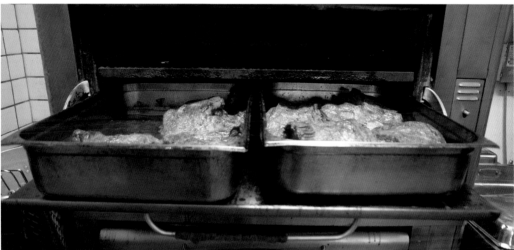

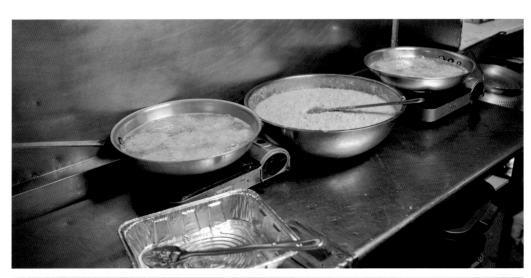

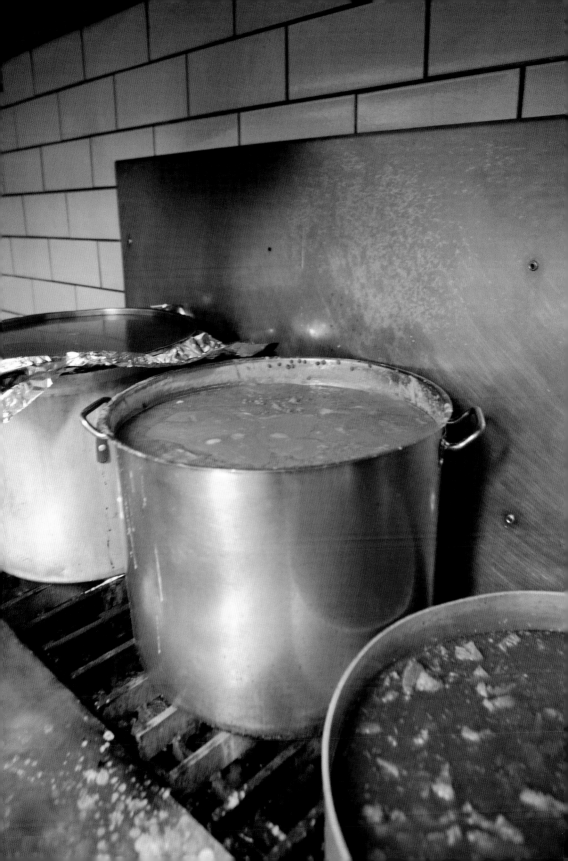

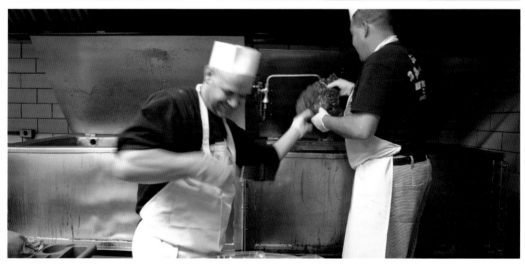

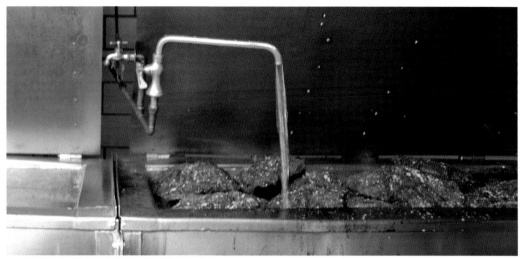

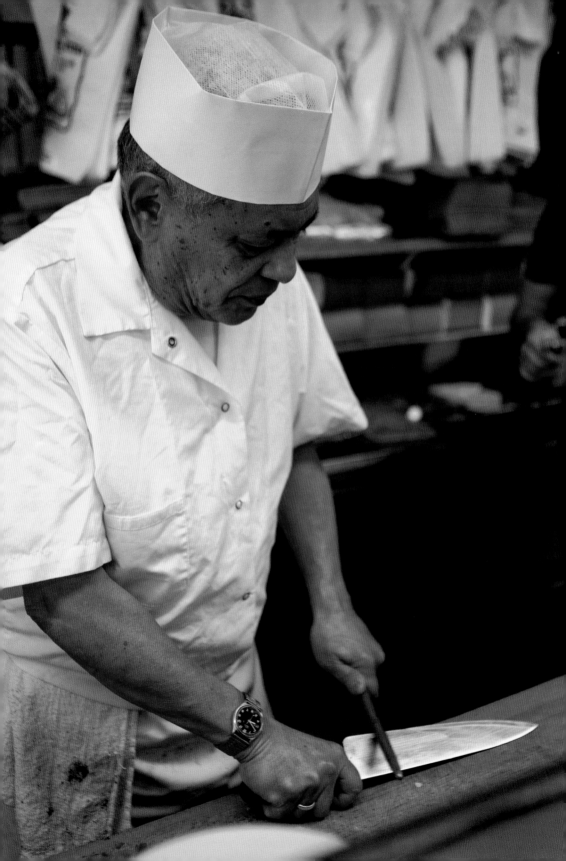

Meat Showdown:
Pastrami vs. Corned Beef

Despite the large variety of items on the menu, most of our patrons come for our world-famous meats. The two most popular sandwiches are, by far, pastrami and corned beef. While corned beef was always the traditional favorite, dating as far back as 1888, tastes have certainly changed. What's your preference?

For those who don't know the difference between the two meats, here's a breakdown:

The Cut The first major difference between pastrami and corned beef is the cut of meat. Pastrami comes from the navel, which is a wonderfully juicy and fatty section of the steer. This high-quality cut better absorbs the spices applied as a rub during the smoking process. Corned beef is a brisket cut (from the shoulder). These hefty slabs of beef are ideal for absorbing the pickling spices during the second part of the brining process.

Brining Process Both pastrami and corned beef are pickled in a basic salt solution, but the brining process is slightly longer

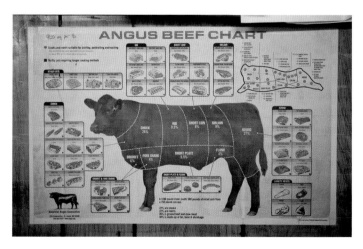

for corned beef. Every piece of meat spends two weeks in an airtight barrel, submerged in a condensed saline solution. Corned beef then spends an extra two weeks in our large pickling tanks. "Corned" literally means "brined," so "corned beef" can be thought of as "meat that has been pickled."

Smoking The second major difference is that after brining, corned beef is ready to be cooked, whereas pastrami undergoes a delicious smoking process. The navels spend up to three days in our smokehouse in Brooklyn, cooked at a low temperature for forty-eight to seventy-two hours over our unique blend of wood chips. A rub of salt, pepper, garlic, coriander, and other all-natural spices is applied during this process and is part of what sets our pastrami apart from the others.

Weight of a typical pastrami sandwich: 14 oz = 1 football = 145 ping pong balls.

Cooking Process Both meats are cooked the same way. We load each double boiler with two to three hundred pounds of pastrami or corned beef, letting the meat cook for three to five hours (depending on the cut). The meat is then brought to the steam table behind the cutting stations where it spends up to thirty minutes softening even more!

Hand Sliced After steaming, the meat is freshly sliced to order by one of our skillful cutters. The meat is so juicy and so incredibly tender that it needs to be carved by hand—it would simply fall apart in a slicing machine! Assembling the meat into a proper sandwich is a labor-intensive process and, quite frankly, a true art form.

The Verdict While there are plenty of fans of our homemade corned beef, the preference for pastrami is roughly two to one. Our customers eat on average fifteen thousand pounds of pastrami and eight thousand pounds of corned beef every week. The Reuben sandwich, which consists of corned beef, sauerkraut, melted Swiss cheese, and homemade Russian dressing, is largely responsible for the quantity of corned beef sold. The popular Reuben is a relatively new addition to the menu. When my father was young, there was no such thing as a Reuben—no real Jewish deli would ever think of serving meat and cheese together! But our regulars demanded that this delicious invention be added to Katz's menu, and, ultimately, we agreed.

Right:
The Reuben sandwich.

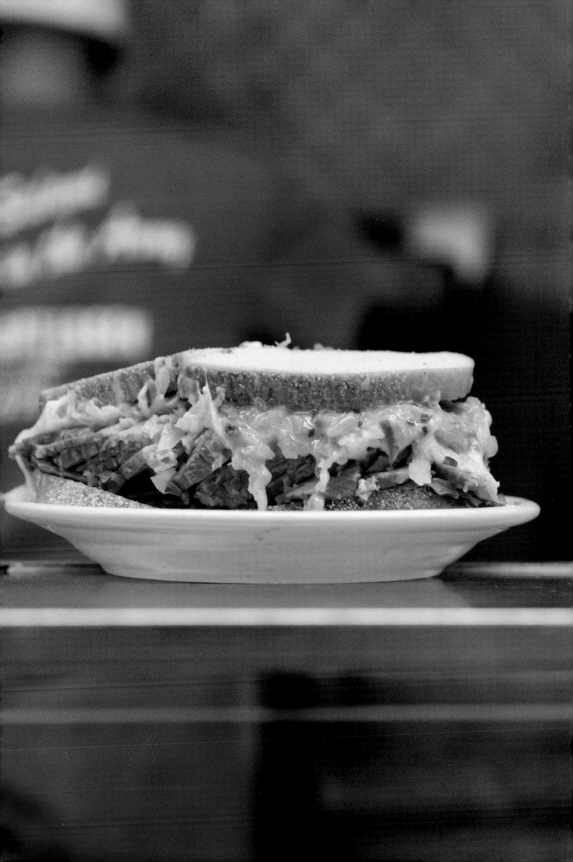

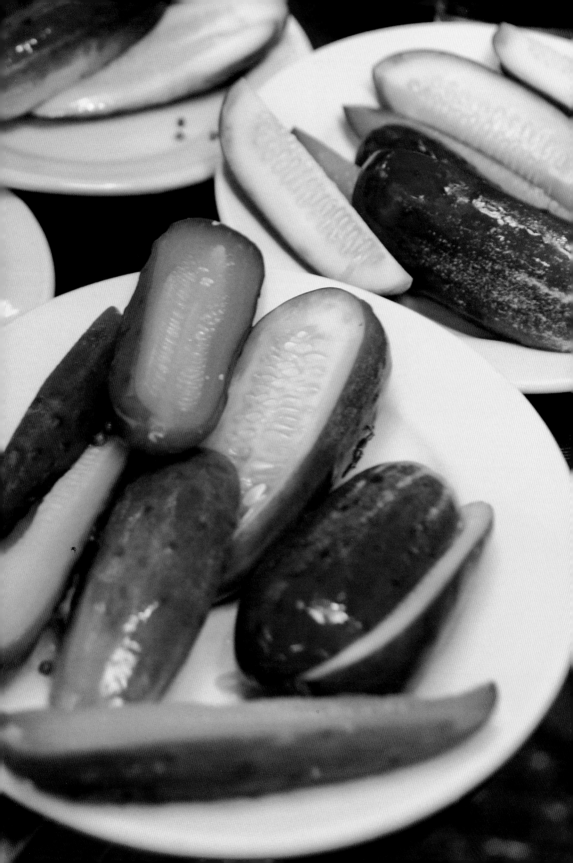

Pickle Showdown: Half-Sour vs. Full-Sour

Every Katz's sandwich comes with a selection of our delicious pickles, made in-house using our unique recipe. With more than half a million sandwiches served every year, it's no wonder we go through over fifteen thousand pickles during a busy week. Our customers are loyal to their pickled fruits, whether one of the cucumber pickles or a pickled green tomato. The tomatoes, an old-time preference, are now a distant third to both the half-sour and full-sour pickles. So what's the difference between these two favorites?

The Cucumber Both the half-sours and full-sours start off as fresh Kirbys. *Verdict: Identical*

Spices Both use the same unique blend of peppercorns, pickling salts, and all-natural dried spices. *Verdict: Identical*

Left: The bright green pickles are half-sours; the darker ones are full-sours.

Below: Pickled tomatoes.

Pickling Solution Both are placed in large sealed barrels that each hold more than five hundred cucumbers, along with water, vinegar, and pickling spices. *Verdict: Identical*

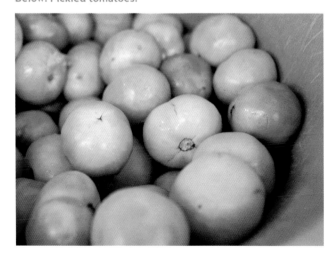

Time Half-sours come out of the barrels after three to five days, while full-sours spend up to four weeks in the pickling solution. *Verdict: Different*

Amount Sold Ten years ago, full-sours handily outsold the half-sours. Today they sell in equal numbers, with ten to twenty barrels of each type consumed every week. *Verdict: Identical!*

What's Your Preference?

My father's favorite uncle, Sidney, would often take him to Coney Island. On the way back, they would feast on corned beef on rye. Back then, almost everyone preferred corned beef, complete with a plate of full-sours and a Dr. Brown's Cel-Ray Tonic. Times and tastes have evolved. Here are the preferences of just a few of our customers . . .

Raised a corned-beef person, Alan Dell now prefers pastrami, but still only eats full-sour pickles.

Friends for 67 years, Irv (l.) and Bill (r.) have both been coming in from Brooklyn to Katz's for over 80 years. Bill eats pastrami on rye with half-sours and Irv always gets full-sours and pastrami on club, an extra 50 cents!

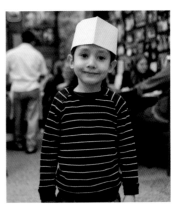

Joaquin loves pastrami, but at age 5, he has time to change his mind.

Regulars since the 1950s, Donna (l.) and her older sister, Laurie (r.), grew up nearby on the Lower East Side. Laurie mixes pastrami and corned beef every time, while Donna is loyal to the Reuben.

Steve moved from Boston in 1975 and discovered Katz's. His mother, Irene, was consoled with Katz's corned beef on his visits home.

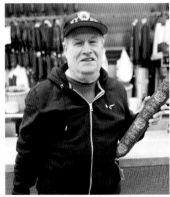

Alan's brother received a salami from Katz's while serving in World War II. A regular for 35 years, Alan loves their soft salami.

Rick Meyerowitz and Maira Kalman, well-known illustrators, are both longtime "pastramists" of Katz's. Rick says, "If I want corned beef and cabbage, shouldn't I oughta have it in Galway?"

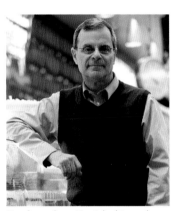

Mike (above r.) began the family tradition. He and his son, Steven (far l.), have been eating Katz's pastrami since well before Harry met Sally! Grandkids Destini and Steven Jr. are third-generation regulars. Everyone eats half-sours, aside from Steven Jr., who prefers the fries.

First brought to Katz's by his mother in 1959, Marshall has been eating their corned beef, lean, on club, with lots of mustard ever since.

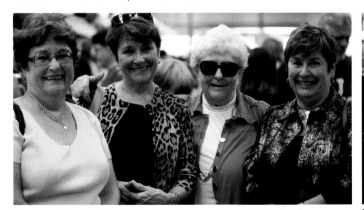

The three sisters and their friend have been meeting up in the city for 16 years. On this visit (l. to r.) Mary Ann (Illinois), Susan (Minnesota), friend Marilyn (Iowa), and Jane (Arizona) came to Katz's after visiting the Tenement Museum nearby. They ate corned beef and pastrami.

To Adolfo, Katz's symbolizes what New York is. He has been eating their full-sours and pastrami for over 30 years.

Chris has been eating Katz's pastrami for 30 years (no comparison to the 80 years his wife's grandmother was a regular).

For over 6 years, Kathe has been coming from Michigan for Katz's corned beef and half-sours.

Some tourists from Newbury, England, took the "tube" down to the Lower East Side just to eat at Katz's.

First timers from Louisville, (l. to r.) Al, Marcia, Cheryl, Randy, Marcia, and waiter Lenny (who took Mark's seat and prefers pastrami and full-sours). Mark saw Katz's on Adam Richman's show and dragged the group here, but missed his photo op!

Michelle prefers corned beef and swears Katz's has the best full-sour pickles around.

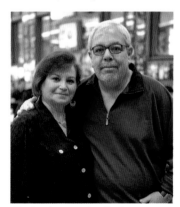

Alan has been eating Katz's pastrami since age 5. His wife, Barbara, switched from corned beef when they met 35 years ago.

Londoner Gina ordered corned beef, but preferred the pastrami her boyfriend, Patrick, ordered.

When Gary was 7, his dad started bringing him to Katz's after closing up his family shop nearby—for round knishes and pastrami.

A regular since 1976, Peter just ate three pastrami sandwiches—without the bread, but still a feat!

Angela, known to many as "Big Ang," has been eating Katz's pastrami for over 35 years.

A Katz's pastrami sandwich with a full-sour pickle and Ballantine Ale was heaven to Donald J. as a teenager and continues to be in his 70s.

Fernando saw Katz's on the Food Network and came all the way from California for their pastrami and half-sours.

Fred Austin's cousin Alan and his wife, Nancy, would walk the two miles to Katz's on weekend mornings to visit (and for the pastrami).

Stephenie prefers their pastrami and always full-sour pickles.

(L. to r.) Danish, Michael, Jordan, James, and Paul squeezed in a pastrami breakfast before their business meeting. First timers from Fresno, California, they all agree the pastrami was amazing and worth another flight back!

Their company prints Katz's tickets! Larry mixes his pastrami with corned beef. He, Elizabeth, and 4th-generation Margaret Rose love full-sours.

Alan Dell
Co-owner since 1988

Fred Austin
Co-owner since 1988

Jake Dell
Co-owner since 2010

The People Who
Make Katz's Katz's

It takes a village to run a deli.

Most of our operation is what you see behind the counter. During any given shift, as many as twenty-five countermen and counterwomen work the line, acting as liaisons between the customers and the food. But those aren't the only people needed to make this store run smoothly. It takes a staff of more than a hundred, working day and night, to ensure Katz's will remain the best delicatessen in New York City.

Busboys continually clear tables, their buckets quickly filling up with dishes. Porters clean throughout the day, sweeping, refilling napkin dispensers, and sprinkling sawdust on the worn terrazzo floor. The kitchen staff keeps food coming out piping hot, while delivery drivers make sure hot sandwich orders get to their final destinations throughout the five boroughs. Finally, for customers who are wary of the counter experience at Katz's, we offer a limited number of waiter-service tables and a full complement of wait staff and hosts to make this run effortlessly.

ALL IN THE FAMILY
Many of our staff are the second or third generation working at Katz's. The two largest families here are the De La Cruzes and the Paez/Adames/Marines clan. There are also the Gomez/Reyes and the Herrera/Rosario *mishpuchas* (families). They all work together in positions ranging from busboy to manager, ensuring that the restaurant operates as efficiently as possible.

Then there are the Albinders—the family with the most combined years of experience. Their lineage, the longest running here at Katz's, descends from one of the earliest

owners, Harry Tarowsky. Rob Albinder, our general manager, has worked at Katz's since 1976. His younger brother, Kevin, our second highest-ranking manager, started in 1981. Kevin's son Justin began working here a few years ago, continuing the family tradition.

Kevin, Justin, and Robert Albinder

Without the care and hard work of my enormous extended family, Katz's would not be the destination it is today. I am grateful to each and every one of them and know that our customers will continue to see their faces for decades to come!

STAFF STATISTICS

Number of staff with triplets: 1

Number of third-generation staffers: 9

Number of actors on staff: 1

Number of Jewish waiters: 2

Number of José De La Cruzes working at Katz's: 3

Number of staff since 1888: 1,300

Total years of experience among current staff: 1,100

Average hours a week co-owner Harry Tarowsky worked in 1940: 70

Average hours a week co-owner Jake Dell worked in 2012: 70

De La Cruz
Family

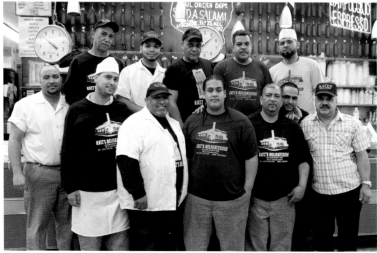

Paez/Adames/Marines
Family

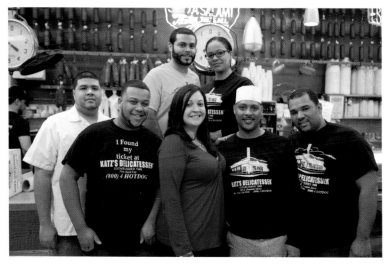

Gomez/Reyes
Family

MANAGERS

Robert Albinder

Kevin Albinder

Erick Cespedes

Charlie De La Cruz

Alex Iglesias

Kenneth Kohn

Elvin Marte

Faye Weissman

CUTTERS

Mario Adames

José De La Cruz

Jefrito De La Cruz

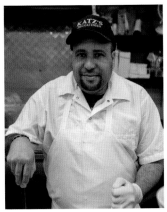

Esteban De La Cruz

Alfredo Fernandez

Rony Garcia

Edwin Gomez

Miguel Herrera

CUTTERS

Miriam Isaac

Ramon Peña

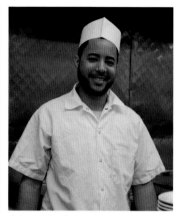

Johanny Perdomo

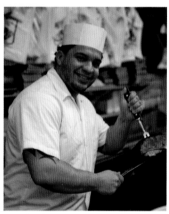

David Polanco

Alejandro Polanco

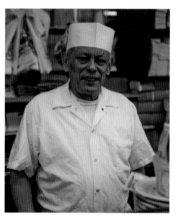

Benny Quiros

John "Toast" Ramirez

Bradley Ramirez

Gerardo "Jerry" Reyes

CUTTERS

Delby Rodriguez

Eddie Romero

Eduardo Ezequiel Romero

Anthony Rosario

Johanny Rosario

Juan Carlos Santos

José Tavares

Juan Carlos Tiburcio

Aneury Zapata

GRILL AND SODA

Reynaldo Adames

Oscar DeLuna

Juan Pablo Liz Veras

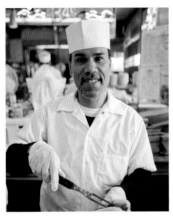

Porfirio Rosario

Will Francis Troncoso

Marcelo Vega, Jr.

Franklyn Veras

Jhonny Veras

Josmayky Villa Lopez

BACK COUNTER

Edwin "Chino" Adames

Manny De La Cruz

Willie DeLeon

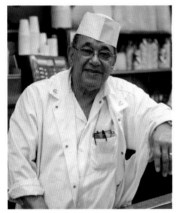

John Finch

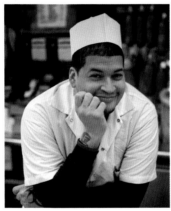

Wilfredo Gomez

Noel Marte

Orlando Rodriguez

Wilson Rodriguez

WAITERS

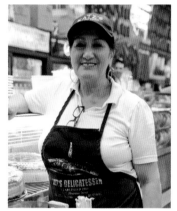

Fanny Alava

David Dominguez

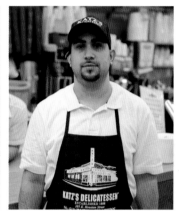

Lenin "Lenny" Espinal

Ivan Grullon

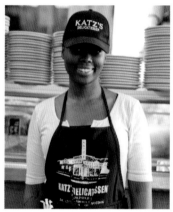

Tamara Isaac

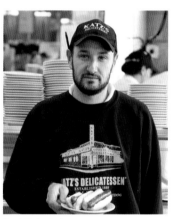

David Manheim

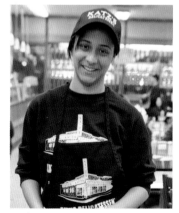

Anelissa Marine

Ismail Radwan

Katy Ziegel

FLOOR/PORTERS

José Almanzar

José Luis Balbi Cruz

Zacaria Cabrera

Jesus De La Cruz

José De La Cruz

Ysidro Peralta

German Reyes

Fernando Torres

Alberto Vasquez

KITCHEN

Sergio Colon

José De La Cruz

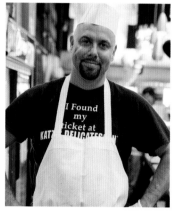

José De Los Santos Lora

Rafi Esteves

Juan Ferreira

José Gonzalez

Valestine "Val" Henderson

Andres Lora

Bernardo Marines

KITCHEN

Francisco Marines

José Marines

Jorge Martinez

David Paez

Fidel Paez

Hilario Paez

Kewing Paez

Rafael Rodriguez

Anastacio Romano

CASHIERS

Sheila Adames

Yakayra "Kyra" Correa

Anthony "Tony" Gomes

Awilda "Pachi" Gomez

Themis "Marlene" Vasquez

DELIVERY

Travis Diaz

Angel Navarro

David Rodriguez

TICKETS

INVENTORY

Justin Albinder

Christian Estrella

Arlyn Guzman

Benson James

Felo Marinez

SECURITY (Independent of Katz's, but still part of the family)

Pierre Dutes, Jr.

Kelly Washington

Corven Desir

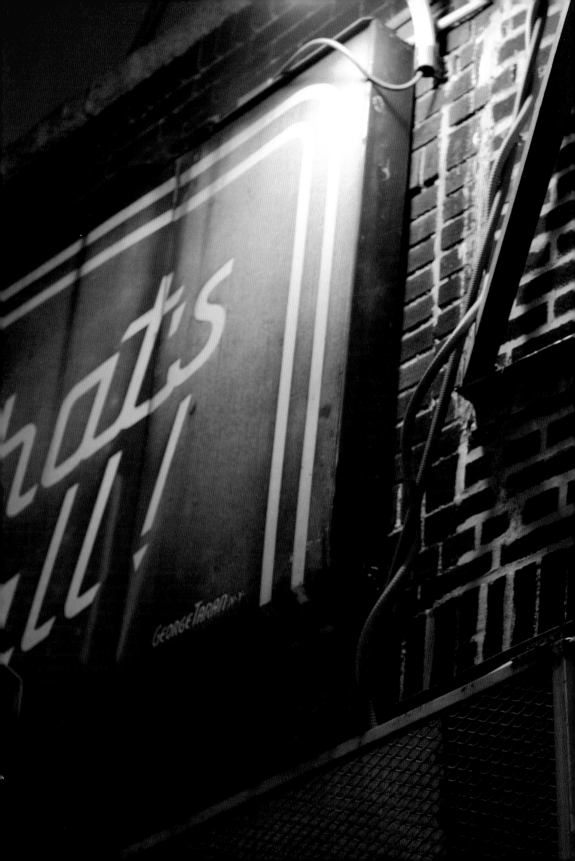

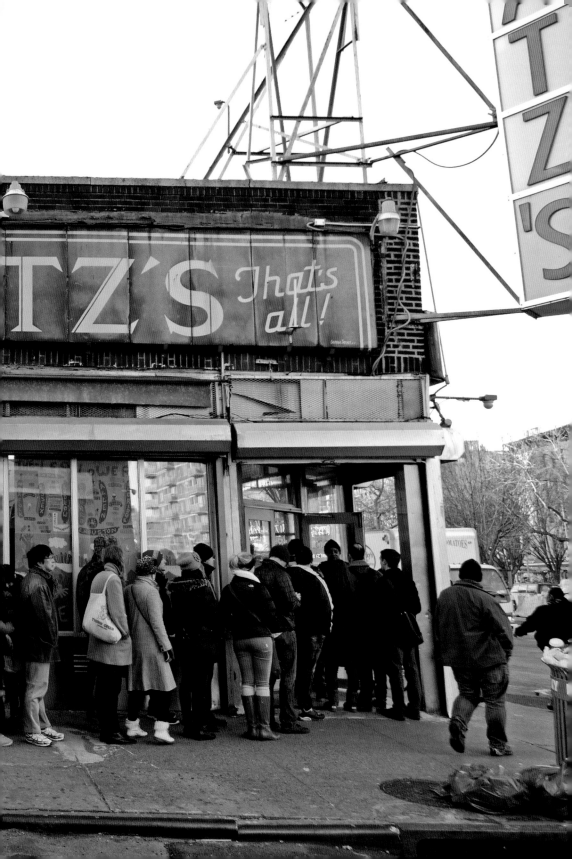

Katz's—That's All!

When expansion was completed in 1949, the owners wanted to put a large sign on the Ludlow Street facade of the new brick building. The sign maker asked exactly what words he should include. Harry Tarowsky, in his thick Yiddish accent, replied:

"KATZ'S . . . That's all!"

PUBLISHER'S ACKNOWLEDGMENTS

There are two reasons why this book was conceived: Bob Bransome's desire to stop at Katz's on his way from North Palm Beach, Florida, to Middleville, New York; and Alan Dell's ten-minute explication on the differences between pastrami and corned beef.

I want to thank Alan Dell, Fred Austin, and Jake Dell for agreeing to let us do this book . . . or rather, for not saying "No!" when the idea was first proposed to them.

This book was a team effort and the following deserve significant credit: first and foremost photographer, Baldomero Fernandez, for braving another book; Kathy Hart for her eye and dedication; Betty Eng for her invaluable guidance and advice; Chandra Wohleber for her respect of grammar; Janet Daugherty, Wendy Kenney, and Maureen Lischke for their proofreading skills; Dan Wood for his gift with words; Michael Lyon for looking at all stages of the book and providing the floor plan; Michael Psaltis and Eileen Stringer for being effective liaisons; Kevin Albinder and Wendy Robinson for contributing photographs from the past; Netta Avineri and Amy Simon for their knowledge of Yiddish; Iñaki Zubizarreta for his proficiency with color and image files; and Marco Poon and Steve Bloom of Pimlico for their skills at producing a beautiful book.

In addition, these friends and colleagues offered advice on various aspects of the project: Cynthia Conigliaro, Evelyn Dean-Olmsted, Janice Evans, Rebecca Fitting, Anna King, Jonas Kyle, Avery Lozada, Gary McElroy, Janet Mercel, Charles Miers, and Joe Pilla.

We could not have done the book without the help of the over one hundred employees of Katz's. Everyone made the experience a pleasure and added to the character of the book. In particular: Kevin Albinder for his memory and helping with a long list of names; Erick Cespedes, Alex Iglesias, Elvin Marte, and Faye Weissman for helping with staff portraits and questions; John Ramirez for providing us with plates of good food for an abandoned idea; Charlie De La Cruz for tolerating us on busy days; David Manheim for his commentary; Ramon Peña for the best café con leche in town; and especially Fanny Alava for introducing us to long-time regulars.

We could not have been more fortunate than to have Adam Richman write the perfect introduction to the book. He sets the tone in a wonderfully evocative way.

The book would not be the way I envisioned without Jake Dell's enduring willingness to give to the project. His voice and intelligence added new and invaluable dimensions.

Above all, the book could not have happened without Glenn Horowitz. His support and belief in the project gave birth to what you hold in your hands, and I will be forever grateful to him.

JAKE DELL'S ACKNOWLEDGMENTS

I am grateful for the love and support of my family—Mom, Dad, Aunt Juli and Freddy—with special thanks to Becks who didn't complain when I bugged her at all hours of the day. Thanks also to everyone at Katz's for sharing their experiences and memories as I attempted to piece together an accurate history; to David Gottesman, Rahul Kulkarni, Jessica Nepom, and Rachel Zar for turning my stream of consciousness into coherent sentences; and most important, to Poppy (Martin Dell) for introducing our family to the deli world.

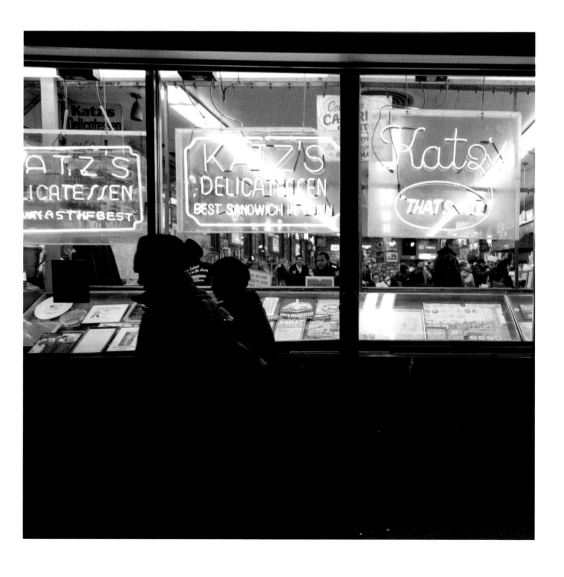

Autobiography of a Delicatessen: Katz's

Photography credits:
Unless indicated below, all photographs were taken by Baldomero Fernandez
Page 6: Kevin Albinder
Pages 17, 22 bottom: Wendy Robinson
Pages 15, 18: unknown
Page 13 bottom: postcard sold at Katz's
Pages 22 top, 23: Diana Dell

Book concept: Beth Daugherty
Design: Kathy Hart
Copyediting and proofreading: Janet Daugherty, Wendy Kenney,
Maureen Lischke, and Dan Wood

Typeset in Neutraface No. 2, Steelfish, and New Millennium
Printed on 157 gsm Japanese Kinmari matte art paper

Printed in China

ISBN-10: 0-9838632-6-1
ISBN-13: 978-0-9838632-6-7

Library of Congress Control Number: 2013937727

Bauer and Dean Publishers, Inc.
P.O. Box 98
Times Square Station
New York, NY 10108
www.baueranddean.com

Distributed in the UK and other countries outside the USA:
Antique Collector's Club

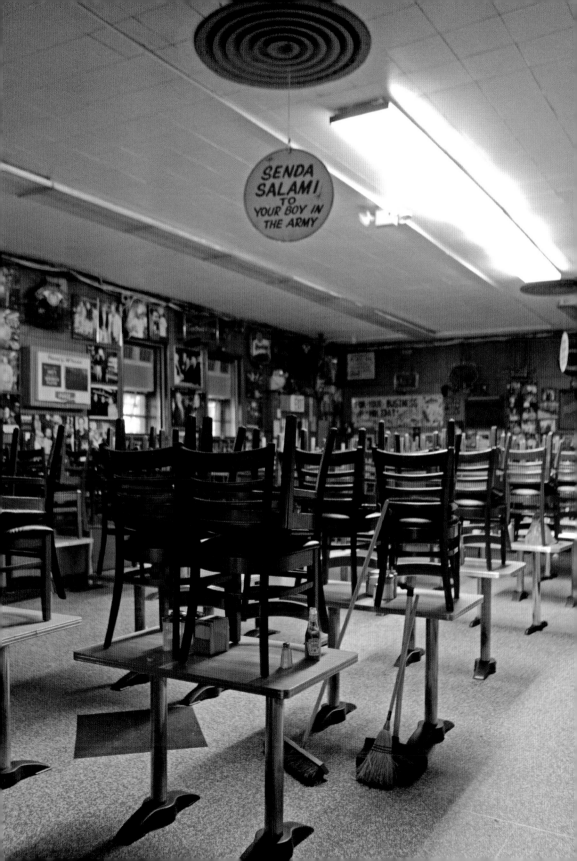